bestspasusa

THE GUIDEBOOK TO LUXURY RESORT, HOTEL AND DESTINATION SPAS

bestspasusa

THE GUIDEBOOK TO LUXURY RESORT, HOTEL AND DESTINATION SPAS

by Eileen Barish

bestusa
PUBLISHING

Scottsdale, Arizona

MEMBER

Library of Congress Catalog Card Number: 2006910642
First Edition

Photo credits
Page 38, Cheeca Lodge
Page 68, Grand Hotel Marriott Resort
Page 72, Ponte Vedra Inn & Club
Page 76, Bernardus Lodge

"TWENTY YEARS FROM NOW YOU WILL BE MORE DISAPPOINTED BY THE THINGS YOU DIDN'T DO THAN BY THE ONES YOU DID."

Mark Twain

CONTENTS

YOUR SPA EXPERIENCE

FEATURED RESORT, HOTEL AND DESTINATION SPAS

CONTENTS

WHEN IT'S ALL ABOUT YOU.

Like a romantic interlude, a spa vacation makes you feel special. The world stops. Time is endless. Reality fades. There is only softness, touch and dreaminess. Unlike any other getaway, spas are sanctuaries, escapes from the pressures of life. The welcoming environs of a spa lull you with luxury and uncommon attentiveness. They offer an atmosphere of privacy, a place where you can achieve a rapport with nature and with your own spirituality while you discover the best in yourself. A place where you can think quiet thoughts or think nothing at all.

The joys of a spa are many – sumptuous surroundings, talented hands with a knowing touch, aromatic oils, rare balms, exotic herbs and elixirs. The joy of choosing from an alluring selection of masques, body scrubs, facials, herbal wraps, massages and reflexology to name but a few. Rejuvenate within the healing waters of a Vichy shower, steam room or sauna. Indulge your senses with the natural wonders of the sea, garden and the vine.

No longer regarded as havens where the rich go to be pampered, spas have become requisites to maintaining a healthy lifestyle and looking good while you're at it. Spas provide a stress-free, noncompetitive encounter in a venue that promotes inner balance, a youthful radiance and overall wellness.

"TAKE A REST, A FIELD
THAT HAS RESTED GIVES A
BOUNTIFUL CROP."

OVID

YOUR JOURNEY TO INNER RADIANCE.

"I'M TIRED OF ALL THIS
NONSENSE ABOUT BEAUTY
BEING ONLY SKIN-DEEP.
THAT'S DEEP ENOUGH.
WHAT DO YOU WANT, AN
ADORABLE PANCREAS?"

JEAN KERR

The primary goal of the resort, hotel and destination spas in this book is to make you feel good and look even better. Their treatments and programs are designed with those thoughts in mind. But they take your well-being one step further. In addition to concentrating on the outside elements of beauty, they integrate cosmetic treatments with holistic benefits. Your spa excursion will educate you on skin care, healthy living and diet. You'll be introduced to products and techniques that can extend your spa experience and help you maintain that "spa glow" – from exercise to aromatherapy and everything in between.

More than sixty million Americans visited spas last year seeking relief and relaxation. Of course, that's nothing new. Ancient civilizations began the practice of healing waters and natural baths thousands of years ago. But today's spas have taken the experience to the nth degree.

Visit one of the spas in this book and leave
behind your hectic schedule, your social
commitments, your BlackBerry and your cell.
Lose yourself in utter indulgence and find yourself
in renewed balance. Temples of healing and
wellness, spas are tranquil sanctuaries designed
to pamper mind, body and spirit.

The resort, hotel and destination spas overviewed
in this guidebook represent a cross section of
spas throughout the country. Whether you're a
seasoned spa goer or a first-time visitor, there's
a spa getaway that's just right for you.

SYBARITIC SEDUCTION,
WHAT TYPE OF SPA SUITS YOU BEST?

RESORT SPAS

Many of the luxury resorts in this book have made their spas the focal point of the resort experience. More than just places for a massage or facial, the resort spas are based on a philosophy of combining blissful, beautifying emollients in treatments that restore and refresh. Constantly refining their services, the individual spa directors have perfected the art of pampering with therapies that incorporate restorative, indigenous elements from the desert, sea, garden and even the vine. Many combine spa indulgences with activities to keep your batteries charged and your working parts in good condition including golf, tennis, state-of-the-art fitness centers, extravagant swimming pools, yoga, tai chi, stretching and meditation classes, Pilates, personal fitness trainers as well as the requisite nail and hair services of a salon boutique. You'll become more knowledgeable on how to treat your skin and your body and how to keep yourself in a relaxed *spa state of mind.*

DESTINATION SPAS

The destination spas in this guidebook offer you the chance to change the way you live your life. They encourage guests to develop healthy lifestyle habits encompassing nutrition, fitness, coping skills and spiritual vitality. Many are comprised of three-day, four-day or weeklong, goal-oriented retreats with specific regimens. Their objectives are accomplished by a comprehensive agenda of spa services, physical fitness activities, wellness education and other special interest programs. They employ experts in their fields to help you be your best: dieticians who will counsel you on healthy living and nutrition; estheticians who will cleanse and beautify your body. They offer fitness classes, help you jump-start your diet, provide cooking demonstrations for healthful living or yoga classes for a more flexible body and a calmer spirit. Some might include shopping-smart classes or private consultations to get you

on track in both the physical and spiritual sense. You'll leave slimmer, trimmer and more energetic. When you return home, your newfound knowledge will help you on your journey to a more healthful lifestyle.

HOTEL SPAS

The hotel spas featured in this guidebook are oases of sophistication in the heart of a city environment. They offer all the amenities and services you'd expect from a fine hotel plus a luxurious spa facility. If you're a business traveler looking to be indulged, you'll find state-of-the-art electronic systems and attentive staff; if you're a vacationer seeking to combine the attractions of city travel with pampering rituals, look to a hotel spa as well. In addition to a convenient in-town location, hotel spas offer a comprehensive menu of massage, body and facial treatments as well as fitness studios and salon services.

"MEN ALWAYS WANT TO BE A WOMAN'S FIRST LOVE. WOMEN HAVE A MORE SUBTLE INSTINCT. WHAT THEY LIKE IS TO BE A MAN'S LAST ROMANCE."

OSCAR WILDE

WHAT YOU DO FOR YOUR BODY GOES RIGHT TO YOUR HEAD.

VACATION AT A SPA AND EXPERIENCE QUALITY "YOU" TIME. GO WITH THE KNOWLEDGE THAT YOU'LL BE IN A PLACE WHERE STRESS DISAPPEARS AND RENEWAL BEGINS. A HAVEN WHERE SKILLED THERAPISTS PROVIDE DOZENS OF OPTIONS RANGING FROM THE TRADITIONAL TO THE EXTRAORDINARY. IN ADDITION TO A SLATE OF INDULGENCES YOU'LL FIND CLASSES IN YOGA, AEROBICS, MEDITATION, TAI CHI, DANCE AND OTHER DISCIPLINES.

TIMING IS EVERYTHING.

Once you've decided which resort, destination or hotel spa is right for you, review the spa offerings and begin to make plans accordingly. If you wait until you arrive, treatment options and times will be limited. This is particularly important if you want to sample a specific therapy. The sooner you book, the better. The same holds true on your choice of a male or female therapist. Make your request when booking your treatments. Most spas will do their best to accommodate your preferences.

KNOW THYSELF.

To get the most out of your spa experience, consider the type of service you'd enjoy most. Do you like heat or cold? Do you want to add moisture to your skin? Are your muscles sore and tight? Will a deep Swedish massage loosen you up? Or would you prefer one with aromatherapy? Will you be more comfortable with a traditional protocol or something exotic?

When you book your appointments, plan them in logical succession. Scrubs and wraps should come first, before your massage. Why? Your newly exfoliated skin will more readily absorb oils employed during your massage. If a facial is on your agenda, plan it after your massage and avoid the puffiness and creases that can occur when your face is pressed into the massage table opening.

If you have the time and inclination, treat each part of your body to something special. Spread out the services so to speak. Take it from the top to the bottom or the other way around. Manicures and pedicures, save them for last and avoid smudging. Consider too what your social schedule will be like during the evenings of your vacation. For example, you wouldn't want to schedule a deep cleansing therapy or peel on the night you have a special event to attend.

PRACTICAL DETAILS.

WHEN SHOULD I ARRIVE?

Arrive early and plan to spend the day. The whole point is to slow down and decompress for a while. And there's no better place for that than a spa environment. Most spas suggest arriving thirty to forty-five minutes prior to your first treatment. This is definitely an added benefit to you. By arriving early, you'll be able to check in, relax and fully enjoy your spa adventure. You'll have time to change into a robe and slippers and relax in the steam, sauna or whirlpool prior to your appointment. These quiet, tranquil areas offer precious time for introspection and a chance to unwind. In addition to the pleasantries of the experience, the enveloping heat will warm your muscles, making them more relaxed and pliable. By the time your therapist comes to get you, you'll be in the mood for some blissful pampering.

WHAT SHOULD I BRING?

A robe, spa sandals and a private locker for your personal belongings will be provided. Towels are aplenty. Amenities such as shampoo, conditioner, soap, hair dryers, combs and other grooming aids can be found in the locker/dressing room areas. These rooms have separate sections for men and women including private bathroom facilities. Some resorts also have co-ed rooms. Since the very core of a spa environment is one of tranquility and relaxation, you are asked to respect everyone's right to privacy and quietude. No cell phones or pagers please. Spas also recommend that you do not bring jewelry or other valuables with you.

HOW SHOULD I DRESS?

Comfort is the key word so wear loose fitting clothing and sandals. If you intend to use the fitness studio or take a yoga, tai chi or Pilates class for example, appropriate attire is required including athletic shoes. If you plan to use the swimming pool, bring a bathing suit as well.

WHAT IF I'M PREGNANT OR HAVE A MEDICAL CONDITION?

Many treatments are available for the mother-to-be. The spa's well-trained staff will advise you on which treatments are appropriate, which are not. Inform the staff when you make your reservations or when you arrive if you are pregnant, have high blood pressure, allergies or other conditions that may impact your therapies.

WHAT CAN I EXPECT ONCE I'M IN THE TREATMENT ROOM?

Spa therapists have been trained to respect the privacy of guests. You will always be given time to undress and slip under the sheet that will cover you during your session. During each treatment, the areas of the body not involved will be artfully draped. If you're particularly modest, the choice of wearing underwear is up to you. Remember too, this is your time, you're the pamperee, your therapist is the pamperer. If the room is too warm, too cool, if you'd prefer different music or no music at all, say something. If your therapist's touch is too rough or too light, make your wishes known and adjustments will be made.

WHAT HAPPENS WHEN MY TREATMENT HAS ENDED?

When your session is completed, your therapist will gently rouse you if you've fallen asleep. You'll then be left alone and given time to awaken, stretch and slip into your robe before being escorted to the lounge or bathing area. Since the staff at the reception desk has a schedule of your appointments, when the time draws near for your next treatment, a therapist will find you and once again you'll be taken to the appropriate room or spa area. When your appointments for the day are completed, don't rush away. Extend this blissful time and use the spa facilities for as long as you like.

IS A GRATUITY INCLUDED IN THE PRICE?

Spas vary in their policy; some leave the choice entirely up to you while others add a gratuity or resort fee for spa services. If one has not been added and you would like to leave a gratuity, 15% to 20% of the cost of the treatment is the average. You can tip the practitioner directly or have it added to your room bill.

WHAT ABOUT CANCELLATION POLICIES?

Times vary between spas but most require anywhere from four to twenty-four hours cancellation notice before your scheduled appointment to avoid a service charge. At the time you schedule your treatments, inquire about individual policies.

ARE THERE AGE RESTRICTIONS?

Most spas require that guests be at least sixteen years of age, although some have set the age requirement at eighteen.

A SPA STATE OF MIND

Welcome to a whole world dedicated to your wellness. A spa vacation has many benefits other than the obvious. It's more than just a relaxing diversion, it's a journey of well-being that provides an escape from all aspects of daily life. You'll be coddled and pampered, stroked and restored. Your face will look brighter, your body more toned. By the time your spa journey has ended, you'll feel a new stamina has been awakened. Your step might be a little bouncier, your confidence that much higher. Perhaps a smile will come more quickly to your face. Somehow, you'll have changed.

Don't let that feeling pass. Take the new you home and nurture it. Keep the spa state of mind with you and don't be surprised if you experience a recharged commitment to health and beauty, a promise to take better care of your "equipment."

> "IN ROMANCE, IF YOU LET THE GRASS GROW UNDER YOUR FEET, SOMEONE ELSE WILL MOW YOUR LAWN."
>
> EILEEN BARISH

SPA TREATMENTS.

A CORNUCOPIA OF HEALTHFUL PAMPERING AND INDULGENCE, SPAS ENHANCE YOUR OVERALL WELLNESS THROUGH A VARIETY OF PROFESSIONAL SERVICES INTENDED TO RESTORE AND REJUVENATE THE MIND, BODY AND SPIRIT. EACH SPA EXPERIENCE IS VERY PERSONAL AND QUITE UNIQUE, THE CHOICES SEEMINGLY ENDLESS. ALTHOUGH SOME SPAS OFFER SIMILAR TREATMENTS AND THERAPIES, THEY HAVE ALL ADDED THEIR INDIVIDUAL IMPRINT.

THESE MODALITIES PAMPER, CLEANSE, DETOXIFY, SMOOTH THE SKIN, RELIEVE TENSION AND STIMULATE THE SENSES. WHILE YOU'RE BEING INDULGED, TAKE PLEASURE IN THE ADDED BENEFIT OF TIME… PRECIOUS TIME TO UNWIND IN A TRANQUIL, SERENE ENVIRONMENT WHILE YOUR CARES EVAPORATE BENEATH THE HANDS OF A SKILLED ESTHETICIAN.

ORGANIZED IN BASIC CATEGORIES, A SAMPLING OF TREATMENTS AND THEIR UNUSUAL PROPERTIES FOLLOW. A NUMBER OF PROTOCOLS COMBINE MORE THAN ONE ELEMENT, I.E., A MASSAGE MIGHT ALSO INCLUDE A BATHING RITUAL, A SCRUB MIGHT INVOLVE AN OIL TREATMENT, ETC. IN SOME CASES WHEN A PROCEDURE CONTAINS A VARIETY OF THERAPIES, IT IS INCLUDED UNDER THE GENERAL HEADING OF "BODY TREATMENTS."

OTHER MODALITIES ARE QUITE SPECIFIC INCLUDING THOSE FOR PREGNANT WOMEN, MEN, COUPLES, CLASSES OR SALON-TYPE SERVICES.

THE FOLLOWING IS A BRIEF DESCRIPTION OF THE DIFFERENT THERAPY CATEGORIES OVERVIEWED IN THIS GUIDEBOOK.

FACIAL CARE

There are numerous varieties of facials and most include some or all of the following: massaging the face, cleansing, toning, steaming, exfoliating and moisturizing. When European is indicated in the description, it refers to the use of European products. Some facials include a peeling mask designed to lift dead skin and encourage new skin growth. Another variation is the paraffin mask, intended to increase circulation and hydrate your skin. Still another involves a deep cleansing of the face and neck to purify and revitalize your skin. Some provide a non-surgical "facelift" by erasing fine lines and uplifting the skin with various trademarked procedures.

MASSAGE THERAPY

Among the most popular spa treatments, massages can transport you to a state of nirvana or renewed energy. They relieve tension and stress, improve circulation, tone and stretch connective tissue and hasten elimination of waste. There are more than a dozen types of massage and multiple variations on those dozen. In addition, some massages integrate the treatment with masques, reflexology and any number of other compatible procedures.

HERBAL OR THERMAL WRAP

During an herbal or thermal wrap, your body is enclosed in warm linen or cotton sheets that have been steeped like tea bags in a medley of aromatic herbs. You're then covered with blankets or towels to prevent the moist heating from escaping. A cool compress is often applied to the forehead. Herbal wraps help relax muscles, soothe soreness and soften the skin.

SEAWEED-BASED PROCEDURES

For centuries, seaweed has been used for its health and beauty benefits. It has a natural tightening and firming effect. In addition to the detoxifying and slimming properties of seaweed, it aids in collagen synthesis and is naturally abundant in anti-oxidants and essential fatty acids. Similar to herbal wraps, a seaweed wrap is combined with heat packs, using seawater and seaweed to remove toxins from the body. The ocean's nutrients, minerals such as zinc, copper and silica, rare trace elements, vitamins and proteins, are soaked into the bloodstream to revitalize skin and body. A seaweed masque gets its anti-aging power from the cellular cleansing and collagen producing capabilities of seaweed.

CLAY AND MUD TREATMENTS

Practiced by cultures around the world, mud-based therapies have been used for centuries to detoxify, tighten and firm the skin. The natural ingredients culled from the earth are recognized for their healing effects. The quality of mud differs according to its origin. Organic mud, such as Moor Mud from Europe has detoxifying properties which stimulate and hasten toxin elimination through the skin. A highly mineralized mud may be mixed with oil or water and applied over the body as a heat pack. Sometimes only an area such as a shoulder is covered. Its benefits include stimulating circulation and relieving muscular and arthritic pain. Parafango is mud mixed with paraffin. This treatment relaxes the body, alleviates sore muscles and softens the skin. Fango, the Italian word for mud, creates an all-encompassing gooey warmth and works like a poultice, softening your skin. Natural ingredients, such as peat moss and sea kelp, often are mixed into the mud to help contain the warmth and increase mineral content. Clay contains many of the same natural ingredients as mud and is brushed on like mud but tends to act more as a exfoliant.

BODY SCRUBS & TREATMENTS

A body scrub stimulates blood flow, removes dry patches and awakens skin cells. Body scrubs include brush and tone, dulse scrub, loofah scrub, paraffin treatment and Vichy shower. The brush and tone is a dry brushing of the skin intended to remove dead layers and impurities while stimulating circulation. This is just one of many exfoliation techniques that precede a mud or seaweed body masque. The body is brushed in invigorating, circular motions to remove dead skin, followed by the application of moisturizing lotion to leave your skin silky smooth and glowing. Dulse scrub is a vigorous scrubbing of the entire body with a mixture of powdered dulse seaweed and oil or water to remove dead skin. It provides a mineral and vitamin treatment to the skin and leaves it incredibly smooth.

Loofah, a natural plant akin to a dried sponge, is used to slough off dead skin, especially effective after a sauna or steam bath. A full-body loofah massage is performed with a mixture of sea salt, warm almond or avocado oil for exfoliation of skin and renewed circulation.

In a paraffin treatment, warm paraffin wax is brushed over the body. The liquid wax coats the skin and, as it solidifies, forms a vacuum that causes any dirt in the pores to be drawn out, removes dead skin and induces a loss of body fluid in the form of perspiration. The deep heat created by this treatment relieves stress, promotes relaxation and results in silky smooth skin.

SALT GLOW

The body is rubbed with an abrasive scrub consisting of coarse salt usually mixed with essential oils and water. This procedure cleanses pores and removes dead skin. A gentle shower and body moisturizer usually follows.

VICHY SHOWER

Invigorating shower treatment from several water jets of varying temperatures and pressures applied while lying on a waterproof cushioned mat. This treatment is often followed by an exfoliating treatment such as a dulse scrub, loofah or salt glow.

AROMATHERAPY

An ancient healing art dating back to 4500 BC, aromatherapy usually refers to treatments such as massage, facials, body wraps or hydro baths that include the application of essential oils from plants, leaves, bark, roots, seeds, resins and flowers. Plants and flowers from which these oils are extracted include rosemary, lavender, roses, chamomile, eucalyptus and pine.

REFLEXOLOGY

This ancient Chinese technique uses pressure point massage (usually on the feet but also hands and ears) to restore the flow of energy throughout the body. Charts are available that correlate zones to internal organs.

By rubbing the crystals on the nerve endings in the soles, a reflex reaction is set up between the zone and its associated body part. An alternative and complementary medicine, its holistic approach is being integrated into health remedies. This procedure is recommended for chronic conditions such as asthma, headaches and migraines.

Much more than a foot massage, reflexology can help the body to heal itself. It can soothe nerve endings, loosen tight muscles, improve blood circulation, reduce stress, enhance nutrient delivery throughout the body and remove toxins by stimulating areas on the feet that correspond to different parts of the anatomy. Think of each sole as a miniature model of your entire body. Tension, stress, illness and pain cause a chemical, Substance P, to build up around the nerve endings at our extremities. Applying nurturing pressure to targeted spots breaks down and initiates the natural process.

THALASSOTHERAPY

Thalassotherapy is from the Greek word Thalassos, meaning "sea." It heals and refreshes skin and hair by applying the therapeutic benefits of vitamins, minerals and trace elements of sea and seawater products.

Developed in the seaside towns of France during the 19th century, Thalassotherapy is used today in European-style spas to promote re-mineralization, detoxification and stimulate metabolism. The therapy is applied in various forms - as showers of warmed seawater, applications of marine mud or algae paste, or the inhalation of sea fog. Many treatments begin with a dry brushing, continue with a seaweed body mask and aromatherapy oils and end with a heated blanket wrap.

FELDENKRAIS METHOD

Employing movement and awareness as the primary vehicle for learning, the Feldenkrais Method is an educational system intended to provide greater functional self awareness. Due to its focus on physical movements, the method is often classified as a complementary or alternative medicine. The Feldenkrais Method is popular with dancers, musicians, artists, and others who want to improve their movement repertoire and use the method as a way to enrich their well-being and personal development.

REIKI (ENERGY HEALING)

Defined as universal life force energy, Reiki is a deeply relaxing and centering hands-on healing technique that utilizes light, non-touch. People experience many benefits from Reiki including a heightened sense of awareness, increased intuition, enhanced well- being, emotional resolution, reduction in pain and inner peace.

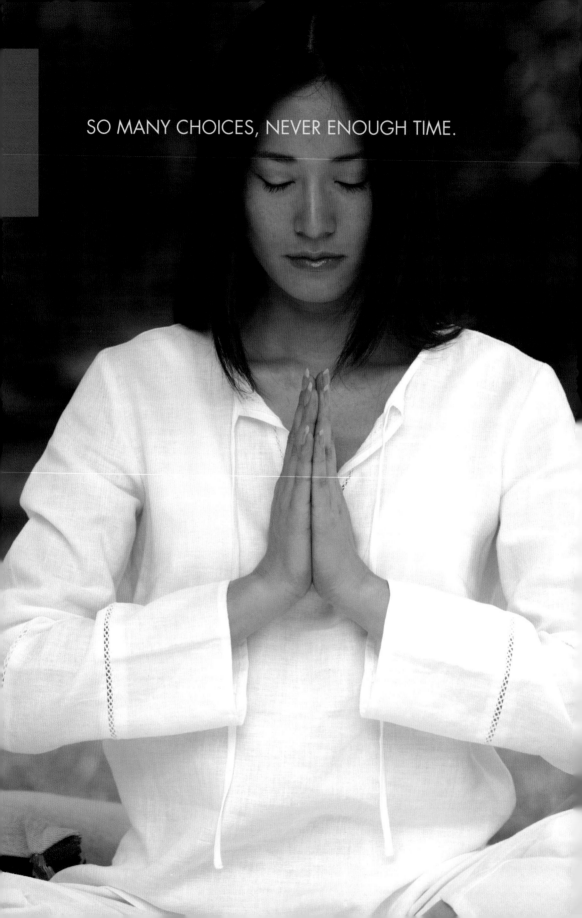

SO MANY CHOICES, NEVER ENOUGH TIME.

YOUR CHOICE OF THERAPIES IS MORE COMPREHENSIVE THAN EVER BEFORE. PAMPERING IS AT THE HEART OF EVERY DELECTABLE INDULGENCE ON THE MENU OF MASQUES, BODY SCRUBS, FACIALS, HERBALS AND OF COURSE, MASSAGES. IN ADDITION TO THESE TREATMENTS, THERE ARE OTHER MODALITIES INCLUDING PILATES, YOGA, TAI CHI, MEDITATION, DANCE, LONG WALKS AND A MEDLEY OF MIND, BODY AND SPIRITUAL DISCIPLINES ALL MEANT TO RESTORE YOUR ENERGY AND YOUTHFUL RADIANCE.

THE SAMPLING THAT FOLLOWS PRESENTS SELECTIONS FROM EACH SPA IN THE BOOK. SOME EXEMPLIFY THE SPA'S LOCALE OR HIGHLIGHT SIGNATURE TREATMENTS, WHILE OTHERS WERE SELECTED FOR THEIR INNOVATIVENESS OR USE OF VERY SPECIALIZED INGREDIENTS. SOME OFFER ASIAN-BASED MASSAGES, EMPLOY NATIVE AMERICAN-INSPIRED INGREDIENTS OR UTILIZE SOPHISTICATED EUROPEAN SKIN PROCEDURES. THERE ARE HUNDREDS MORE FROM WHICH TO CHOOSE. FOR THE COMPLETE SPA MENU OF YOUR SPA VACATION CHOICE, VISIT WWW.BESTSPASUSA.COM.

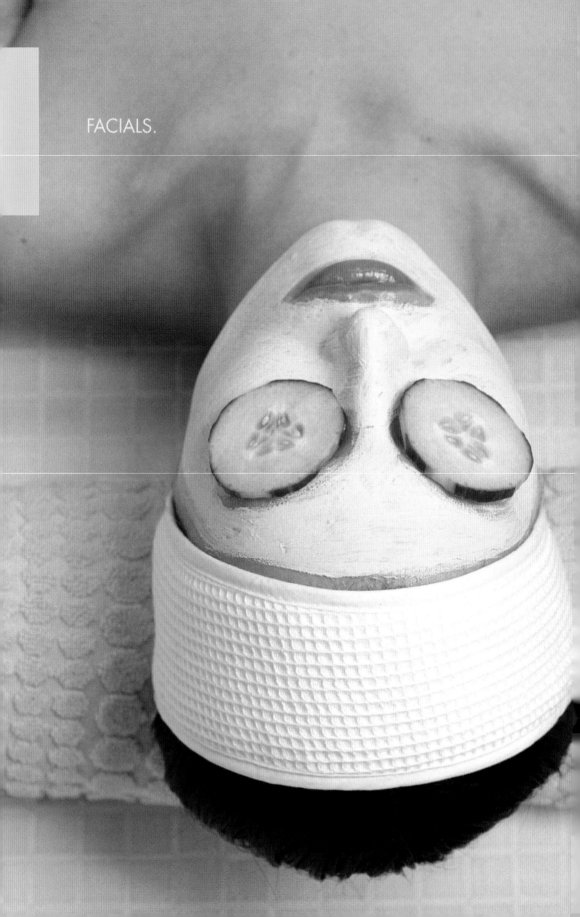

FACIALS.

LUMILIFT®

A non-surgical lifting treatment, the LumiLift®
procedure is a revolutionary way of rejuvenating
the skin and lifting sagging muscles. Performed
with two special electrodes that feature an
advanced application of micronized current
and light energy, this therapy lessens fine lines
and wrinkles while it lifts and tones your facial
contour. Results are immediate and visible.

– Deerfield Spa
 East Stroudsburg, Pennsylvania

RE-VITAL EYES

This targeted treatment devotes extra care to
the tender eye area. You have a choice of
treatment: smooth wrinkles and fine lines or
diminish swelling and puffiness.

– Ocean Key Resort & Spa
 Key West, Florida

COPPER PEPTIDE FACIAL

This age-defying facial will reverse the effects
of time by working to improve skin tone,
renew tissue and smooth and relax facial
features by utilizing a revolutionary collagen
masque and copper complex to keep the skin
firm and supple.

– JW Marriott Desert Ridge Resort & Spa
 Phoenix, Arizona

EMINENCE ORGANIC CUCUMBER FACIAL

Cool off and heal with this treatment that uses
only the highest quality organically grown fruits,
vegetables, herbs and spices. Calming ingredients
like cucumber, parsley and peppermint help to
soothe and reduce inflammation in sunburned
or sensitive skin, leaving your face well hydrated
and cool as a cucumber.

– The Spa at the Westin Maui
 Lahaina, Hawaii

CHATEAU ULTIMATE EXPERIENCE FACIAL

Revitalize your skin and soothe away stress with this aromatherapy facial customized for your skin type. A combination of products rich in active, organic herbal extracts are employed to enhance your skin's natural beauty and radiance. The protocol also includes a heated hand treatment and relaxing foot and neck massage.

– Spa Chateau
 Branson, Missouri

MICRODERMABRASION FACIAL

Microdermabrasion is a method of resurfacing the skin via intense exfoliation. By using diamond-tipped wands, the use of powders and crystals is eliminated and your safety and hygiene are assured. There is no trauma to the skin and no downtime for healing and recovery. The immediate result is healthier skin.

– Spa At The Shoals
 Florence, Alabama

Q-10 SKIN ENERGIZING FACIAL

This anti-oxidant therapy improves your skin's moisture level, texture and activates its own energy production. Your skin is cleansed and exfoliated, the Q-10 is applied and the procedure ends with a hydrating mask.

– Ponte Vedra Inn & Club
 Ponte Vedra Beach, Florida

FOUNTAIN OF YOUTH FACIAL

This indulgent treatment from Babor provides skin with a new lasting vitality for a more youthful appearance. Fleece masks drenched in specially formulated lifting concentrate are applied to your face, with décolleté improving elasticity to lift, smooth and tone.

– Cheeca Lodge, Florida Keys
 Key West, Florida

DEEP SEA DETOX FACIAL

Expert evaluation and product selection to hydrate, tone and eliminate unwanted skin conditions precedes the modality. Detox includes extraction of impurities, detoxification of tissues and skin rebalancing.

– Longboat Key Club & Resort
 Longboat Key, Florida

DELUXE FACIAL WITH OXYGEN BOOST

This firming anti-aging treatment will help reduce the appearance of fine lines and wrinkles and restore a smooth, more youthful appearance. The direct application of pure oxygen, vitamins, minerals, amino acids and the mini face-lift mask provides immediate and dramatic results. Excellent for dehydrated and mature skin.

– Park Hyatt Resort & Spa
 Beaver Creek, Colorado

GRAPE SEED ANTI-OXIDANT FACIAL

A mud mask made from finely crushed grape seeds is the highlight of this facial. A special collection of products and treatment lotions boosted with grape seed extract are used in this anti-oxidant, anti-aging therapy for the skin.

– Bernardus Lodge
 Carmel Valley, California

ESSENCE OF YOUTH FACIAL

For men and women displaying signs of skin pigmentation, this highly effective, ultra-concentrated treatment acts on pigmentation marks using a powerful skin brightening plant complex, rich in pure Vitamin C. It includes an alpha-hydroxy protocol for an intense exfoliation, enabling products to be deeply absorbed into your skin. Lightens and unifies your complexion to give your skin an "essence of youth."

– Cranwell Resort, Spa & Golf Club
 Lenox, Massachusetts

CARITA SIGNATURE FACIAL

This anti-aging facial is a distinct fusion of science and natural ingredients. Specialized massage techniques promote lymphatic drainage and a mask of roasted sunflower seeds aged in essential oils is applied for superlative facial rejuvenation.

– Claremont Resort & Spa
 Berkeley, California

ROYAL HAWAIIAN FACIAL

This signature facial is a customized treatment that permeates the skin with trace elements, minerals and vitamins. Medicinal ti leaves are layered and steamed with towels to relieve tension and release toxins from your skin while hands, feet, neck and shoulders are treated to a relaxing massage.

– ANARA Spa Grand Hyatt Kauai
 Poipu, Hawaii

FOUR LAYER FACIAL

This procedure provides layer upon layer of pure pleasure. A soothing massage will lull you to sleep and a cool, refreshing seaweed mask will imbue your face with a more youthful appearance. Take blissfulness to the highest level and combine the facial with the complementary Sea Escape and treat your hands, décolleté and shoulders to the same soothing elements.

– Sanibel Harbour Resort & Spa
 Fort Myers, Florida

LIGHTEN UP FACIAL

An extra gentle facial for those with sensitive skin. It doesn't use steam, just cool therapy and is ideal for rosacea skin types. Vitamin K works to support and strengthen capillaries to reduce visible redness and smooth and protect skin, leaving your once irritated skin calm and balanced.

– Seaview Resort & Spa
 Galloway, New Jersey

ENERGETIC HEALING FACIAL

The three major chakras (energy centers) affected by this treatment are crown, throat and third eye. A Sagamore trademark, this facial incorporates the universal life force energy of Reiki with the healing massage of a facial. A powerful and uncommon treatment, it provides healing that is not only physical, but also spiritual. People experience many benefits from Reiki including a heightened sense of awareness, increased intuition, enhanced well-being, emotional resolution, reduction in pain and tension and inner peace and quietude.

– The Sagamore
 Bolton Landing, New York

THE ULTIMATE CAVIAR FACIAL

This signature modality hydrates and firms skin with protein-rich caviar and powerful Chinese botanical anti-oxidants. The exclusive Caviar group of products combined with two specialty contour lifting facial massages – the innovative Marine Matrix Sheet and a state-of-the-art ampoule - will visibly smooth fine lines while infusing your skin with age defying moisturizers. Results are immediate, creating healthy luminescent skin. Upon completion of the facial, you'll be given the gift of the remaining ampoule.

– The Spa at Ross Bridge
 Birmingham, Alabama

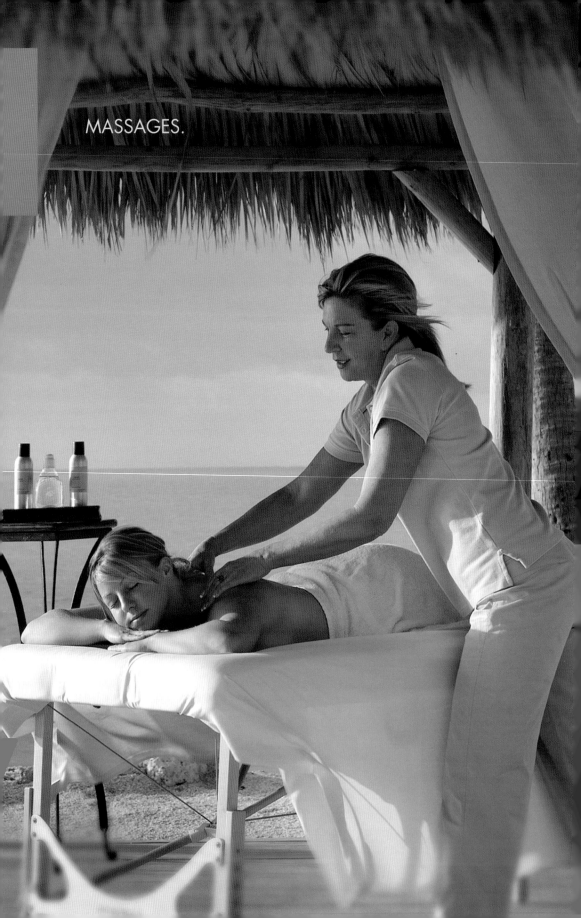

MASSAGES.

ACUMASSAGE

The combination of healing acupuncture and soothing therapeutic massage provides a powerful, natural tool for addressing chronic pain and athletic injury rehabilitation. It enhances energy levels and improves circulation and body functions. Each treatment is personalized to meet your individual needs.

– Sedona Spa at Los Abrigados Resort
 Sedona, Arizona

DESERT HOT STONE

This Native American treatment combines traditional Swedish massage with warm stone therapy and is particularly helpful for poor circulation and relief of arthritis pain. Essential oils are gently applied so that beautifully smooth, heated river stones can glide over your skin, warming muscle tissue, relieving tension and inducing day-dreaming deep relaxation.

– The Wigwam Golf Resort & Spa
 Litchfield Park, Arizona

AUTHENTIC TEEPEE MASSAGE

Enjoy any of the spa's massages in a luxurious Native American Teepee. A Teepee Massage is the ultimate setting in which to be pampered, Santa Fe style.

– Bishop's Lodge Ranch Resort & Spa
 Santa Fe, New Mexico

SUNRISE TO SUNSET MASSAGE

This session is a combination of various massage styles designed to target all your high stress areas. The sunrise portion of the massage focuses on your neck, back and shoulders while the sunset portion focuses on your feet utilizing the ancient techniques of reflexology.

– Cheeca Lodge, Florida Keys
 Key West, Florida

BALINESE MASSAGE

Be transformed by this traditional Balinese massage ritual. A combination of acupressure, rolling motions and rhythmic strokes relieves tension and promotes total relaxation.

– Ocean Key Resort & Spa
 Key West, Florida

BODY CONTOURING/
ANTI-CELLULITE TREATMENT

In this treatment, a sub-dermal vacuum massage smoothes and diminishes the dimpled appearance of cellulite, pre and post surgery edema, heavy legs, muscular tension and poor circulation.

– Deerfield Spa
 East Stroudsburg, Pennsylvania

CAMELBACK SIGNATURE MASSAGE TREATMENT

To bring your mind, body and spirit into balance, this treatment combines aromatherapy, hot and cold stone massage, reflexology and the detoxifying benefits of castor oil. Warm juniper sage oil is massaged into neck and shoulders. Precious stones are placed on the chakras for a peaceful and restorative effect. Gentle pressure is applied to the reflex points on your feet to dissolve stress, followed by a scalp and cold aquamarine stone massage.

– Camelback Inn, a JW Marriott Resort & Spa
 Scottsdale, Arizona

GOLF CHAMPIONS MASSAGE

Tailored for golf (and tennis) enthusiasts, your massage therapist uses therapeutic techniques targeting the areas of your body impacted most by your golf game or other sports activities.

– La Costa Resort & Spa
 Carlsbad, California

ASHIATSU

Barefoot massage is an ancient form of bodywork originating in Thailand, China and Japan. A specially trained therapist uses precise footwork compressions and long, gliding strokes to knead through tight muscles, resulting in a very deep yet profoundly soothing experience. This therapy is designed to release pain and produce long lasting results.

– Grand Hotel Marriott Resort, Golf Club & Spa
 Point Clear, Alabama

CRYSTAL CHAKRA BALANCING MASSAGE SIGNATURE TREATMENT

Using the vibration from colored lights, the body's seven main chakra vibrations are balanced. Light, smooth strokes along the meridians complement the energy flow in your body.

– Aspira Spa at the Osthoff Resort
 Elkhart Lake, Wisconsin

LOMI LOMI "HAWAIIAN STYLE"

Passed down through Hawaiian tradition, Lomi Lomi means to "touch with loving hands." Massage strokes are more vigorous, rhythmic and faster than Swedish massage and incorporate more elbow and forearm work. When this one is over, you'll feel like you've been worked.

– ANARA Spa Grand Hyatt Kauai
 Poipu, Hawaii

HOT STONE MASSAGE

This massage is a contemporary approach to alternating temperature in massage. It is performed with volcanic river stones that have been heated in water and strategically placed along the body. This therapy leaves trails of heat flowing deep within your body, upward from your feet, through your legs and radiating all over your back, lingering long enough to melt the tension in each muscle.

– The Grove Isle Hotel & Spa
 Coconut Grove (Miami), Florida

MINERAL MASSAGE

Coordinated with the time of day concept of Spa Avania, this therapy is similar to a sports massage and blends Thai stretching, Esalen techniques and a French balm with semi-precious gemstones crushed into it. The Esalen technique employs long fluid three-dimensional strokes and was conceived in Big Sur, California.

– Hyatt Regency Scottsdale Resort & Spa
 Scottsdale, Arizona

SAMUNPRAI

Nurture your tired spirit with this revitalizing Thai herbal heat energizing protocol. A hot poultice of medicinal herbs relieves muscle tension and invigorates your mind in this healing blend of massage and aromatherapy techniques. And the poultice is yours to keep.

– Hotel Viking
 Newport, Rhode Island

THAI MASSAGE

This traditional Thai massage has its roots in yoga, Ayurvedic medicine and Buddhist spiritual practice. It combines rhythmic massage, acupressure, gentle twisting and meditation. Muscular tension slowly dissolves, blood and energy flow freely, aiding your body's natural detoxification process and boosting its immune response. You'll experience a deep state of relaxation, centeredness and overall wellness.

– Rancho La Puerta
 Tecate, Baja California (Mexico)

SWEDISH MASSAGE

This classic, relaxing massage uses soothing strokes to promote balance and body harmony, light to moderate pressure to enhance circulation and gentle stretching to reduce tension.

– Sanibel Harbour Resort & Spa
 Fort Myers, Florida

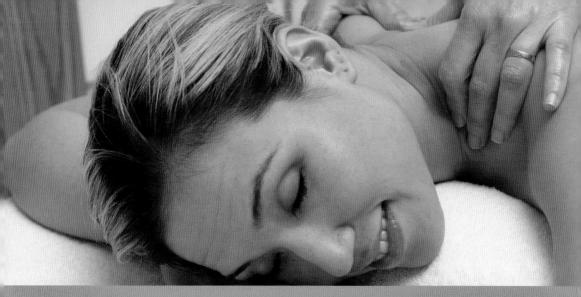

SUNBURN RELIEF MASSAGE

This massage combines their signature Heavenly Massage with the addition of cool marble stones and a special lavender-aloe blend. The cool stones eliminate the heat while the lavender-aloe blend comforts the skin with its healing properties.

– The Spa at The Westin Maui
 Lahaina, Hawaii

DOSHA BALANCING MASSAGE

From ancient Ayurvedic medicine, herbal-infused oils are customized to balance your personality and health type (dosha) and suit your constitutional needs. Your experience is intensified with a moist heat pack to leave you relaxed and centered.

– Bernardus Lodge
 Carmel Valley, California

DEEP TISSUE MASSAGE WITH MOIST HEAT

This firm pressure massage can be a total body experience or an opportunity to address specific areas. Moist hot packs are used to relax stressed muscles and facilitate in releasing blockages, tightness and tension.

– Cranwell Resort, Spa & Golf Club
 Lenox, Massachusetts

LA STONE MASSAGE

Using Native American traditions and heated smooth, black basalt lava stones, this deep heat massage is great for achy joints and muscles. The stones are layered upon the body and used to melt away daily stress.

– Ponte Vedra Inn & Club
 Ponte Vedra Beach, Florida

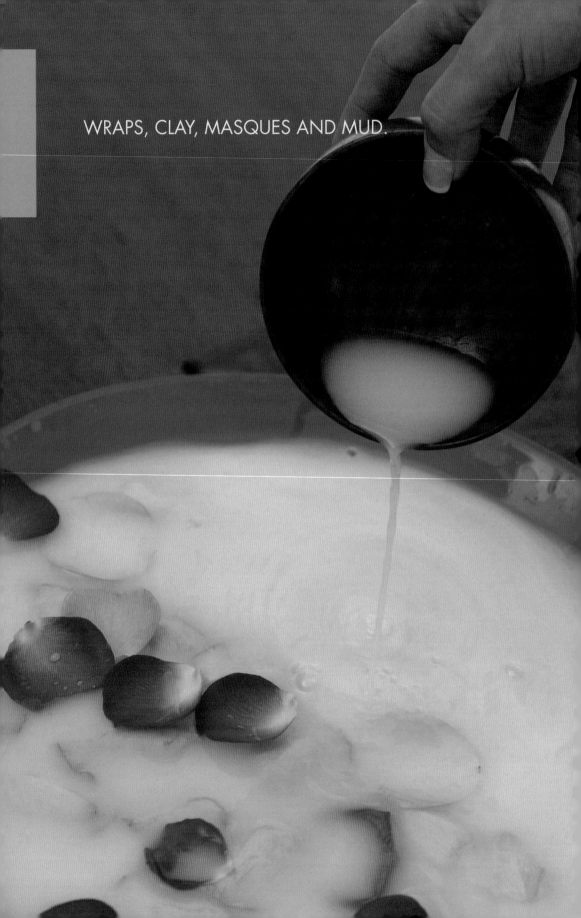

WRAPS, CLAY, MASQUES AND MUD.

TESUQUE CLAY WRAP

A high desert treatment, it begins with a light dry exfoliation of your skin followed by a mineral rich clay masque applied to your entire body to nourish and detoxify your skin. After a refreshing splash in the Swiss Shower, the treatment concludes with a light massage using a signature blend of oil infused with native herbs to balance and moisturize your skin.

– Bishop's Lodge Ranch Resort & Spa
 Santa Fe, New Mexico

RE-MINERALIZING SEA ALGAE BODY WRAP

This indulgent body masque is formulated from natural algae. After exfoliation, a warm marine algae is applied from neck to toe. A gentle wrap enhances nutrient absorption. Mountain mist and moisturizing body milk make for a blissful ending.

– Sun Mountain Lodge
 Winthrop, Washington

CHAI SOY MUD RITUAL

Drawing on centuries of healing tradition, this Asian-inspired ritual combines a spicy, fragrant Chai Soy Mud Wrap followed by a warm hydrotherapy bath. Your session ends with a full-body massage.

– Park Hyatt Resort & Spa
 Beaver Creek, Colorado

SLENDERIZING ANTI-CELLULITE ESSENTIAL OIL BODY WRAP

This therapy incorporates three types of imported European products in three consecutive steps. The first is an application of six essential oils, the second occurs when you are unwrapped and wiped down with an antiseptic herbal solution. The third is an overall massage with a light application of anti-cellulite oil to release hardened pockets of cellulite and fatty deposits.

– Regency Resort & Spa
 Hallandale Beach, Florida

POLYNESIAN NONI WRAP

This treatment combines a salt scrub, herbal wrap, Polynesian noni wrap and massage. Noni is a tropical fruit known for being an anti-oxidant, anti-inflammatory and breathable sealant skin protector that lifts and tightens.

– ANARA Spa Grand Hyatt Kauai
 Poipu, Hawaii

MOUNTAIN MAPLE ESCAPE

A hot mineral-rich fusion of natural healing elements from the Adirondacks begins this escape. A blend of maple cream and sugar, honey, a medley of exfoliating kernels and healing herbs embraces your entire body. While you are wrapped, you'll be given a foot massage. This treatment is completed with the euphoric sensation of cascading warm flowing water.

– The Sagamore
 Bolton Landing, New York

CHAI SOY MUD WRAP

This treatment begins with the Papaya Pineapple Grape Seed Scrub. Papaya helps soften the skin and is very beneficial to dry, sun damaged skin. Pineapple is an excellent anti-inflammatory and grape seed is a powerful anti-oxidant. You'll be wrapped in the rich nutrients of Epicuren's Chai Soy Mud to activate the mud's healing properties. This draws out toxins from soft tissue layers while smoothing and tightening your skin. Epicuren's Papaya Pineapple lotion will be applied at the conclusion of the protocol.

– Le Merigot, a JW Marriott Beach Hotel & Spa
 Santa Monica, California

VEGETABLE CLAY WRAP

An exfoliating massage cream prepares your skin to receive California's therapeutic, mineral-rich clays to help restore moisture and draw out impurities. Afterwards, luxuriate in a rinse under six shower heads of the Vichy Rainshower.

– La Costa Resort & Spa
 Carlsbad, California

PHYTO-ORGANIC HYDRATING WRAP

This moisturizing experience uses the spa's Floriani organic skincare line and begins with an Olive Oil Salt Scrub to exfoliate dry, dull skin. You're then covered from head to toe in a nourishing anti-aging, anti-oxidant rich olive oil mask to hydrate and combat any signs of moisture loss. The wrap ends with an application of Floriani Ultra Hydrating Cucumber Body Cream.

– The Wigwam Golf Resort & Spa
 Litchfield Park, Arizona

VOLCANIC EARTH CLAY RITUAL

An ancient ritual, it softens, purifies and renews your skin. A detoxifying volcanic body mask, pampering Balinese foot massage, aromatic shower and traditional Balinese massage comprise the therapy.

– Hotel Viking
 Newport, Rhode Island

PARAFANGO THERAPY

In this treatment, you'll experience the thermal and detoxifying effects of warm paraffin and "fango" – Italian for sea mud. The therapy draws toxins from fat cells, reducing cellulite and stimulating fluid elimination resulting in lost inches and a reshaped silhouette.

– Regency Resort & Spa
 Hallandale Beach, Florida

DETOXIFYING SEAWEED WRAP

This body wrap begins with an application of seaweed extract to aid in the detoxification process and relax your mind and body. Warm seaweed from France is applied to stimulate circulation and increase metabolism.

– Arizona Biltmore Resort & Spa
 Phoenix, Arizona

ULTIMATE DETOX WRAP WITH GREEN TEA

Warm herbal linen wraps are layered on your body to seep in the curative properties of the herbs and encourage deep relaxation for the mind. Ginger root, sage and clove are used for their powerful anti-oxidant properties and detoxifying effects.

– The Spa at Glenmoor
 Canton, Ohio

DESERT NECTAR HONEY WRAP

In this protocol, your skin is drenched with pure Arizona honey, buttermilk and oats and a fragrant conditioner is massaged into your hair to bring out a radiant shine. Your body is rinsed and treated with a rich hydrating cream and conditioning spray. Natural orange blossom water, sweet lavender oil and a light cucumber mask leave your face baby soft.

– Camelback Inn, a JW Marriott Resort & Spa
 Scottsdale, Arizona

BALINESE BOREH ENVELOPMENT

Boreh, a blend of tropical essences in this traditional spicy body mask, stimulates circulation and invigorates muscles. Your body will experience deep relaxation from this wholly natural treatment.

– Aspira Spa at the Osthoff Resort
 Elkhart Lake, Wisconsin

ALPHA VITAL

A skin resurfacing AHA/BHA facial, the fruit-acid treatment uses organically sourced alpha-hydroxy acid and beta-hydroxy acid from natural fruits. The therapy improves skin roughness and promotes healthy cell renewal. Your skin will become noticeably smoother without increased sensitivity. A freshly prepared, deliciously scented "fruitplasty" mask leaves your complexion luminous.

– Rancho La Puerta
 Tecate, Baja California (Mexico)

DESERT ESSENCE WRAP

This dry wrap begins with a brush exfoliation followed by a hydrating serum. Your body is then enveloped in a warm wrap while the therapist performs a face and scalp massage. After the cocooning wrap, a hydrating moisturizer is applied. The treatment finishes with a signature Spa Avania hot towel foot cleanse.

– Hyatt Regency Scottsdale Resort & Spa
 Scottsdale, Arizona

SEDONA CLAY WRAP

A high desert treatment, the wrap begins with a light exfoliation followed by the application of a mineral-rich Sedona clay masque over the entire body to nourish and detoxify the skin. The therapy is completed with a light massage using oil infused with native herbs to balance and moisturize your skin.

– Mii amo Spa at Enchantment
 Sedona, Arizona

MOOR MUD BATH

The famous Moor Mud Bath is one of nature's truly luxurious treats. The Moor Mud penetrates deeply, creating a soothing and rebalancing effect. During the bath, you'll be given a revitalizing tension-reducing scalp massage.

– The Spa at the Westin Maui
 Lahaina, Hawaii

ULTIMATE MILK AND HONEY REHYDRATING TREATMENT

This therapy begins with a brisk body peel followed by a milk and honey body wrap. Lactic acid eliminates dry rough spots while vitamins and trace elements activate skin metabolism to leave your skin velvety soft and revitalized.

– Ponte Vedra Inn & Club
 Ponte Vedra, Florida

SEAWEED-BASED TREATMENTS.

THALASSOTHERAPY WRAP

This intensive treatment fortifies your body's natural detoxification powers with the stimulating properties of seaweed. Excellent for reducing water retention and cellulite problems, Thalassotherapy is used in European spas to promote re-mineralization, detoxification and stimulate metabolism. Beginning with dry brushing to prompt the flow of precious lymph beneath the skin's surface, the powerful combination of a seaweed body mask, aromatherapy oils and a heated blanket wrap completes the detoxification process.

– Bernardus Lodge
 Carmel Valley, California

SEAWEED HEALING COCOON

Your body is swathed in healing marine-based products that stimulate your skin on the cellular level to absorb minerals and eliminate toxins. Your skin will be youthfully replenished and hydrated.

– Longboat Key Club & Resort
 Longboat Key, Florida

PEPPERMINT SEA TWIST

An aromatic body treatment, it combines peppermint oil with fresh European seaweed to stimulate, rejuvenate and purify. The therapy focuses on improvement of circulation and is an ideal choice for sore, aching muscles.

– Sanibel Harbour Resort & Spa
 Fort Myers, Florida

CHAMPAGNE OF THE SEA

This treatment begins with an exfoliation to increase the skin's receptivity to the active ingredients in the body masque. You'll be enveloped in frothy effervescent seaweed foam in this sensory experience. The body masque is complemented by a mini face and scalp massage followed by a cascade of warm southern rains pulsating over your entire body. This protocol is perfect for those with tight, sore muscles or stiff joints.

– Grand Hotel Marriott Resort, Golf Club & Spa
 Point Clear, Alabama

ATLANTIC SEAWEED BODY MASK

This blend from the sea is used for beautification and therapeutic purposes. You'll relax and renew in comforting warmth while your skin detoxifies, re-mineralizes, cleanses, hydrates and benefits from a rich array of seaweed-based vitamins and minerals.

– Ocean Key Resort & Spa
 Key West, Florida

COFFEE AND SEA KELP CONTOUR WRAP

This wrap uses coffee and sea kelp, rich in vitamins and anti-oxidants to increase cellular metabolism and detoxification. Stimulating nanah menthe leaves, vanilla and grapefruit awaken the senses. Ground pumice exfoliates and smoothes and macadamia nut oil leaves skin soft with no residue.

– The Waterleaf Spa at Skamania Lodge
 Stevenson, Washington

SOOTHING SEAWEED BODY MASK

A detoxifying body mask, it is soothing and firming for the skin. Beginning with a gentle skin brushing, a warm blend of seaweed is applied to your body, then you're wrapped in a blanket of warmth during which you'll receive a gentle scalp massage. After a warm shower, a moisturizer is applied to leave skin revitalized.

– The Spa at The Westin Maui
 Lahaina, Hawaii

DETOXIFYING SEAWEED BODY MASQUE

This body masque eliminates dead skin cells and releases toxins. The seaweed's rich algae, minerals and enzymes improve skin elasticity and smoothness. A body moisturizer is applied as a final soothing touch to tone and refresh.

– Deerfield Spa
 East Stroudsburg, Pennsylvania

SEAWEED SOOTHING MARINE BODY MASQUE

A true gift from the sea, this seaweed wrap from Brittany is soothing and smoothing. Relax and luxuriate in steady warmth while your skin detoxifies and benefits from the rich array of micronized minerals, vitamins and enzymes naturally abundant in French seaweed.

– Le Merigot, a JW Marriott Beach Hotel & Spa
 Santa Monica, California

SEAWEED AND FRENCH GREEN CLAY

A mud masque treatment, it combines a soft body exfoliation and a liberal application of a healing mud. High potency, stimulating and detoxifying marine clays of spirulina and laminara are combined with green tea extract, grapefruit and kelp to slim, tone and encourage the release of toxins.

– The Spa at Glenmoor
 Canton, Ohio

SEA BREEZE

This seaweed treatment hydrates the epidermis through osmosis, stimulating and energizing the skin by encouraging natural exchanges owing to its seaweed content. It was developed to soothe sun-exposed irritated skin and dilated capillaries while leaving your skin soft, supple and radiant.

– Hotel Viking
 Newport, Rhode Island

SPRING RAIN SHOWER AND SEAWEED WRAP

This detoxifying seaweed thermal wrap rehydrates and re-mineralizes. It is followed by a gentle shower with special jets of water at a comfortable temperature designed to enhance relaxation and improve circulation. Full body moisturizing completes the treatment.

– Rancho La Puerta
 Tecate, Baja California (Mexico)

SCRUBS, GLOWS, POLISHES AND TANNING.

CHEECA'S TROPICAL TREAT

In this signature treatment, your therapist will assist you in choosing from a selection of scrubs – an exotic display of fragrance-infused sugars and salts including pineapple, coconut, starfruit and frangipani. Body mask choices include mud, seaweed or Dilo nut oil; finishing moisturizers comprise body butter, essential blended oil or fine hydrating lotion.

– Cheeca Lodge, Florida Keys
 Key West, Florida

MADE IN THE SHADE

Achieve a natural-looking sun-kissed glow without the dangers of the sun. This treatment begins with a mineral salt scrub followed by the application of a moisturizing tanning cream to ensure even, lasting coverage. Upon completion of the service, you'll receive the gift of the remaining bronzer.

– The Spa at Ross Bridge
 Birmingham, Alabama

OLIVE OIL BODY GLOW

A combination of salt, healing olive and other essential oils transforms dull, tired skin into polished, hydrated smoothness. For a complete feeling of bliss, the glow includes a neck, shoulder and back massage.

– The Wigwam Golf Resort & Spa
 Litchfield Park, Arizona

SOIN VELOURS

A refurbishing algo or citro-essence body polish, your technician will choose either a body polish that utilizes a refining, re-mineralizing marine complex or a hydrating, repairing plant and flower formula. Following the "strip away of dead leaves" (the literal meaning of exfoliate"), your new contours will be treated to a marvelous body massage with a rebirthing, silky blend of botanical oils and lotions.

– Rancho La Puerta
 Tecate, Baja California (Mexico)

SUGAR CANE & COCONUT SCRUB

In this delightfully gentle and moisturizing treatment, natural anti-oxidants and alpha hydroxy acids work together to make skin look young and healthy. Blended with pure coconut extract, honey and the finest oils, this scrub will leave your skin incredibly soft. It concludes with a sugar cane and coconut rinse and lotion application.

– Park Hyatt Resort & Spa
 Beaver Creek, Colorado

SEASIDE SALT GLOW

Uncover smooth, glowing skin with this gentle exfoliation derived from Dead Sea salts and essential oils. A rich body butter application restores moisture.

– The Grove Isle Hotel & Spa
 Coconut Grove (Miami), Florida

ISLAND GLOW

Renew your island glow with the help of a professionally trained color specialist. Choose from an extensive color palette to complement your healthy complexion.

– Longboat Key Club & Resort
 Longboat Key, Florida

AVEDA SEA SALT BODY GLOW

Aveda's aqua therapy sea salt exfoliation purifies your skin and includes the use of aromatic steam and light massage.

– Regency Resort & Spa
 Hallandale Beach, Florida

WILDFLOWER GOMMAGE

Dry skin is erased from your body with a creamy soft beaded exfoliation. Warm towels and the application of a hydrating balm leave your skin smooth, your spirits uplifted.

– Cranwell Resort, Spa & Golf Club
 Lenox, Massachusetts

SPA SENSATION SALT RUB

This body peeling treatment unites cleansing, peeling and aromatherapy in just a single product. Marine salts, rich in minerals, combined with skin-friendly essential oils, lavender and peppermint, leave your body balanced and rejuvenated.

– Ponte Vedra Inn & Club
 Ponte Vedra, Florida

OLA BODY LATTE WITH VICHY

This luscious and effective body scrub exfoliates, softens and nourishes your skin while enticing your senses with an organic honey coffee sugar scrub from the Big Island. Complemented by a warm Vichy shower and a moisturizing coconut-lemon mist, it will leave your skin soft and hydrated.

– The Spa at the Westin Maui
 Lahaina, Hawaii

BODYOLOGY

A papaya scrub is combined with other natural ingredients to create a blended body smoothie to exfoliate, soften and smooth from head to toe. A rich garden mint mask completes the treatment.

– The Spa at Glenmoor
 Canton, Ohio

SEA SALT DEEP CLEANSING BODY POLISH

Your body is briskly exfoliated before an invigorating body scrub is applied using sea salts and essential oils. Finished with a mountain mist and moisturizing body milk, it exfoliates, softens and moisturizes the skin and soothes fatigue.

– Sun Mountain Lodge
 Winthrop, Washington

EUROPEAN BODY TREATMENT

This signature treatment blends an invigorating almond scrub, Swedish massage and hot herbal wrap for nearly two hours of bliss.

– Copperhood Spa
 Shandaken, New York

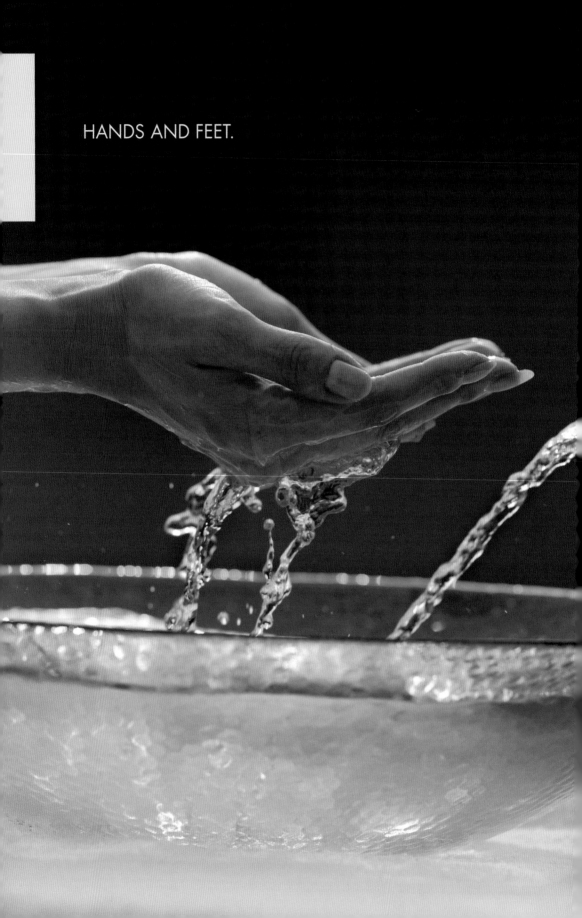

HANDS AND FEET.

CHARDONNAY PEDICURE

Discover the benefits of grapes with this decadent vinotherapy using chardonnay grapes. This outdoor treatment starts with a glass of Bernardus Winery Chardonnay and cheese plate to enjoy while soaking your feet in chardonnay bubble bath, followed by a pure cane sugar and chardonnay grape seed scrub. Your feet are then massaged with chardonnay moisturizer to soothe, calm and tone the skin while providing anti-oxidant benefits. Your pedicure ends with a polish style finish of your choice.

– Bernardus Lodge
 Carmel Valley, California

SUN REPAIR MANICURE

A facial for the hands with the power of marine-derived products to exfoliate, ultra-hydrate and plump over-exposed hands.

– Longboat Key Club & Resort
 Longboat Key, Florida

DELUXE SPA MANICURE

A luxurious citrus-based manicure including extensive treatment of nails and cuticles, hand exfoliant, arm and hand massage and, of course, your choice of polish. Add a hot paraffin wax dip and leave your skin feeling absolutely silky.

– Sedona Spa at Los Abrigados Resort
 Sedona, Arizona

ICE CREAM PEDICURE

This "tasty" treatment provides complete refreshment for the senses. The pedicure features ice cream flavored bath products from MeBath! and consists of a soak in a flavored bath fizz, a chocolate sherbet flavored foot scrub and a foot mask in chocolate, marshmallow or caramel flavor followed by your choice of nail color. According to healer and astrologist Davine Del Valle, it's an ideal protocol for those who have a fiery edge like Aries, Leo and Sagittarius.

– Loews Santa Monica Beach Hotel
 Santa Monica, California

RIVER STONE PEDICURE

This pedicure begins with a soothing foot soak to soften skin and relieve stress. After a thorough exfoliation, warm stones are massaged into your feet and calves, rubbing out tension. Next comes a marine algae mask followed by a paraffin foot procedure. Nails are shaped, buffed and polished in your choice of color.

– Cheeca Lodge, Florida Keys
 Key West, Florida

HEAD TO TOE

Unwind with hot tea and an herbal foot soak. Afterwards, moisturizing lotion is applied to your feet before they're dipped into a warm paraffin wax and wrapped in towels. Your head and neck are massaged and the treatment finishes with an hour of reflexology. This experience eases tension and promotes an overall sense of wellness.

– Sun Mountain Lodge
 Winthrop, Washington

THE CRANWELL TRADITION

Your nails will be shaped, cuticles trimmed; hands and arms exfoliated and massaged. Your hands will then be dipped in soothing paraffin to seal in moisture and your nails polished to perfection.

– Cranwell Resort, Spa & Golf Club
 Lenox, Massachusetts

ESSENCE OF LAVENDER PEDICURE

This pedicure will restore your senses and soothe your soles with therapeutic lavender. The therapy begins with a relaxing lavender soak, exfoliation and hydrating mask. Then your feet are wrapped in heated scented towels and treated to a massage with nourishing lavender moisturizer.

– Seaview Resort & Spa
 Galloway, New Jersey

WATERLEAF SPA PEDICURE

This treatment turns an ordinary pedicure into an extraordinary spa experience and begins with an effervescent pedicure tablet with sanitizing Chloramine-T, white tea tree oil and thymol. Moisturizing leaves are then added to the water to protect and soften your feet. You have the choice of three different fragrances: papaya green tea, Tuscan citrus herb or milk and honey.

– The Waterleaf Spa at Skamania Lodge
 Stevenson, Washington

CHOCOLATE MANICURE

Hands are pampered with a milk soak that whitens the nails. Nails are shaped, followed by a stimulating chocolate sugar scrub to exfoliate. Hands and arms are then treated to a delicious chocolate mint massage.

– Claremont Resort & Spa
 Berkeley, California

COOLING HAND & FOOT TREATMENT

A relaxing therapy, it nurtures the parts of your body that work the hardest. Your hands and feet will be gently exfoliated and then treated with a tingling Peppermint Masque. A cooling Cucumber Butter massage follows.

– Bishop's Lodge Ranch Resort & Spa
 Santa Fe, New Mexico

SEA SPA PEDICURE

Intense therapy for feet in need, a foaming sea soak and scrub starts the renewal process followed by an AHA callus removal treatment to smooth even the roughest spots. A hydrating, conditioning marine mask and restorative foot massage complete the procedure.

– The Wigwam Golf Resort & Spa
 Litchfield Park, Arizona

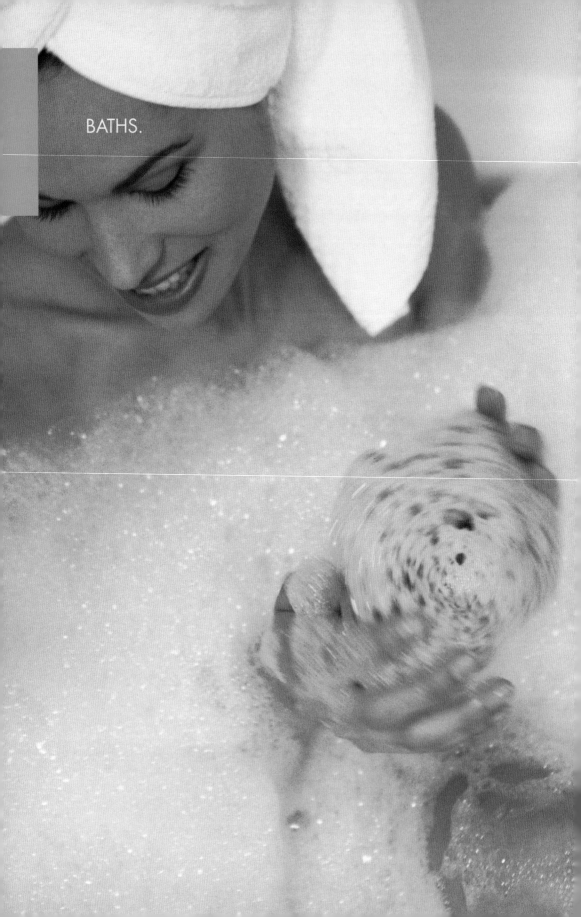

BATHS.

DESERT RAIN LOOFAH

This deep cleansing treatment exfoliates and softens the skin while improving circulation. The body is rubbed with sea salt and almond oil. A loofah mitt and body gel with desert botanicals cleans and polishes the skin. The treatment is followed by the gentle "rain" of the Vichy shower. Your session concludes with a blended moisturizer of prickly pear nectar, aloe vera gel and essential oils.

– Camelback Inn, a JW Marriott Resort & Spa
 Scottsdale, Arizona

BATH KURS

Baths have been used for centuries to relieve muscle aches and fatigue while promoting relaxation and rejuvenation. Choose from seaweed to detoxify, mineral to nourish or a krauter herbal bath from rich botanicals and then soak away your cares.

– JW Marriott Desert Ridge Resort & Spa
 Phoenix, Arizona

EUCALYPTUS SPORTS SOAK HYDROTHERAPHY BATH

This 100% seawater bath is the purest messenger of the ocean's healing secrets. Minerals and trace elements in seawater are readily absorbed into the tissue, making those curative powers possible. Combining the restorative benefits of the ancient ocean with aromatherapy and the newest technology in color and light therapy, this is truly a singular bathing experience.

– Grand Hotel Marriott Resort, Golf Club & Spa
 Point Clear, Alabama

SWEET LAVENDER MILK BATH

Enjoy an indulgent bathing experience that pampers, soothes and moisturizes. An aromatic treatment, it includes a softening exfoliation, milk, honey and lavender bath and full-body massage with lavender créme. A delight for the senses, it leaves your skin sleek and silken.

– Park Hyatt Resort & Spa
 Beaver Creek, Colorado

WHITE RIVER BATHING RITUALS

In this sensory and relaxing treatment, you select from an array of aromatherapy oils. Your bath experience is enhanced in a whirlpool, infinity tub that fills from a waterfall in the ceiling. The ambience is set for relaxation with candle light throughout the room and soft background music. When your bath is over, your body will be covered in oil moisturizer and cocooned in warm blankets for enhanced moisturizing. Your session concludes with an aromatherapy treatment and a head, neck and shoulder massage.

– Spa Chateau
 Branson, Missouri

AQUA RITUAL

This sumptuous experience starts with a stimulating exfoliation before you move into a complementary warm bath and finish with a mask or massage of your choosing.

– Seaview Resort & Spa
 Galloway, New Jersey

AVANIA VICHY TREATMENT

A signature modality; a full body scrub and massage is performed under cascading water from a Vichy shower. As you experience the Vichy and sea salt scrub, you'll be soothed by the aroma of white sage. The session ends with a finishing cream to soften and smooth your skin.

– Hyatt Regency Scottsdale Resort & Spa
 Scottsdale, Arizona

ULTIMATE UNWIND

With this water treatment, you can slow down, chill out and recharge. A muscle soothing salt scrub is combined with steam therapy and topped off with a therapeutic sports oil massage for the deepest relaxation.

– Bernardus Lodge
 Carmel Valley, California

MILK AND HONEY BATH

This is an exfoliating and moisturizing treatment for the entire body. After a buffing with a honey scrub, you'll enter a warm hydrotherapy tub filled with milk and honey and be massaged with a hand-held water jet. The treatment culminates with a light massage to hydrate your skin.

– Mii amo Spa at Enchantment
 Sedona, Arizona

HYDROTHERAPY MASSAGE

Feel weightless in a rushing stream of underwater jets as a skilled therapist soothes tense muscles and stimulates circulation. A blend of pure seaweed and aromatic essences are added to the water and seventy-five variable-pressure hydrotherapy jets ease you into a state of deep relaxation. The treatment concludes with a brisk massage.

– Rancho La Puerta
 Tecate, Baja California (Mexico)

PHILIPPINE JOURNEY

Lose yourself in a decadent bath infused with guava leaf and traditional plant extracts. Experience the gently exfoliating fresh ginger and raw sugar scrub followed by a therapeutic massage with warm coconut oil. A refreshing mist of neroli water leaves your skin silky and smooth.

– Claremont Resort & Spa
 Berkeley, California

KNEIPP HERBAL BATHS

Bathe away stress, strain and fatigue while you soak in the purest natural herbs. High concentrations of essential oils interact with the natural healing and soothing powers of water. The bath benefits body and mind through skin absorption and inhalation of herbs. The aroma and color of each chosen bath matches its own kind of therapy.

– Le Merigot, a JW Marriott Beach Hotel & Spa
 Santa Monica, California

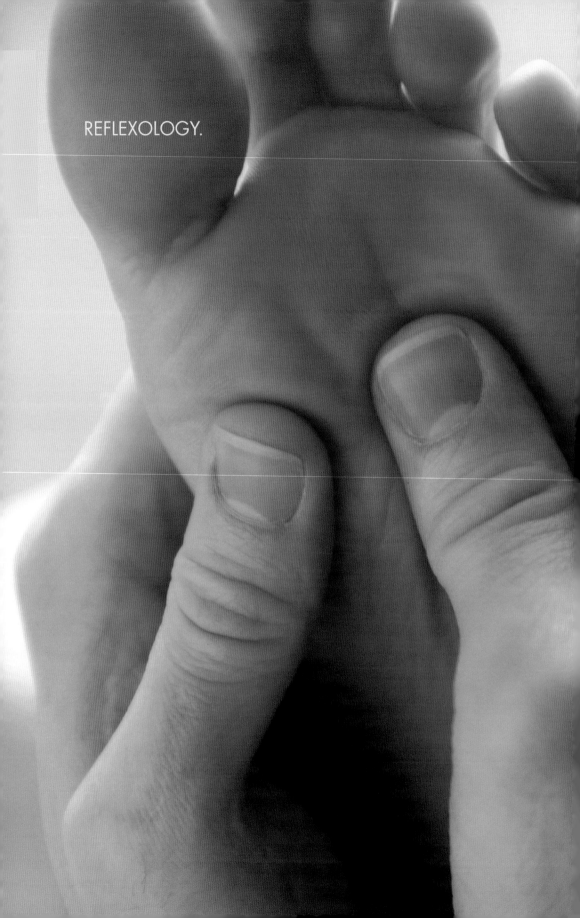

REFLEXOLOGY.

REFLEXOLOGY AT PONTE VEDRA

Based on the theory that certain zones of the body correspond to specific organs and structures, this stimulating massage makes use of special techniques applied to the feet to achieve a true systemic reaction and result in complete restoration of body and mind.

– Ponte Vedra Inn & Club
 Ponte Vedra, Florida

REFLEXOLOGY MASSAGE

A therapeutic massage of your hands and feet uses reflexology techniques to relax and rejuvenate your entire body. Beginning with a moisturizing hand and foot treatment, it also includes a stress-relieving scalp and neck massage.

– La Costa Resort & Spa
 Carlsbad, California

DESERT HEAT REFLEXOLOGY

This modality starts with a self-heating, hydrating foot mask, followed by a relaxing head and scalp massage and reflexology on the hands. The reflexology treatment is then extended to the feet. The procedure induces a state of deep relaxation.

– Spa Chateau
 Branson, Missouri

SKI & SNOWBOARD FOOT REFLEXOLOGY RECOVERY

Cramming feet into tight-fitting ski and snowboard boots means your foot muscles are often sore and fatigued at the end of the day. This treatment helps restore lift to your achy feet.

– Teton Mountain Lodge
 Teton Village, Wyoming

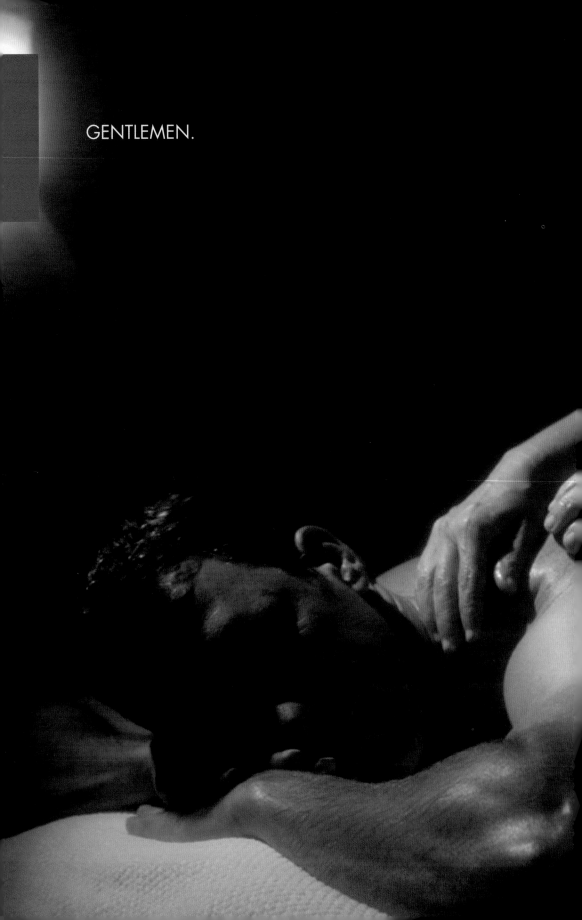

GENTLEMEN.

CHATEAU REGAL SIGNATURE SHAVE

Experience an old-fashioned lather shave as your face and neck are released of stress. Hot towels infused with essential pre-shave oils and sage will soothe dry, irritated skin while you enjoy the aromas and simply relax. A comforting aftershave and complete Oriental scalp massage transport you into a stress-free zone.

– Spa Chateau
 Branson, Missouri

GENTLEMEN'S SEA FACIAL

Designed for men, this relaxing cool marine facial deep cleanses and purifies. Using Phytomer's specially designed men's skincare line, the treatment leaves skin refreshed and invigorated. The soothing neck, shoulder and scalp massage relieves tension and restores a sense of wellness.

– Cheeca Lodge, Florida Keys
 Key West, Florida

GOLF TRAIL MASSAGE

A targeted deep tissue massage geared for pre- and post-physical activity to relieve overworked muscles. The massage focuses on releasing the muscles in the back, shoulders and neck to increase range of motion thus enhancing the golfer's swing (or heighten any athlete's range of motion and endurance).

– The Spa at Ross Bridge
 Birmingham, Alabama

GENTLEMEN'S TIME OUT

This package is for the man who is overworked, stressed and needs to unwind. De-stress tired muscles in a state-of-the-art steam room, relax with a therapeutic massage, enjoy a deep cleansing facial with penetrating lotion for hydration and finish your session with a haircut and nail trim.

– Spa At The Shoals
 Florence, Alabama

SPORTS RELIEF MASSAGE FOR HIM

Relieve muscle fatigue and soreness with this massage that focuses on individual muscle groups using specific strokes and deep compression. Excellent after a workout, a round of golf or tennis.

– JW Marriott Desert Ridge Resort & Spa
 Phoenix, Arizona

DEFENSE ZONE FACIAL FOR MEN

Microbeads of pumice instantly buff away dry skin, keeping pores clean and clearing the way for an effortless shave. Vitamins and extracts hydrate and instantly soothe redness, tingling or other signs of irritation.

– Camelback Inn, a JW Marriott Resort & Spa
 Scottsdale, Arizona

GENTLEMEN'S FACIAL

Men have special skin care needs and this facial has been designed with those needs in mind. Warm, moist towels are applied to the face and specially formulated products are used to deep cleanse, nourish and condition the skin. The end result is skin that feels toned, healthy and vital.

– Grand Hotel Marriott Resort, Golf Club & Spa
 Point Clear, Alabama

ACTIVE MEN'S FACIAL

Relax with an anti-oxidant facial and steam wrap specifically designed for today's active outdoor enthusiast. It's physical therapy for your face to ease tension and stress and soften the effects of the elements.

– Teton Mountain Lodge
 Teton Village, Wyoming

FOR MEN ONLY

Your journey begins with a 60-minute custom massage that releases tension and tightness brought on by the daily stress of life. Your massage is followed by a relaxing scalp and hair treatment. The experience concludes with a facial designed specifically with men in mind.

– Bishop's Lodge Ranch Resort & Spa
 Santa Fe, New Mexico

MEN'S BACK TREATMENT

This journey starts with the application of a warm mud pack to relax tight muscles while your therapist massages tension out of your feet. A precision back, neck and shoulder massage follows, removing tension from areas that are prone to stress.

– Arizona Biltmore Resort & Spa
 Phoenix, Arizona

BODY BRONZER

Enjoy the radiant look of a golden tan without spending hours in the sun. Your skin will be smoothed with a gentle exfoliation and then an even layer of self-tanning lotion will be applied. You'll have a natural looking tan in two to three hours.

– Seaview Resort & Spa
 Galloway, New Jersey

THE HOLISTIC FACIAL FOR MEN

This certified organic facial is customized for men. Products contain coenzyme Q10, Alpha Lipoic Acid and Vitamins A, C and E for a perfect blend of luxury and science.

– Park Hyatt Resort & Spa
 Beaver Creek, Colorado

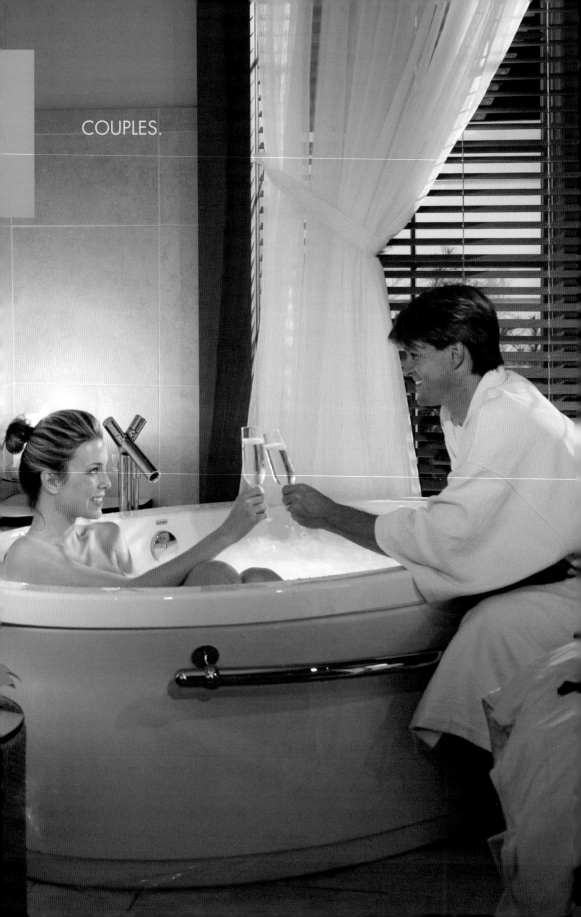

COUPLES.

THE CALOOSA EXPERIENCE

A one-of-a-kind sensation, this couple's experience, inspired by the native and spiritual Caloosa Indians, provides healing for the mind, body, spirit and relationship. Couples are ushered into a private, candlelit steam chamber where they are acquainted with the story of the Caloosa while enjoying a pampering foot soak of healing seawaters. Four sea-based products in large seashells will be presented and your therapist will explain the benefits of the product application. After instruction, you and your significant other will be left alone and given time to relax, unwind and leisurely apply the specialty products onto each other. A warm shower removes the products, transforming the intimate chamber into a soothing steam bath for the final 20 minutes of the session.

– Sanibel Harbour Resort & Spa
 Fort Myers, Florida

BEAUS AND BELLES

A couple's massage with twice the relaxation. Two massage tables, two therapists, one double hydrotherapy tub and the two of you – paired to enjoy this completely relaxing treatment. It begins with a warm Krauter hydrotherapy bath followed by the application of warm towels and key points of massage.

– The Spa at Ross Bridge
 Birmingham, Alabama

UNWIND TOGETHER PACKAGE

This package comprises a deep cleansing facial including skin analysis, exfoliation, a personalized mask and moisturizer; an aromatherapy soak to lull your senses; a deep tissue massage to promote relaxation and soothe sore and tired muscles; an aromatherapy steam shower to wash away the last of your tension; and a pampering spa pedicure.

– Ponte Vedra Inn & Club
 Ponte Vedra Beach, Florida

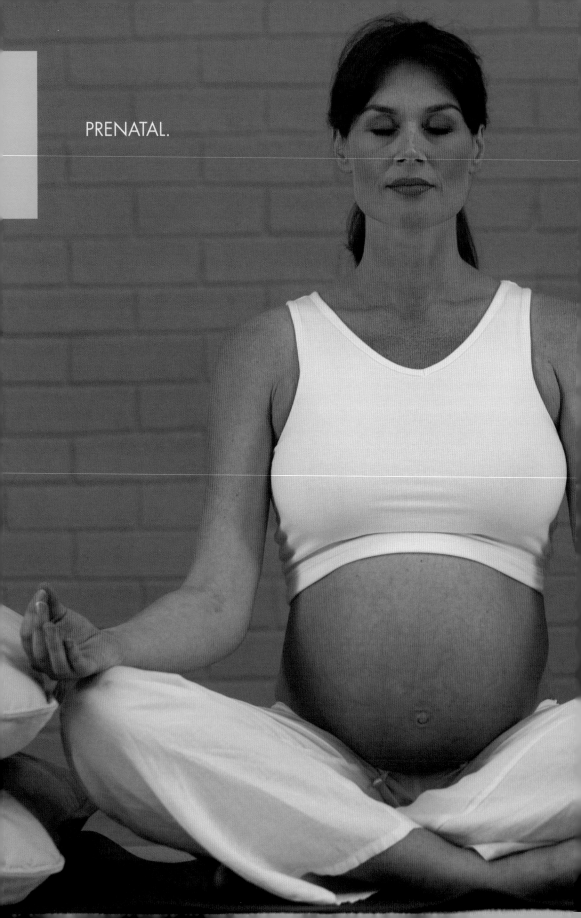

PRENATAL.

PRENATAL MASSAGE

Mommies-to-be can enjoy a side-lying massage designed to address the unique needs of expectant mothers.

– Claremont Resort & Spa
 Berkeley, California

MATERNITY FACIAL

This facial is designed for the expectant mother with her special skin care needs and physical comfort in mind. Products with soft scents hydrate and balance, leaving the skin fresh and invigorated. Gentle polishing beads buff away dry skin from the back and shoulders, followed by an application of moisturizing botanicals. These rich nutrient oils pamper delicate skin.

– Camelback Inn, a JW Marriott Resort & Spa
 Scottsdale, Arizona

MOTHER'S MASSAGE

This soothing and gentle massage eases muscle tension and fatigue during pregnancy, focusing on the special needs of the mother-to-be.

– La Costa Resort & Spa
 Carlsbad, California

BABY LOVE MASSAGE

Designed to meet the needs of the mother-to-be, the massage relaxes and relieves the added stress that is placed on the back, neck and joints of the body during pregnancy. Specific requests are addressed directly and privately with your massage therapist.

– The Spa at Ross Bridge
 Birmingham, Alabama

AROMATHERAPY.

SPA MOSAIC ULTIMATE AROMATHERAPY

Choose from a selection of four luscious treatments: anti-aging, detoxification, relaxation or circulation. After a body exfoliation and polish with mosaic powder, a specific aromessence enveloping balm is applied while gentle steam ensures that your skin absorbs the active botanicals. You'll be left nurtured, nourished and balanced.

– Grand Hotel Marriott Resort, Golf Club & Spa
 Point Clear, Alabama

JIVANA BODY POLISH

"Jivana," meaning a purposeful life full of joy, suits this treatment. An aromatic blend of Rose Hip seed oil and cardamom, this exfoliation soothes and hydrates your body with its nourishing ingredients. Skin is polished to a lustrous silken glow. Your session ends with a Swedish or Vichy shower.

– Estancia La Jolla Hotel & Spa
 La Jolla, California

AROMA BALANCING

Through an aroma journey, a fragrant blend of essential oils is created just for you and then applied using a base of Swedish massage with a smorgasbord of other energy balancing techniques including polarity, Trager and acupressure.

– Seaview Resort & Spa
 Galloway, New Jersey

SPRING PURIFICATION RITUAL

The cleansing ritual begins with an aroma steam followed by an invigorating body purifier salt exfoliation and rain dance rinse. A rejuvenating massage with detoxifying aromatherapy oil completes this total renewal.

– Bernardus Lodge
 Carmel Valley, California

COMBINATION BODY THERAPIES.

SHIRODHARA

A traditional treatment still found in India today, it begins with a slow pouring of warm, aromatic oil onto the forehead to stimulate the third eye and window to the soul. The oil is then massaged into your hair and scalp. Nourishing herbs are also massaged into the hair with the oil to cleanse and clarify.

– Bishop's Lodge Ranch Resort & Spa
 Santa Fe, New Mexico

ANTI-OXIDANT ADVANCE

Warm Spirulina algae imbues nourishing and detoxifying benefits into this anti-aging, anti-oxidant therapy for the entire body. While gently cocooned, a balancing pressure point facial exercise and scalp massage extend the anti-aging benefits. A pampering aromatherapy massage application completes the experience.

– The Spa at Ross Bridge
 Birmingham, Alabama

HAMMAM RITUAL

This centuries-old Moroccan body cleansing ritual begins with aromatherapy in the steam room, followed by an exfoliation and body shampoo. A Moroccan hot oil massage provides the finishing touch to this exotic experience.

– Aspira Spa at The Osthoff Resort
 Elkhart Lake, Wisconsin

CHATEAU "DOGWOOD" SIGNATURE BODY TREATMENT

This experience begins with a full-body sea salt exfoliation administered by hand and completed by a hot towel compress and moisturizing treatment. Afterwards you're cocooned in warm blankets for deep moisturizing. The session concludes with Japanese acupressure and a combination of massages including Thai stretch, Swedish and compression. The final touch, a guided power nap.

– Spa Chateau
 Branson, Missouri

CLARY SAGE GOMMAGE

In this modality, a cleansing, rehydrating and exfoliating clary sage gommage is painted on your body. You're then wrapped and given a gentle massage to aid in additional exfoliation of your skin. The therapy is followed with a warm aloe clary sage spritz and ends with a hot drip oil application to moisturize. This procedure is excellent for exfoliating and hydrating.

– JW Marriott Desert Ridge Resort & Spa
 Phoenix, Arizona

OXYGENATING PARSLEY AND CUCUMBER

This treatment assists in stimulating cellular repair and blood circulation while helping to increase the skin's metabolism. Pores are opened and oxygen intake is increased allowing better absorption of minerals and hydration. Helps to lighten pigmentation and detoxify the skin.

– Estancia La Jolla Hotel & Spa
 La Jolla, California

BLUE CORN VICHY

Native Americans used ground corn to cleanse and purify the skin. In this treatment, blue corn is blended with mineral salt crystals and oil to produce a vigorous scrub that is then rinsed off under the seven showerheads of the Vichy. The modality ends with a hydrating massage that leaves you feeling as rejuvenated as the earth after a refreshing thunderstorm.

– Mii amo Spa at Enchantment
 Sedona, Arizona

ROSE JOURNEY

The San Francisco Bay Area's climate and nutrient-rich soil are known to be ideal for cultivating the perfect rose. This indulgence engulfs you with the local fragrances of rose, lavender and eucalyptus in a luxurious bath. The bath is followed by a body polish and wrap of honey and rose petals. Tension melts away as you continue your journey with an aromatherapy massage and manicure.

– Claremont Resort & Spa
 Berkeley, California

PARA-JOBA BODY MOISTURIZER

Perfect for skin exposed to the desert sun or extreme weather conditions, this treatment incorporates a natural bristle body brush to exfoliate skin and stimulate circulation. Your skin is then cooled with a lavender spritz. Pure jojoba oil is applied and your body is wrapped in warm paraffin sheets, providing soothing relief for lower back pain and sore muscles. The paraffin is removed and shea butter cream is applied leaving skin smooth and glowing.

– Camelback Inn, a JW Marriott Resort & Spa
 Scottsdale, Arizona

THE HEALING GARDEN TREATMENT

This head-to-toe therapy uses healing elements from the earth to rejuvenate and renew. Inspired by the rich history of holism, this Ayurvedic treatment begins with a specially blended, detoxifying body exfoliation, a body mask, an intensive eye hydrator and a scalp procedure. All work together with a full-body Abhyanga massage.

– Estancia La Jolla Hotel & Spa
 La Jolla, California

BELAVI FACELIFT MASSAGE

This stimulating massage helps sagging facial muscles and sun-damaged skin. The procedure includes luscious creams, oils, warm moist towels, an herbal "rainshower mist" and a unique "honey-lift treatment." A combination of strokes and acupressure to hands, feet, scalp, neck and shoulders completes the massage.

– Sedona Spa at Los Abrigados Resort
 Sedona, Arizona

JAVANESE LULUR

Lose yourself in this lavish ritual direct from the Yokyakarta Palace in central Java. Originally designed for princess brides to soften their skin and make it radiant, the protocol includes a luxuriant Balinese massage with essential oil, an herbal exfoliation, a cool yogurt splash and aromatic shower. Your experience ends in a traditional soaking tub prepared with rose petals and infused with tropical fragrances.

– Ocean Key Resort & Spa
 Key West, Florida

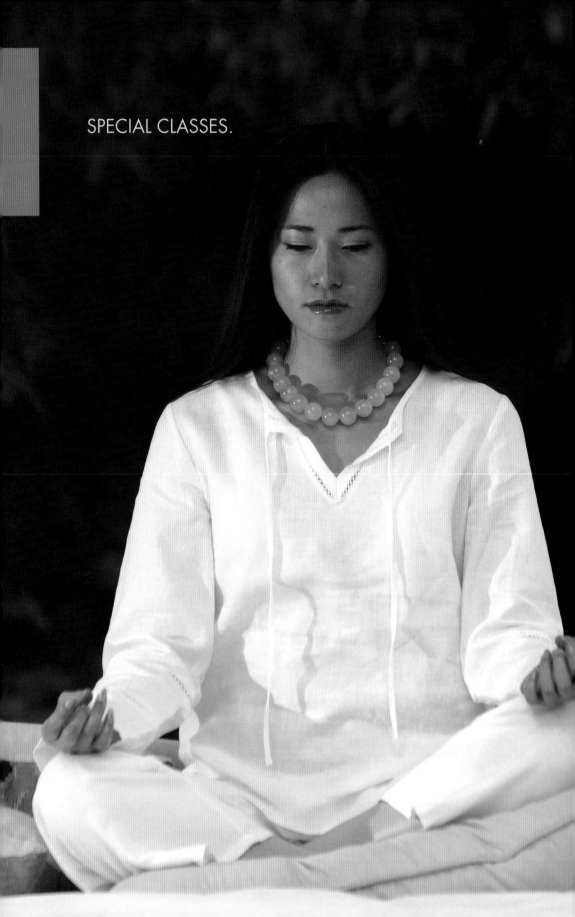

SPECIAL CLASSES.

BELLY DANCE AMERICAN TRIBAL STYLE

Starting with a gentle, yoga-style warm up, you'll learn ritualistic movement and motion and the bonding power of the movement practiced in a group setting. A fusion of traditional Middle Eastern dance combining synchronized, fluid dance movements of hips and arms, the dance brings each participant of the "tribe" together in a union of dance. You'll be taught correct posture, arm and foot placement, improvisational dance moves using cues and transitions and choreographed routines.

– Copperhood Spa
 Shandaken, New York

THE FELDENKRAIS METHOD

You'll learn gentle movements for transforming your posture and improving flexibility and physical efficiency in an individual, hands-on functional integration lesson.

– Sedona Spa at Los Abrigados Resort
 Sedona, Arizona

AYURVEDIC YOGA

This specialized yoga brings the mind and body back into balance. You'll be instructed on yoga poses, breathing techniques and meditation exercises to harmonize your dominant dosha.

– Mii amo Spa at Enchantment
 Sedona, Arizona

TAI CHI

One of the most ancient forms of Chinese martial arts, this class merges slow, gentle movements with deep breathing to coordinate the mind, body and spirit.

– ANARA Spa Grand Hyatt Kauai
 Poipu, Hawaii

ASSISTED STRETCHING

Stretching is a great way to loosen up before a round of golf or after a hard workout. Designed specifically to enhance your stretching experience and increase your range of motion.

— Camelback Inn, a JW Marriott Resort & Spa
Scottsdale, Arizona

PERSONALIZED MEDITATION

Release the stress of daily life through visualization and guided imagery. Meditation helps to transform the effects of negative emotions, strengthen the immune system and increase vitality to achieve a state of peace, balance and harmony.

— The Sagamore
Bolton Landing, New York

SPORTS ENTHUSIAST

Improve your swing with a one-hour golf lesson on the Robert Trent Jones Golf Course. After your lesson you'll unwind in the steam room. Once you're warmed up, a sports massage and reflexology will target and relieve tight muscles, aches and pains.

— Spa At The Shoals
Florence, Alabama

MODERN DANCE

This class offers a supportive environment to explore movement through a combination of different dance forms as well as yoga and Pilates. A wide variety of music is used. The class starts with a floor warm-up followed by a series of movements to strengthen body awareness leading into a dance phase across the floor and ending with a meditative stretch.

— Copperhood Spa
Shandaken, New York

bestspasusa

FEATURED RESORT, HOTEL AND DESTINATION SPAS

RENAISSANCE ROSS BRIDGE GOLF RESORT & SPA
BIRMINGHAM, ALABAMA

THE SPA AT ROSS BRIDGE

4000 Grand Avenue
Birmingham, Alabama 35226
Phone: 866.485.7677 / 205.949.3042
www.ROSSBRIDGERESORT.com

TYPE
Resort Spa

ACCOMMODATIONS
The resort exudes a residential feel that
melds 1920s style with modern features.
There are 259 guest rooms and 10 suites
with balconies and beautiful views. Each room
is well appointed including granite counters
in four-fixture bathrooms, triple sheeted plush
beds and unique headboards.

SPA
With its refreshing décor of bamboo,
hammered copper and subtle lighting,
the Spa at Ross Bridge provides a peaceful
and refreshing escape. The 12,000-square
foot facility features separate areas for men
and women from steam rooms to quiet rooms.
It provides a welcoming setting for guests
seeking serious pampering.

In this inviting, beautiful milieu, you'll be in
harmony with nature. Fresh breezes ruffle
the woodlands carrying the soothing sounds
of water across generous acres. The resort
makes a strong impression from the moment
you arrive. Rich sheers and rugs, a stacked
stone fireplace and mosaic flooring adorn
the gracious lobby. In the newly opened
Spa at Ross Bridge, the attention to detail
continues at every turn, ensuring a comfortable
and serene atmosphere. Nature's bounty and
restorative cadence are echoed in the spa's
philosophy, ambience and menu of treatments.
The leisurely pace recognizes the measured
rise and fall of a day's light, the moon's
phases and the cycle of the seasons.
The rhythm of life and the gentle tempo
that embodies the spa will immediately
put you in the mood for pampering.

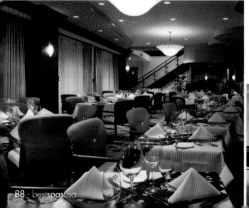

AS ONE OF THE OLDEST HEALING ARTS, A MASSAGE REDUCES AND RELIEVES MUSCLE SORENESS AND STIFFNESS AND HELPS ELIMINATE TOXINS IN THE BODY. THE ROSS BRIDGE SIGNATURE MASSAGE INCLUDES A "CALM MIND" EXPERIENCE ALONG WITH EXCLUSIVE RELAXATION TECHNIQUES.

Select one of their facials and receive a professional skin care analysis and customized skin care program. Consider the Southern Belle, a facial where luxury and high-tech merge. Oxygenating and anti-aging ingredients combat the affects of premature aging while you're treated to a lavish facial and hydrating hand modality. For men there's the Grand National Facial. This deep cleansing facial removes impurities and specifically targets sensitivity to razor burn.

Their body treatments emphasize total wellness through exfoliation, detoxification and hydration. The Crimson Tide Kur is a centuries-old European tradition employing medicinal mud and light massage therapy. The Alabama Mineral Scrub is a double exfoliation that allows your skin to recapture vital minerals and trace elements.

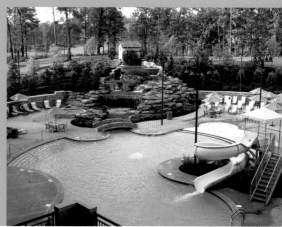

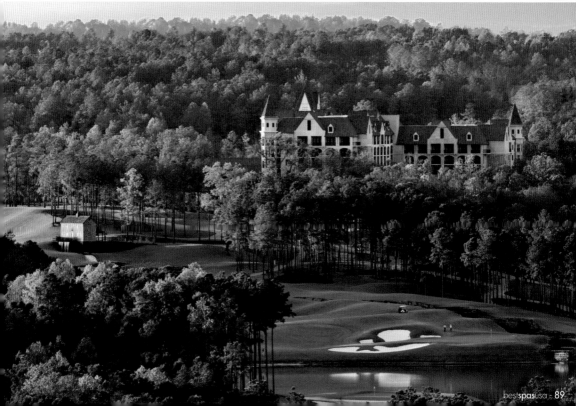

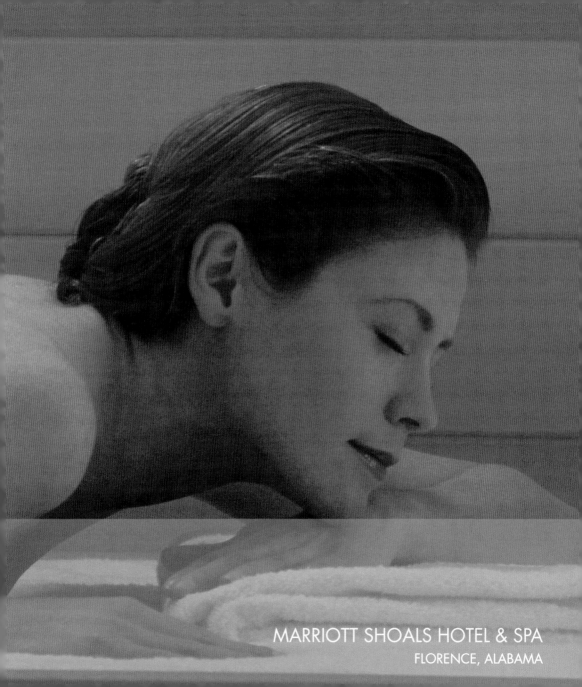

SPA AT THE SHOALS

800 Cox Creek Parkway South
Florence, Alabama 35630
Phone: 256.246.3696 / 256.246.3600
www.MARRIOTTSHOALS.com

TYPE
Hotel Spa

ACCOMMODATIONS
This handsome and stylish hotel is situated in the heart of the Mid South. Its 200 well-appointed guest rooms and spacious suites are fashionably decorated with modern furnishings and include private balconies and riverfront views. Experience southern hospitality at its best – delivered by a warm, attentive staff in a lovely environment.

SPA
A European-style spa and salon set in the Tennessee Valley, the 6,000-square foot Spa at the Shoals is a sanctuary for health, well-being and pampering. Reflecting the elemental forces of river and land, the treatments mirror the finest water-inspired and earth-based protocols and services in a serene setting.

Situated along the famed Robert Trent Jones Golf Trail, the Marriott Shoals Hotel & Spa is among the premier hotels in the tri-state area. It provides an aura of elegance and comfort and is a perfect blend of southern hospitality, sophistication and charm. Treat yourself to an entirely new type of Alabama hotel experience in a place where sumptuous accommodations combine with distinctive amenities to create an inviting, relaxing atmosphere. The hotel features three restaurants offering everything from gourmet to casual. For fine dining, the 360 Grille is an elegant restaurant atop the Renaissance Tower. At the Bronzeback Café choose from fine cuisine in a relaxed venue. Or go entirely casual at the Swampers Bar & Grill overlooking the outdoor pool.

THE SPA AT THE SHOALS HAS CREATED A NEW TRADITION OF SOUTHERN HOSPITALITY AND SOPHISTICATION IN A WONDERFULLY TRANQUIL SPACE. REJUVENATE BODY AND SPIRIT WITH YOUR CHOICE OF BODY TREATMENTS AND MASSAGE THERAPIES, HYDROTHERAPY SESSIONS AND PAMPERING SKIN CARE PROTOCOLS. OR CONSIDER ONE OF THEIR SPECIAL PACKAGES.

Lady Shoals combines an exfoliating and illuminating Salt Glow Treatment, Swedish Massage and a European Facial to nourish and enhance your appearance. Afterwards, a hair styling and makeup application is custom designed for you. A Shoals Spa Lunch is also part of the package.

The Mother-To-Be provides a day of serenity with peaceful time to contemplate new horizons. A back massage will relax your aching muscles and a facial will nourish and replenish dehydrated skin. This package gives you time to reflect on days past and dream of the years to come.

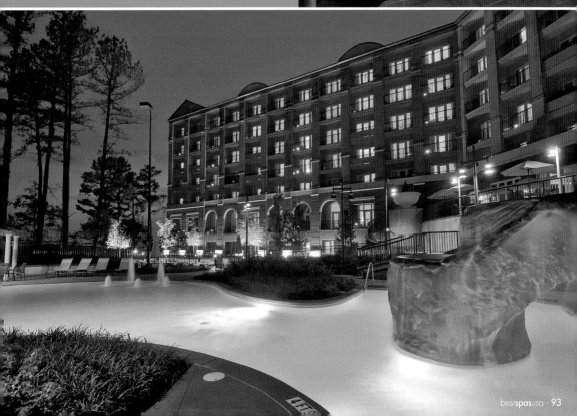

GRAND HOTEL MARRIOTT RESORT, GOLF CLUB & SPA
POINT CLEAR, ALABAMA

GRAND HOTEL MARRIOTT RESORT, GOLF CLUB & SPA

One Grand Boulevard
Point Clear, Alabama 36564
Phone: 251.928.9201
www.MARRIOTTGRAND.com

TYPE

Resort Spa

ACCOMMODATIONS

Secluded on 550 acres overlooking Mobile Bay, the historic Grand Hotel offers 405 luxury guest rooms, including 36 suites. The resort features a spa, two redesigned golf courses, three swimming pools, a marina, fitness center, movement studio and salon.

SPA

In an atmosphere reflecting true southern hospitality, the Grand's 20,000-square foot European-style spa is a sanctuary to health, pampering and well-being and consistently ranks as one of Marriott's best. Guests can enjoy the spa's comprehensive body treatments, massages, skin care and both marine and botanical-based therapies.

Opened since 1847, the elegant Grand Hotel and stunningly beautiful Grand Spa offer a peaceful escape. The resort overlooks sailboats in the marina, picturesque Mobile Bay and 550 acres of luxuriant landscaping featuring giant oaks dripping with Spanish moss, a spectacular pool complex and five restaurants and lounges. The Grand Spa was completed in 2002 as part of the major resort renovation. It includes nine temperature-controlled treatment rooms, separate men's and women's lounge areas with lockers, steam and sauna rooms, whirlpools, heated indoor pool, state-of-the-art fitness center, movement studio for yoga and Pilates, personal training, and a full-service Spa Salon and Spa Boutique.

THE SPA OFFERS AN ARRAY OF TREATMENTS RANGING FROM THE TRADITIONAL TO THE EXOTIC, THERAPIES THAT WILL REJUVENATE YOUR BODY, MIND AND SOUL. A SAMPLING OF SERVICES FOLLOWS:

Couple's Massage and Lesson
Ashiatsu – Asian Barefoot Massage
Signature Aromatic Warm Stone Massage
East Meets West – Aromatic Bliss Relaxation
Reflexology
Great Expectations Treatments
 for "Mothers-to-be"
Signature European
 Facials – Gift from the Sea
Botanic and Marine
 Intensive Anti-aging Facials
Clear Sailing,
 Double Masque Oxygen Facial

Eucalyptus Sports Soak Hydrotherapy Bath
Ocean Glow Grand Hydrotherapy Bath
Detoxification Seaweed Body Experience
Sugar 'N Spice Body Scrub
My First Facial for Teens
Gentlemen's Sports Manicure and Pedicure
Gentlemen's Facial

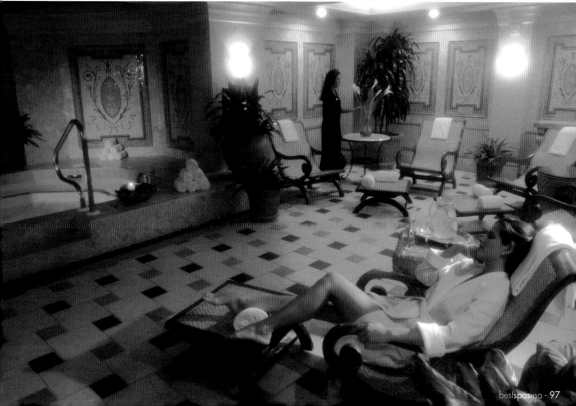

THE WIGWAM GOLF RESORT & SPA
LITCHFIELD PARK, ARIZONA

THE WIGWAM
GOLF RESORT & SPA

300 East Wigwam Boulevard
Litchfield Park, Arizona 85340
Phone: 623.935.3811 / 800.327.0396
www.WIGWAMRESORT.com

TYPE
Resort Spa

ACCOMMODATIONS
Spread across a residential-style campus, the Wigwam offers guests a choice of 331 spacious accommodations from guest rooms to luxury suites. Each room is imbued with the ambience of Authentic Arizona™ traditional adobe casita rooms decorated in an appealing Southwestern color palette.

SPA
Distinguished by Wigwam's signature abode-style architecture, the two-story Red Door Spa encompasses 26,000-square feet. Renowned for its beauty and spa services, the Red Door Spa is an inviting, uncluttered space where guests can lounge in attractive surroundings ideally designed for quiet, meditative relaxation.

Beautiful star-filled nights, warm sunny days spent poolside, romantic dinners and spectacular sunsets are just some of the charms that await you at the Wigwam Golf Resort & Spa. Sprawled on 75 acres of pristine landscape, the legendary Wigwam Golf Resort & Spa has provided the highest quality accommodations, activities, cuisine and service since 1929. Just 25 minutes from the cultural attractions of downtown Phoenix, the Wigwam's singular, garden-like setting seems a million miles away from the hustle and bustle of everyday life. In this serene milieu, you will discover acres of lush green lawns, fragrant flower gardens and shady citrus groves ensconced in a quaint village atmosphere of guest casitas.

THE SPA MENU FEATURES AN EXTENSIVE SELECTION OF BODY TREATMENTS INCLUDING WRAPS, POLISHES AND MUD MASKS DESIGNED TO TONE, CONTOUR, HYDRATE, REJUVENATE, DETOXIFY, REFRESH AND EVEN TAN THE SKIN.

The spa's signature treatment is the Wigwam Warm Water Ritual, four desert-inspired services - sage foot bath, clay and cornmeal exfoliation, juniper and sage aroma bath, desert sage aroma massage - combined in one truly memorable experience.

Many Red Door body treatments incorporate essential plant and flower oils to stimulate and firm the skin. For added pampering, Red Door services can be paired with one of the spa's many traditional or special massage services or customized body treatments. Each is designed to induce a state of deep relaxation while helping to rebalance and eliminate toxins in the body.

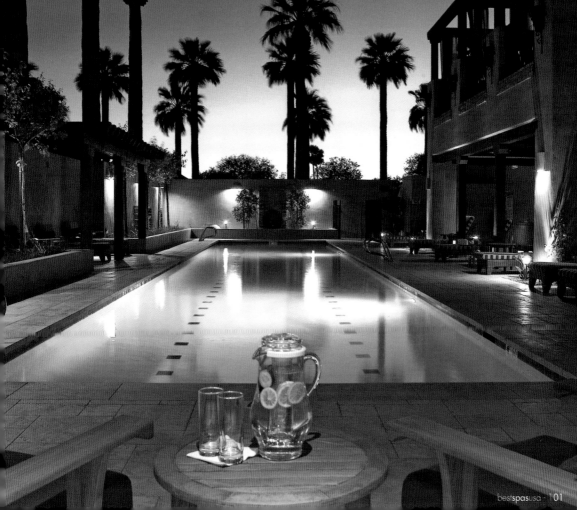

ARIZONA BILTMORE RESORT & SPA
PHOENIX, ARIZONA

ARIZONA BILTMORE RESORT & SPA

2400 East Missouri
Phoenix, Arizona 85016
Phone: 800.950.0086 / 602.955.6600
www.ARIZONABILTMORE.com

TYPE
Resort Spa

ACCOMMODATIONS
The Arizona Biltmore exudes a rich ambience and definitive Frank Lloyd Wright style in all of its historic accommodations. Nestled on 39 acres, the resort features 738 guest rooms including 78 one and two bedroom villas, eight swimming pools, seven tennis courts, an 18-hole putting green and a full-service European spa, salon and fitness center.

SPA
The spa's philosophy is simply to create an environment that allows you to relax, rejuvenate and feet utterly refreshed. The 22,000-square foot facility contains 19 treatment rooms (includes two wet rooms for herbal wraps), a hydrotherapy tub, three spa pools, steam rooms, saunas, a full-service beauty salon and boutique, fitness center, aerobics room and a state-of-the-art cardiovascular and weight training center.

The Arizona Biltmore Spa is more than just a relaxing vacation destination, it is an intoxicating journey that provides an escape from all aspects of daily life. Some treatments are drawn from the wisdom of ancient cultures – from medieval China to the native tribes of the Sonoran Desert. Others rely on the contemporary approaches of the French, the Swedish and Pacific Islanders. But every one relies on only the most natural of elements and ingredients in addressing your physical, mental and spiritual health. Consider an invigorating Shiatsu massage, a therapeutic Moor Mud Wrap or a Rose Quartz Facial. Whatever you choose, the path to rejuvenation is a wonderful experience.

EACH EXOTIC SPA TREATMENT IS A CHANCE TO DISCOVER A FARAWAY LAND OR CULTURE. IN THE PROCESS, YOU MIGHT JUST FIND YOURSELF. LUXURIATE WITH SOME OF THEIR TRADITIONAL AND EXOTIC OFFERINGS.

SPA MENU

Dream Catcher Aromatherapy
Saguaro Blossom Salt Glow
Fiji Island Sugar Glow
Lemon Verveine Body Polish
Desert Rain Body Treatment
Rose Quartz Wrap
Chaparral Clay Wrap
Biltmore Custom Facial
Desert Elements Facial
Rose Quartz Facial
Beauty Fluids
Ayurvedic
 Dosha Balancing Massage
Sedona Mud Wrap

MEN'S SERVICES

Men's Facial
Men's Hand and
 Foot Treatment
Men's Back Treatment
Sports Massage
Men's Body Scrub

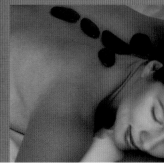

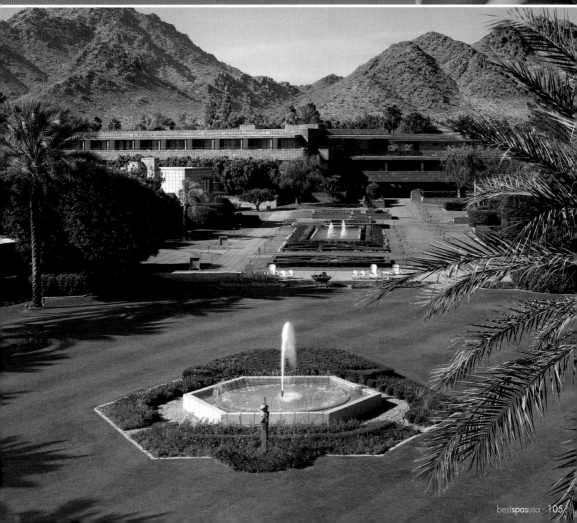

JW MARRIOTT DESERT RIDGE RESORT & SPA
PHOENIX, ARIZONA

JW MARRIOTT
DESERT RIDGE RESORT & SPA

5350 East Marriott Drive
Phoenix, Arizona 85054
Phone: 480.293.3700 / 800.835.6206
www.JWREVIVESPA.com

TYPE
Resort Spa

ACCOMMODATIONS
Where Phoenix meets Scottsdale, Desert Ridge
Resort boasts 950 luxury guest rooms including
81 suites. A destination within itself, the resort
features two 18-hole championship golf courses,
4 pools, the Lazy River, 10 dining rooms
and the nourishing Revive Spa.

SPA
Delight in the beauty of the Sonoran Desert.
Savor the luxuriously appointed surroundings
and relax to the comforting sounds of waterfalls
and swaying palms. Balance your spa experience
with personal renewal and growth. Revive Spa -
a wondrous opportunity for your mind, body
and soul to soar.

Revive Spa offers 28,000-square feet
devoted to your health and well-being.
The spa is highlighted by 41 treatment rooms
and a diverse menu of spa experiences that
incorporate beautiful, tranquil settings and
indigenous flora and fauna into signature
treatments - a place where ancient rituals join
forces with cutting-edge techniques. Escape to
the Sanctuary Pool, dream in a private cabana
and sample the cuisine from their dedicated
Spa Chef in the Spa Bistro. The Health Club,
Movement Studio and an array of classes allow
you to easily sneak in a workout. A full-service
salon completes the day and the Spa Boutique
encourages you to continue your wellness at
home. Live in the moment at "One of America's
Best Hotel & Resort Spas," says the discerning
Mobile Travel Guide.

REVIVE YOUR...

MIND

Powerful Antioxidant
 Caviar Facial

Aroma
 Transformation Facial

Calming Cucumber
 Green Tea Facial

Sami Zen -
 an energy experience

BODY

Sonoran Sands
 Herbal Body Polish

Desert Rain-Hydrating
 Body Drench

Desert Foothills
 Firming Body Wrap

Omega Tropical
 Body Infusion

Lavender Dreams

SOUL

Men's Sports Massage

Guy Facial

Men's Total Wellness Facial

Men's Sport Manicure
 and Pedicure

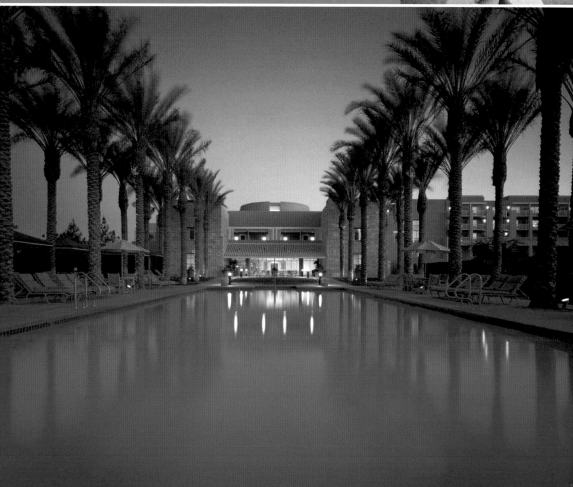

CAMELBACK INN, A JW MARRIOTT RESORT & SPA
SCOTTSDALE, ARIZONA

CAMELBACK INN
A JW MARRIOTT RESORT & SPA

5402 East Lincoln Drive
Scottsdale, Arizona 85253
Phone: 480.596.7040 / 800.922.2635
www.CAMELBACKSPA.com

TYPE
Resort and Destination Spa

ACCOMMODATIONS
Ensconced in a tranquil desert setting,
Camelback Inn offers 453 comfortable, yet
luxurious pueblo-style casitas including 27 suites,
some with private swimming pools. There are
also three guest swimming pools, seven restaurants,
two championship 18-hole golf courses
and a full-service spa.

SPA
The 32,000-square foot world-class spa includes
a fitness center, aerobics studio, 32 treatment
suites and a full-service salon. Swim in their
Olympic-size lap pool or soak in the outdoor
Jacuzzi. Dine on heart-healthy cuisine at Sprouts
while indulging in crimson-hued views of
Camelback and Mummy Mountains.

The Spa at Camelback Inn invites you to
simply relax. Set at the base between beautiful
Mummy and Camelback Mountains, you can
relish moments of balance and serenity in
this quiet, contemplative haven. Take time
to discover the magic of the Sonoran
Desert while connecting with your inner
spirit. Pamper yourself with one-of-a-kind
spa treatments inspired by the techniques
and nature-based ingredients of indigenous
Native American cultures. Experience the
guilt-free pleasures of Sprout's enticing menu
selections in Scottsdale's only spa restaurant.
Come and satisfy your yearning for complete
rejuvenation and relaxation at The Spa
at Camelback Inn.

THE SPA AT CAMELBACK INN OFFERS AN
ARRAY OF RELAXING EUROPEAN MASSAGES,
FACIALS AND BODY TREATMENTS TO EASE
YOUR MIND.

FACIALS
Camelback Signature Facial
Soothing Rescue Facial
Anti-Oxidant Professional Peel
Botanical Back Facial
Dr. Perricone Anti-aging Facial
Defense Zone Facial for Men
Maternity Facial
Sonoran Rose

MASSAGES
Camelback Signature Massage Treatment
Swedish Body Massage
Therapeutic Massage
Aromatherapy Massage
Shiatsu
Maternity Massage
Native Hot Stone Massage

BODY TREATMENTS
Camelback Signature Body Treatment
Desert Rain
Aromatherapy Tea Wrap
Desert Nectar Honey Wrap
Para-Joba Body Moisturizer
Bindi Herbal Body Treatment
Adobe Clay Purification Treatment

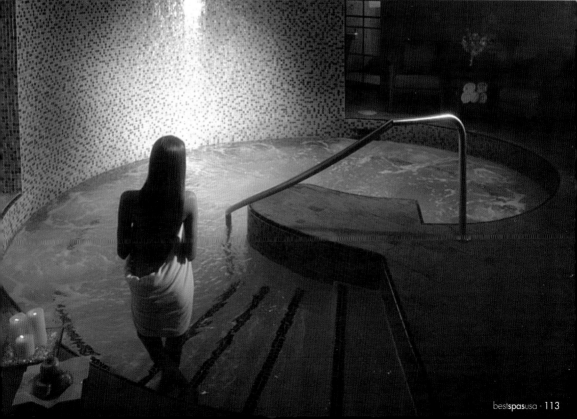

HYATT REGENCY SCOTTSDALE RESORT AND SPA
SCOTTSDALE, ARIZONA

HYATT REGENCY
SCOTTSDALE RESORT AND SPA

7500 East Doubletree Ranch Road
Scottsdale, Arizona 85258
Phone: 480.444.1234
www.SCOTTSDALE.HYATT.com

TYPE
Resort Spa

ACCOMMODATIONS
Set amidst flowering cactus, breathtaking
sunsets and framed against the majestic
McDowell Mountains, Hyatt Regency Scottsdale
Resort and Spa features 490 guest rooms, suites
and casitas. The resort includes Spa Avania,
27 holes of championship golf, world-class tennis,
a two and a half acre "water playground"
and four distinctively different restaurants.

SPA
The 21,000-square foot Spa Avania contains
18 treatment rooms including three couple's rooms,
five garden treatment suites, men's suite, fitness center,
yoga studio, a signature French Celtic Mineral Pool,
hot and cold plunges, steam, sauna and inhalation
rooms, indoor/outdoor relaxation areas, and a
full-service salon.

Carved out of the serene beauty of Arizona's
Sonoran Desert comes Spa Avania, the first
complete spa experience choreographed to
the science of time coordinated with natural
light levels of morning, midday and evening.
Reflecting balance and harmony, the spa
provides a holistic journey of restorative
elements essential to the body's changing
rhythms and requirements. These include
customized treatments, mineral water therapy,
YogaAway, diet, music style, the antioxidant
benefits of fine teas and natural light. You can
indulge your senses in secluded indoor and
outdoor relaxation areas encompassing the
beauty of the spa's signature French Celtic
Mineral Pool, lotus pond and the grandeur of
Camelback Mountain. You'll find all of this
and more at the Hyatt Regency Scottsdale
Resort and Spa.

SPA MENU

Glorious Skin Facial

Crushed Pearl Facial

Mineral Massage

Avania Massage

Golfer's Massage

Blackberry Balm Hand Massage

Foot Ritual

Aroma Rituals

Desert Essence Body Wrap

Aromatic Vichy

Avania Couple's Ritual

Lushly Manicure and Pedicure

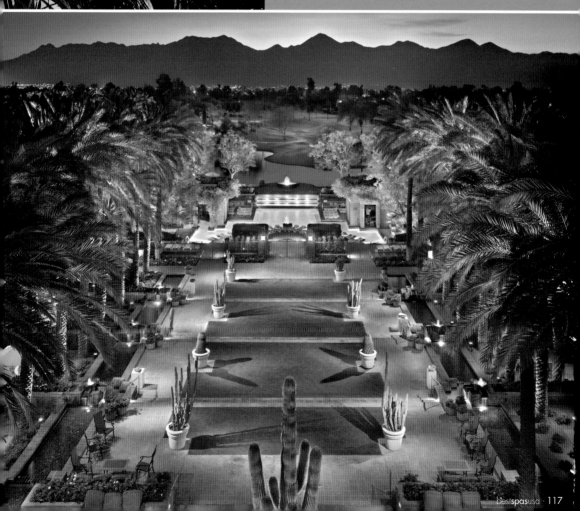

MII AMO SPA AT ENCHANTMENT
SEDONA, ARIZONA

MII AMO
SPA AT ENCHANTMENT

525 Boynton Canyon Road
Sedona, Arizona 86336
Phone: 888.749.2137
www.MIIAMO.com

TYPE
Resort Spa

ACCOMMODATIONS
A legendary haven of breathtaking natural beauty, Mii amo features 16 specially designed spa casitas and suites with spectacular views of Boynton Canyon. These Southwestern-style hideaways are centered amidst a courtyard built in harmony with the red-rock terrain.

SPA
Inspired by the rich wisdom and traditions of Native American people and complemented by the magic and energy of Sedona, you'll find balance and life enhancing rapport of mind and body at Mii amo. Begin your spa journey in the Crystal Grotto where the elements of earth, wind, water and fire come together for meditation and rejuvenation, a place where you'll discover pure and nourishing care and invigorating fitness.

Ensconced in the heart of Sedona, Arizona's beautiful red-rock country, the extraordinary canyon embracing Mii amo is considered sacred and reputed to awaken the senses of all who visit. Mii amo takes its name from the Native American word for Journey... reflecting the fulfilling experience of achieving a transformation in physical health and spiritual renewal. Participation in any 3, 4 or 7 night program is a personal journey to health and wellness. Because spa guests have different goals for their visit – such as indulgent pampering or specific learning – Mii amo has created five journeys that address a different area of life. By choosing a particular journey, you can customize your experience to focus on your own particular goals or intentions.

THE FIVE JOURNEYS

HEALTHY LIFESTYLE
Get your motivation back, start a new exercise program, eat more nutritiously and lose a few pounds.

REJUVENATION
Advice on proper nutrition, exercise routines, anti-aging skincare and overall body care – with daily spa treatments.

DE-STRESS MIND & BODY
If you are constantly thinking of everything you have to do when you're at home, this journey is for you.

SPIRITUAL EXPLORATION
Create balance and peace. This journey combines energy work, crystal therapies, Native American rituals and meditations.

AYURVEDIC BALANCE
Mii amo's Ayurvedic journey begins with at least one private 60-minute consultation and includes Shirodhara, Abhyanga and other Ayurvedic treatments.

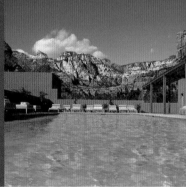

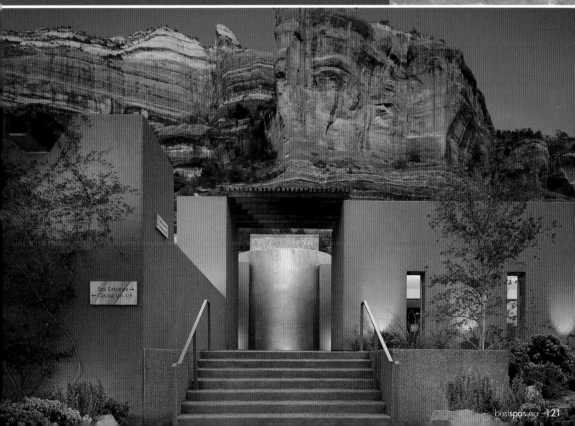

SEDONA SPA AT LOS ABRIGADOS RESORT
SEDONA, ARIZONA

SEDONA SPA AT LOS ABRIGADOS RESORT

160 Portal Lane
Sedona, Arizona 86336
Phone: 928.282.5108
www.ILXRESORTS.com

TYPE
Resort Spa

ACCOMMODATIONS
Taking full advantage of fantastic red rock
views, Los Abrigados Resort & Spa is nestled
against the banks of famous Oak Creek and is
highlighted by 184 one and two bedroom suites.
Sprawled on 22 acres of winding walkways,
cascading fountains and shady nooks,
the resort evokes a sense of seclusion.

SPA
Surrounded by the natural beauty, tranquil
setting and energy of Red Rock Country,
Sedona Spa prides itself on a professional staff
of therapists and estheticians. Featuring eleven
treatment rooms, the spa also encompasses
a fully equipped fitness center, exercise studio,
Pilates reformers studio, two swimming pools,
tennis courts and a mini-golf course.

Discover newfound energy at the Sedona
Spa, an inviting place, a place that promotes
harmony and tranquility. Situated in the main
resort lobby building, plan to pamper yourself
with several one-of-a-kind treatments from a
staff of over thirty skillful therapists. Working
with you, they'll create the ultimate personal
service. You'll experience a sense of renewed
vitality, tensions will be soothed, your mind
and body calmed. In addition to the spa
treatments, an abundance of activities
awaits you including personal trainers,
Pilates instructors and nutrition consultants.
And when day is done, you're only a
short walk from a serene creekside park
with water fountains, a bird sanctuary
and beckoning labyrinth.

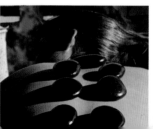

SIGNATURE TREATMENTS INCLUDE THE EXCLUSIVE SEDONA SOJOURN HYDROTHERAPY SKIN TREATMENT THAT COMBINES INDIGENOUS HERBS FROM THE BIOREGION WITH FLOWER ESSENCE RAINDROP THERAPY. THEIR ACUFACIAL REJUVENATION TREATMENTS INCREASE MUSCLE TONE AND ELASTICITY, ERASE FINE LINES AND MINIMIZE DEEP WRINKLES. YOUR COMPLEXION WILL BE LEFT WITH A YOUTHFUL GLOW. OR SAMPLE ONE OF THEIR SPECIALIZED BODYWORK SERVICES BASED ON THE CUTTING EDGE OF THE HOLISTIC HEALTH FIELD.

MASSAGES

Therapeutic
Sports
Deep Tissue
Aromatherapy
Shiatsu
Hot Stone
Maternity
Reflexology
Cranio-Sacral
Feldenkrais
Reiki

FACIALS

Ultra Hydrating Seaweed
Deep Pore Cleansing
Anti-Aging Rosacea
Gentlemen's Facial

SKIN TREAMENTS

Exclusive Sedona Sojourn
Herbal Scrub and Wrap
Sedona Sunset
 Wraps or Scrubs
Desert Dream

ACUPUNCTURE

ACUMASSAGE

WAXING

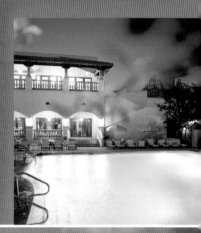

CLAREMONT RESORT & SPA
BERKELEY, CALIFORNIA

CLAREMONT RESORT & SPA

41 Tunnel Road
Berkeley, California 94705
Phone: 800.551.7266 / 510.843.3000
www.CLAREMONTRESORT.com

TYPE
Resort Spa

ACCOMMODATIONS
High in the Berkeley Hills overlooking magnificent San Francisco Bay, the historic Claremont Resort & Spa has 279 tastefully appointed rooms, two award-winning restaurants, a private club with three heated pools, ten outdoor championship tennis courts and a newly renovated 25,000' fitness center.

SPA
Experience unparalleled luxury and renewal in the world-class Claremont Spa. Thirty-two treatment rooms, two couple's massage rooms, steam rooms, Deluge showers and whirlpools enjoy views of the bay. Choose from their signature journeys, massages, body treatments, scrubs and facials. Each therapy is designed to bring mind, body and soul into balance.

Occupying a singular setting with spectacular views, the Claremont Resort & Spa is San Francisco Bay Area's premier resort destination, a place of historic charm and casual California elegance, a place where memories are made. Situated on 22 beautifully landscaped grounds, this 1915 landmark resort is acknowledged for its distinguished service, sophisticated fine dining, world-class spa and outstanding recreational pursuits. Be pampered and soothed by the gentle touch of a skilled therapist in the newly renovated 20,000-square foot Claremont Spa. Choose from an extensive menu of classic and innovative therapies for men and women. Or have a soak in the hydrotherapy baths and delight in the panoramic views of the city below.

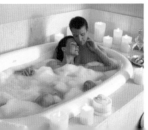

THE CLAREMONT RESORT & SPA HAS GLEANED THE SECRETS OF REJUVENATION, RELAXATION AND RESTORATION FROM SOURCES ACROSS THE GLOBE. FROM SOOTHING INDIVIDUAL TREATMENTS TO GROUP OCCASIONS DESIGNED TO CELEBRATE TOGETHER, THE SPA IS AN INVITING OASIS IN THE GROWING WORLD OF HEALTH AND WELL-BEING.

JOURNEYS

Hawaiian Journey

Rose Journey

Mayan Temple Journey

Brazilian Rainforest Journey

Mediterranean Journey

Japanese Journey

SKIN CARE

Ultimate Exfoliating Facial

Carita Signature Facial

Collagen Revival

Facial Rejuvenation

Acupuncture

Back Facial

Power of Two

BODY WRAPS, POLISHES & SCRUBS

Zen Trilogy Body Wrap

Bamboo Lemongrass Scrub

Mexican Chocolate Scrub

Lavender Essence

Body Bronzing

South Pacific Ginger
 Sugar Polish

MASSAGE

Lomi Lomi Massage

La Stone Massage

Thai Spa Massage

Tibetan Sound Massage

Reflexology

Acupuncture

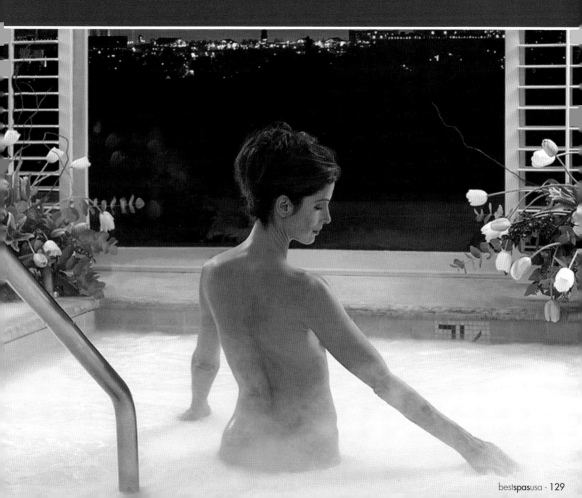

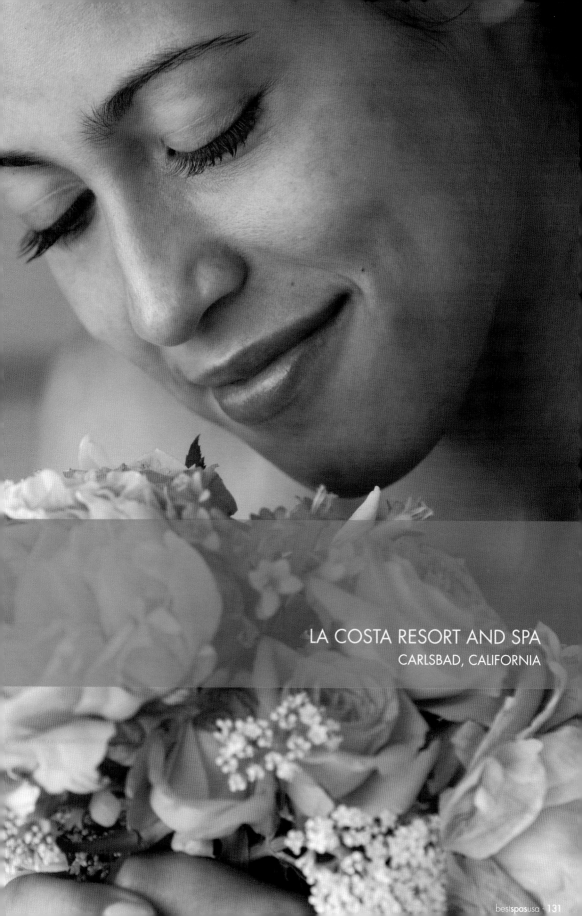

LA COSTA RESORT AND SPA
CARLSBAD, CALIFORNIA

LA COSTA RESORT AND SPA

2100 Costa Del Mar Road
Carlsbad, California 92009
Phone: 800.854.5000 / 760.438.9111
www.LACOSTA.com

TYPE
Resort & Destination Spa

ACCOMMODATIONS
Quaintly nestled among 400 scenic acres
in the coastal foothills of North San Diego,
La Costa's spa experience accompanies many
other resort activities and amenities including
545 newly renovated guest rooms and suites,
two championship golf courses, seventeen
tennis courts, seven pools, lifestyle cuisine,
personal nutrition classes, and a variety
of yoga, Pilates and fitness programs.

SPA
Thoughtfully designed and exquisitely built,
The Spa at La Costa is a tranquil haven
for recharging body and mind and was
made famous by Hollywood celebrities
of past and present. The lushly landscaped
15,000-square foot courtyard, sparkling pool,
signature Roman Waterfall and Spa Café add
to the pleasures of your spa experience.

As the nation's first comprehensive spa and golf
resort, built in 1965, La Costa is a Southern
California classic spa haven. A recent $140-
million renovation has transformed the resort
into an oasis of recreation and relaxation.
Design elements are reminiscent of a peaceful
Mediterranean village and are characterized
by tropical landscaping, palm tree-lined
promenades and appealing water features.
The resort is home to wellness guru, Dr. Deepak
Chopra's Center for Well Being, as well as
Billy Yamaguchi's Salon, the first to integrate
the fundamentals of feng shui into hair design.
An ideal vacation spot for those seeking a
destination spa-like experience, the Spa at
La Costa is complemented by an 8,000-square
foot athletic club, plazas and gardens, and
seven swimming pools. Lifestyle cuisine may
be enjoyed in the sleek BlueFire Grill, at Legends
Bistro, the Splash Café, or the tranquil Spa Café.

THE SPA AT LA COSTA OFFERS A LUXURIOUS EXPERIENCE DESIGNED TO INDULGE, INVIGORATE AND INSPIRE. ENJOY THE CALM CALIFORNIA CLIMATE AMIDST THE TRANQUILITY OF THE OUTDOOR SPA GARDEN COURTYARD WITH ROMAN WATERFALL, POOL AND SPA CAFÉ. TWO V.I.P. SPA SUITES OUTFITTED WITH AN ADOBE-STYLE FIREPLACE AND PRIVATE WHIRPOOL PROVIDE AN EXCLUSIVE RETREAT FOR COUPLES.

THE SPANISH HERBAL BODY RUB

This is one of La Costa's signature body treatments. Native Spanish herbs (fragrant sage, lavender and rosemary) unite with pure olive oils during this indulgent massage and skin polishing. Your body is then enveloped in a fragrant herbal wrap while your scalp is massaged and deeply conditioned with sage oil.

OTHER SIGNATURE TREATMENTS INCLUDE:

Men's Massages and Facials

Chopra Center Ayurvedic Treatments

Thai Massage

Avocado-Cilantro Body Wrap

Pevonia Caviar Timeless Facial

Pregnancy Massage

Hydrotherapy Massage

Couple's Spa Journeys

Girl's Getaways

Yamaguchi Salon Makeovers

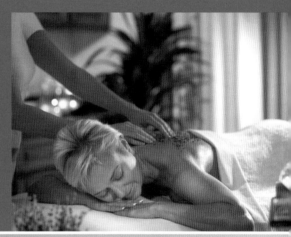

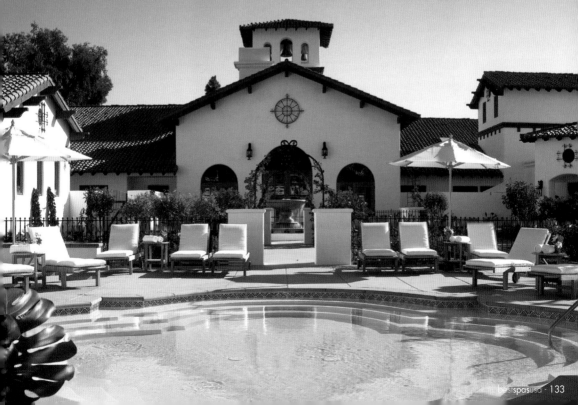

BERNARDUS LODGE

CARMEL VALLEY, CALIFORNIA

BERNARDUS LODGE

415 Carmel Valley Road
Carmel Valley, California 93924
Phone: 888.648.9463 / 831.658.3550
www.BERNARDUS.com

TYPE
Resort Spa

ACCOMMODATIONS
Tucked into the Santa Lucia Mountain Range,
the resort's 57 sumptuous guest rooms feature a
fireplace crafted from Carmel valley limestone,
an oversized bathroom with two-person bathtub,
and French doors that open onto spacious patios
or balconies. Indulgences include wine, fresh
flowers, featherbeds and imported linens.

SPA
A sanctuary for peace, harmony and well-being,
the 5,300-square foot spa has seven treatment
rooms (including one dedicated to couples),
a hydrotherapy tub, warming room and pool,
steam and sauna rooms, a full-service beauty salon
and boutique, fitness studio and outdoor lap pool.

Enveloped by the oaks and vineyards of
picturesque Carmel Valley, Bernardus Lodge is
a gracious, intimate retreat. A place to soothe
your mind, body and spirit in an atmosphere of
utter tranquility. At this haven of rejuvenation,
you'll discover a full range of pampering
treatments incorporating the indigenous
herbs, flowers and essential oils culled from
the lodge's own 22-acre gardens. Savor a
therapeutic soak and quiet reflection in the
open-air warming pool or unwind to the sounds
of bubbling fountains in the meditation garden.
End each day sampling the epicurean delights
awaiting you at Marinus, a favorite among
food and wine lovers and lauded as one of
Zagats top restaurants in the Bay Area.

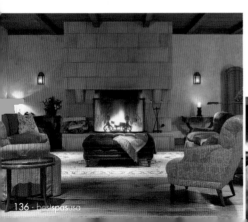

EACH TREATMENT AT BERNARDUS
LODGE PROVIDES THE OPPORTUNITY
TO NURTURE YOUR INNER SELF.

INDIGENOUS TO INTERNATIONAL

Relax and revitalize your mind and body
with European classics, Far Eastern therapies
and the ancient traditions of Ayurvedic healing.

GIFTS FROM THE GARDEN

Herbs and botanicals from the garden refresh
the skin and calm the senses. The Spa at
Bernardus lets you celebrate your spirit with
an array of sybaritic indulgences, from soothing
to invigorating.

VITALITY FROM THE VINE

The healthful benefits of the grape are
meant to heal the skin too. Known for their
high anti-oxidant content, grape seed treatments
are meant to restore the skin and prevent aging.

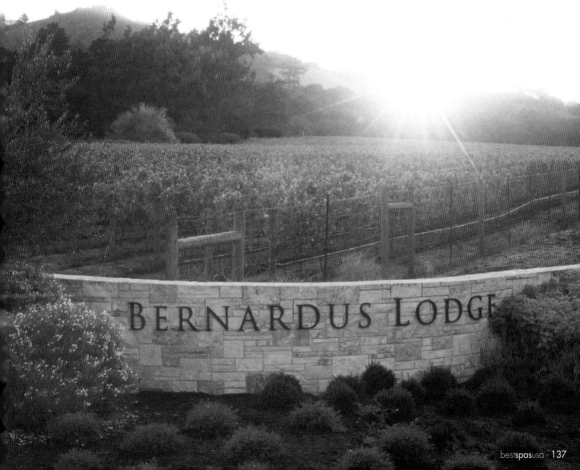

ESTANCIA LA JOLLA HOTEL & SPA

LA JOLLA, CALIFORNIA

ESTANCIA
LA JOLLA HOTEL & SPA

9700 North Torrey Pines Road
La Jolla, California 92037
Phone: 858.550.1000 / 877.437.8262
www.ESTANCIALAJOLLA.com

TYPE
Hotel Spa

ACCOMMODATIONS
Estancia La Jolla Hotel & Spa is a California
ranch-style vacation resort featuring 210 well
designed and impeccably furnished guest rooms.
A heated pool, Jacuzzi, full-service spa and salon,
fitness center, certified conference rooms, business
center, and on-site dining complete the ensemble.

SPA
Begin your day with a Sunrise Yoga class
or enjoy an evening swim in the heated outdoor
pool. The Spa at Estancia La Jolla includes a
state-of-the-art fitness center, garden relaxation
areas with fireplace, whirlpools and steam rooms,
a hot tub, Bridal Party Services, special
packages, and group accommodations.

At the Spa at Estancia La Jolla, you can indulge
in a variety of rejuvenating treatments for mind,
body, and spirit. Choose from an assortment
of indoor and outdoor massage treatments
using only natural, organic products performed
by highly trained staff. Relax in the garden
patio while restoring your body to its natural
balance. Experience the invigorating Rain and
Botanical Body Treatments and begin your
journey to a tranquil state of mind. Luxurious,
refreshing facials leave your skin exfoliated
and hydrated. The fitness facility features Life
Fitness equipment, yoga, circuit training and
master swim. Your personal sense of well-being
begins the moment you step into The Spa at
Estancia La Jolla.

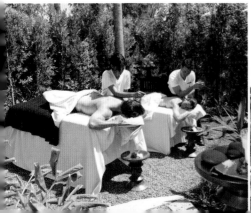

DISCOVER A SANCTUARY AT THE SPA
AT ESTANCIA. A PLACE WHERE GENTLE
RAINS, NATURAL BOTANICALS AND HEALING
TOUCHES REVITALIZE BODY AND SPIRIT
IN THE SOLITUDE OF A PRIVATE ROOM
OR OUT IN THE NOURISHING SOUTHERN
CALIFORNIA SUN. BE THEIR GUEST
AND EXPERIENCE ONE OF THEIR
SIGNATURE TREATMENTS.

THESE ARE JUST A FEW OF THE MANY
LUXURIOUS TREATMENTS FOR YOUR
CHOOSING DURING A DAY OF
REJUVENATION AND RELAXATION.

Stone massage

Pre-natal massage

Stress relief massage

Deep tissue massage

Cellular repair facial

Deep cleansing facial

Estancia garden treatment

Healing garden treatment

Citrus medley body scrub

Herbal cellulite treatment

Thermal mud detoxifying

Manicures and pedicures

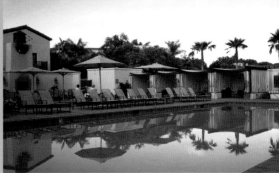

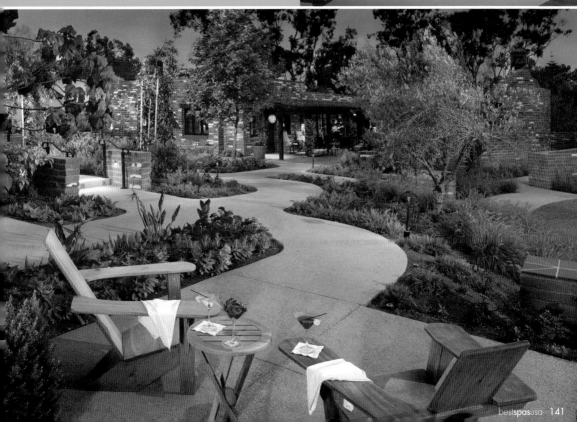

LE MERIGOT, A JW MARRIOTT BEACH HOTEL & SPA
SANTA MONICA, CALIFORNIA

LE MERIGOT, A JW MARRIOTT BEACH HOTEL AND SPA

1740 Ocean Avenue
Santa Monica, California 90401
Phone: 310.395.9700
www.LEMERIGOTHOTEL.com

TYPE

Hotel Spa

ACCOMMODATIONS

Le Merigot blends European elegance with the casual lifestyle of Southern California as reflected in its clean, contemporary feel. The distinctive design of the suites and rooms resembles a private beachside residence. Sand and rust-veined marble, imported African Fiddleback anagre wood, Frette linens and luxurious appointments define the exquisite décor.

SPA

The Spa Le Merigot provides an unparalleled atmosphere of luxuriant beauty, tranquility and privacy; essential elements to creating peace of mind. This full-service spa and health club features eight treatment rooms including a couple's suite and nail room. The pampering treatments employ Kneipp, Epicuren and Pevonia Botanicals.

In the timeless tradition of the very finest hotels of France's Cote D'Azur, Le Merigot features splendidly appointed accommodations, superb cuisine combined with a full-service, European-style spa. On California's sun-washed coast, the hotel's 175 spacious guest rooms include 15 suites with serene ocean views. A dedicated staff and the finest amenities such as oversized desks and access to high-speed Internet data ports contribute to the hotel's allure. Cezanne, Le Merigot's acclaimed restaurant was named L.A's Best Hotel Restaurant by *Angeleno Magazine*. With menus inspired by the local farmer's market and world-class professional table service in the European mode, this fashionable eatery provides an exceptional dining experience. Le Merigot is the ideal destination for your next business journey or romantic and indulgent getaway.

THE SPA LE MERIGOT PROVIDES AN ATMOSPHERE OF ABUNDANT BEAUTY, PEACEFUL TRANQUILITY AND PRIVACY– ESSENTIAL ELEMENTS TO CREATING A SENSE OF WELLNESS. YOU'LL BEGIN YOUR ESCAPE TO BLISS AND CALMNESS THE MOMENT YOU ENTER THE SPA AND ARE GREETED BY THE FINEST AROMATHERAPY ESSENCES.

SIGNATURE TREATMENTS

EPICUREN SIGNATURE FACIAL

A result-oriented protocol that employs a cinnamon enzyme peel as well as active protein enzymes to lift, tighten and firm facial skin. A state-of-the-art therapy, it will improve your skin's health through cell regeneration increasing textural clarity and tone.

SIGNATURE MANICURE

A deluxe "facial for the hands." An intense two-step citric acid exfoliation rejuvenates, deeply hydrates and helps restore skin to a more youthful appearance. It is topped off with an essential oil-infused ceramide and vitamin massage and a perfect polish of the nails.

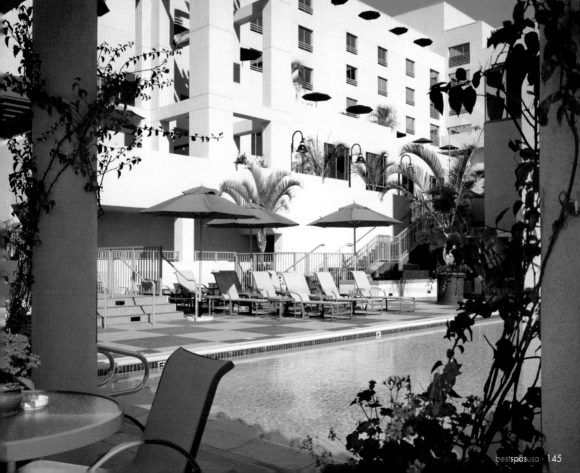

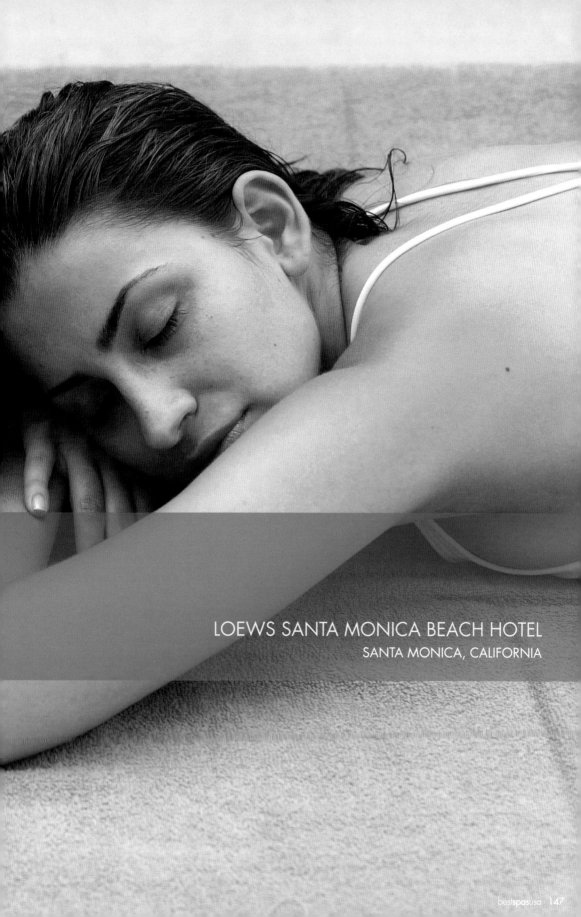

LOEWS SANTA MONICA BEACH HOTEL
SANTA MONICA, CALIFORNIA

LOEWS SANTA MONICA BEACH HOTEL

1700 Ocean Avenue
Santa Monica, California 90401
Phone: 310.458.6700 / 310.899.4040
www.SANTAMONICALOEWSHOTEL.com

TYPE
Hotel Spa

ACCOMMODATIONS
An eight-story hotel with 342 handsomely furnished rooms including 13 one-bedroom suites and four luxury suites. Guest rooms mirror the hotels fresh spirit with natural tones, subtle hues and welcoming design touches. All rooms are "workplace friendly" with contemporary executive desks and high-speed Internet connections.

SPA
The spa and award-winning fitness center is over 6,000 square feet and offers a variety of massage and facial treatments, manicures and pedicures and a full-service hair salon. The fitness center features health, wellness, exercise and weight programs, all designed to keep you fit and looking good.

Located steps from the Pacific Ocean and the famous fitness paths and outdoor gymnastics parks that run along the shore, the Loews Santa Monica Beach Hotel is a city resort with the Pacific Ocean on one side, the colorful cityscape of Santa Monica on the other. It caters to business and leisure travelers with proximity to landmarks such as Pacific Park, Third Street Promenade and boutique-filled Montana Avenue. The hotel has a distinct place in the heart of the history of a beautiful beachfront city. Its inviting restaurant, Ocean and Vine, showcases sweeping ocean vistas and California-inspired "farm to table" cuisine with expertly paired wine from around the world. You can dine alfresco on the spacious patio or fireside in cozy vignettes while you enjoy Chef Gregg Wangard's innovative cuisine.

THERE ARE FOUR
TREATMENT ROOMS
FOR BODY AND FACIAL
PROCEDURES AND A FULL-
SERVICE BEAUTY SALON.
YOU CAN ALSO GET A
WORKOUT IN THE AWARD-
WINNING, STATE-OF-
THE-ART FITNESS STUDIO.
THERE ARE CLASSES FOR
YOGA, PILATES, SPINNING,
CORE-TRAINING, BODY
SCULPTING, TREADMILL
AND WATER AEROBICS.
SPECIAL SERVICES
ENCOMPASS MEN'S
SHAVING, PERSONAL
TRAINING AND LONG-TERM
WELLNESS PROGRAMS.

MASSAGES
Swedish
Sports
Deep Tissue
Shiatsu
Prenatal
Reflexology

BODY TREATMENTS
Salt Glo Aromatherapy
Body Polish
Aromatic Mud Body Wrap
Seaweed Body Wrap

FACIAL TREATMENTS
European Deep Cleansing
Beauty Flash Lifting Facial
Aromatherapy Facial
Beaute Neuve -
 Renewing Treatment
Vitamin C-Liftosome
Rosacea Facial
Men's Facial
Eye Lifting Treatment
Express Facial
Gycolic Acid Peel

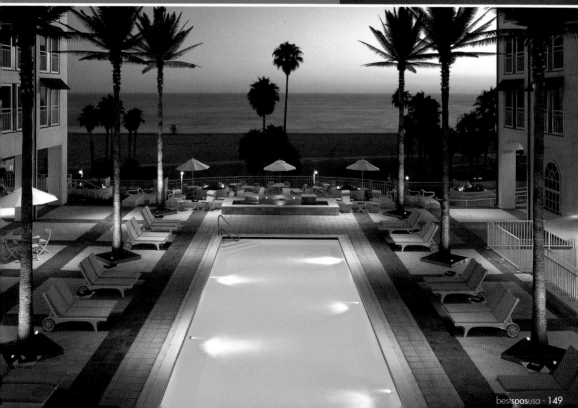

RANCHO LA PUERTA
TECATE, BAJA CALIFORNIA (MEXICO)

RANCHO LA PUERTA

(U.S. Reservations Address)
3323 Carmel Mountain Road, Suite 100
San Diego, California 92121
Phone: 877.440.7778 / 858.764.5500
www.RANCHOLAPUERTA.com

TYPE
Destination Spa

ACCOMMODATIONS
The Ranch encompasses 3,000 acres of rolling
countryside in a nearly perfect year-round climate.
The distinctive terrain is characterized by boulder-
strewn Mt. Kuchumaa, "the exalted high place"
of the Kumeyaay Indians. Spacious casitas are
scattered among vast gardens and feature private
entries, bathrooms with hand-painted tiles, patios,
rare folk art and breathtaking views.

SPA
A fitness resort and spa, the club-like atmosphere
of the Women's Health Center (and a separate
center for men) provides an emphasis on healthful
exercise, spirituality and mind/body awareness.
A complete range of facials, massages and body
treatments are accompanied by saunas, steam
rooms and whirlpools.

Rancho La Puerta has created a fitness resort
in an incredibly lush landscape of native plants,
succulents and seasonal blooms. Oak groves
shade hammock retreats perfect for relaxing
while lily ponds and boulders set the stage for
tranquil contemplation. The Ranch combines
outstanding spa cuisine with hands-on cooking
classes, indoor workshops, outdoor pursuits
and a myriad of pampering treatments.
This creative learning environment offers
everything from yoga and Pilates to personal
growth programs. Their classic labyrinth,
a replica of the eleven-circuit pattern laid in
the floor of Chartres Cathedral over 800
years ago, beckons guests to lose themselves
in their wanderings and rediscover renewed
balance and energy.

"A WEEK THAT WILL CHANGE YOUR LIFE" IS THE RANCH'S MANTRA. AND THE CAMARADERIE YOU FEEL AT WEEK'S END TESTIFIES TO THE SPIRIT OF THAT GOAL. RANCHO LA PUERTA HELPS YOU TAP INTO YOUR POTENTIAL AND LIVE A LONGER, MORE YOUTHFUL LIFE.

Choose from over 75 different treatments and activities including yoga, tai chi, meditation and other mind-body pursuits. Indulge in the finest European facials, body wraps and heavenly personal therapies. The choice at the ranch is always yours. A sampling follows:

Hiking
Yoga
Pilates (Matwork And Reformer Studio)
Feldenkrais
Bird Watching
Dance
Water Works
Meditation

Sculpt And Strengthen
Flexibility Training
Fitball
Volleyball
Cardio Cycling
Tennis
Swimming
Massage
Herbal Wraps
Reflexology
Facials

PARK HYATT RESORT & SPA
BEAVER CREEK, COLORADO

PARK HYATT RESORT & SPA

100 East Thomas Place
Beaver Creek, Colorado 81620
Phone: 970.949.1234 / 970.748.7500
www.ALLEGRIASPA.com

TYPE

Resort Spa

ACCOMMODATIONS

High in the Rocky Mountains, the Park Hyatt
Beaver Creek Resort & Spa sits in a village
reminiscent of alpine Europe. The elegant
slopeside, ski-in/ski-out resort features 190 guest
rooms tastefully appointed with down comforters,
marble baths and signature spa amenities.

SPA

Undergoing a $12 million renovation in 2006,
Allegria Spa was expanded to 30,000-square
feet. It encompasses 23 treatments rooms,
4 deluxe suites for two, a co-ed mineral pool,
steam room, sauna, the ultra-modern Kinesis
weight-training system, an enhanced fitness center,
hardwood floor yoga studio and a beauty salon
and boutique.

The unique spa experience begins with "Aqua
Sanitas" or healing waters, a self-guided water
ritual based on ancient European traditions now
in a modern setting. Infused throughout with
essences of indigenous Colorado wildflowers
and herbs, Aqua Sanitas is defined by an
extraordinary co-ed, juniper-scented hot mineral
pool at the center of the water oasis. Caldaria
steam rooms bathe the body with heat, comfort
and the aroma of spruce. The cascata, a vigorous
rainfall shower rinses and refreshes. Providing a
relaxing warm sanctuary, the tepedarium features
heated tiled loungers and a place to repose.
Four deluxe suites offer an intimate spa journey,
each with a pair of massage tables and its own
signature virtue: side-by-side Vichy showers, an
immense granite soaking tub, a steam shower
for two, or cozy fireplaces with elegant and
comfortable furnishings.

ALLEGRIA SPA'S MOST POPULAR TREATMENTS
ARE THE HOT STONE MASSAGE, OXYGEN
FACIAL AND THE GINGER PEACH DELUXE.
SOME DAY PACKAGES MIX SIGNATURE SPA
TREATMENTS WITH OUTDOOR ADVENTURES
SUCH AS SNOWSHOEING OR HIKING
ALLOWING GUESTS TO EXPLORE THE BEAUTY
OF THE ALPINE ENVIRONMENT
AND EXPERIENCE MOUNTAIN LUXURY
AT AN UNEQUALED LEVEL.

MEN'S SERVICES

Gentlemen's Facial

Men's Hand
 and Foot Treatment

Sports Massage

Gentlemen's Body Scrub

Barefoot Massage

SPA MENU

Classic Swedish Massage

Allegria Hot Stone Massage

Thai Massage

Shiatsu

Ginger Peach Deluxe Body Wrap

The Balancing Hot Oil Wrap

Lavender Hot Oil Wrap

Indian Spring Clay Ritual

Sugarcane & Coconut Scrub

Wild Mountain Berry Scrub

Sweet Orange & Citrus Salt Glow

Pampering Wild Rose Ritual

The Holistic Facial

The Repairing Vitamin C Facial

Deluxe Facial with Oxygen Boost

Resurfacing Peel

The Hydration Facial

Teen Facial

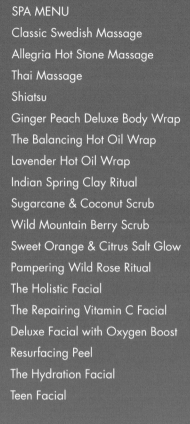

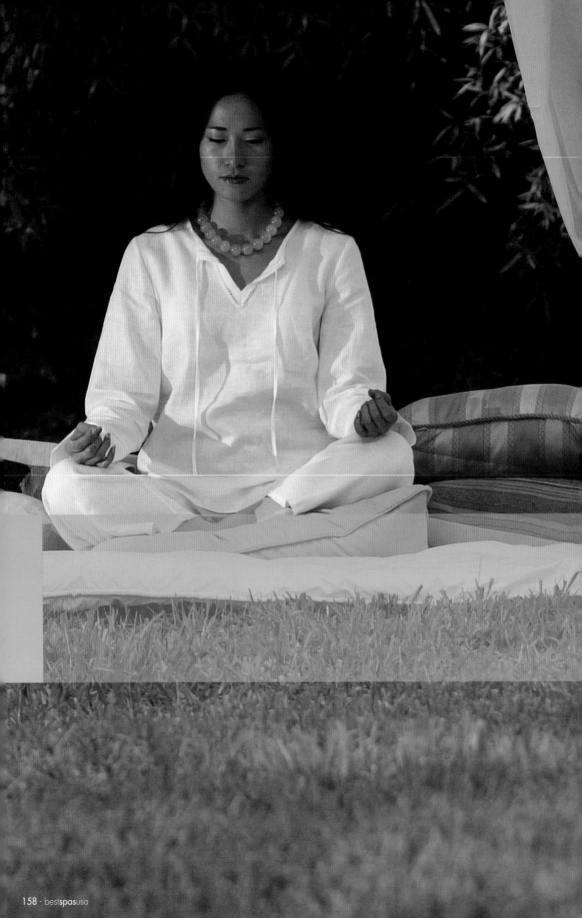

THE GROVE ISLE HOTEL & SPA
COCONUT GROVE, FLORIDA

THE GROVE ISLE
HOTEL & SPA

Four Grove Isle Drive
Coconut Grove (Miami), Florida 33133
Phone: 800.884.7683 / 305.858.8300
www.GROVEISLE.com

TYPE
Resort Spa

ACCOMMODATIONS
This private island retreat is tucked within twenty lush, palm-peppered acres. Endless Biscayne Bay water views reflect through each of the spacious, casually elegant guest rooms. Canopied beds, terra cotta tile underfoot and warm hardwood furnishings evoke the aura of a bygone era. Your cares will be whisked away on gentle tropical breezes.

SPA
A nexus for healing and soothing, SpaTerre's therapies employ herbs, minerals and essential elements indigenous to the area. Indonesian, Thai and Balinese influences are also present in this organic oasis where you can choose from an exotic line of body treatments, facial care, massage therapies and one of the few Watsu massage pools on the Eastern Seaboard.

At this garden island escape, you'll uncover intimate gathering places, strolls through verdant gardens characterized by swaying palms, meandering bougainvillea and tropical terraces cascading into placid Biscayne Bay. You'll experience secluded elegance, not unlike the feel of an exclusive residence and an aura that invites you to unwind and make yourself at home. From the private marina, exotic jungle murals, gilded columns and green metal palm fronds, the quintessence of Old South Florida is recaptured at every turn. And with it all, you're only minutes from the excitement of Miami Beach and the upscale shopping enclave of Coconut Grove. You may feel a million miles away at the Grove but it's all at your fingertips… culture, shopping, championship golf and a host of other activities.

SPATERRE AT THE GROVE ISLE OFFERS A VARIETY OF DISTINCTIVE SIGNATURE TREATMENTS. THEIR DEDICATION TO BLEND PRESENTATION WITH TRUE THERAPEUTIC WELLNESS IS REFLECTED BY THE ARTISANS WHO HAVE THE GIFT OF THE HEALING TOUCH AND THE ABILITY TO CREATE THE ULTIMATE EXPERIENCE FOR EVERY GUEST.

The Watsu is one of Grove Isle's signature treatments. Float in the arms of your therapist in the Waterfall Watsu Pool as your muscles are massaged, joints mobilized, tissues stretched and energy pathways opened. Or choose from one of their other indulgent signature treatments including:

Javanese Lulur Royal Treatment

Volcanic Earth Clay Ritual

Thai Kelapa Ritual

Samunprai

Balinese Massage

Milk & Honey Body Wrap

SpaTerre Signature Facial

Tropical Fruit & Flower Facial

Luxurious Key Lime Margarita Pedicure

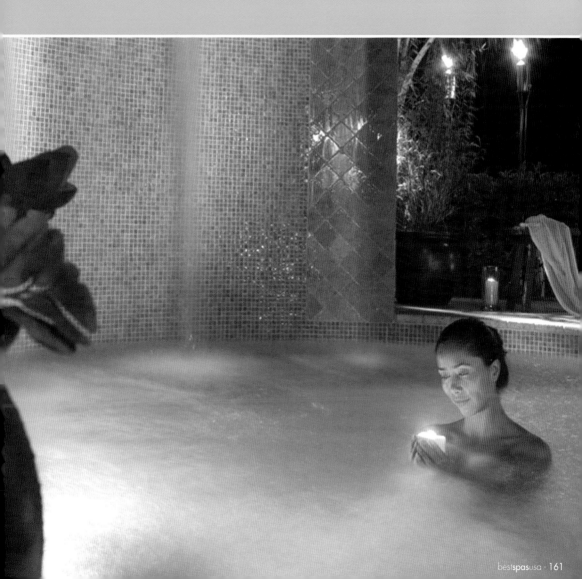

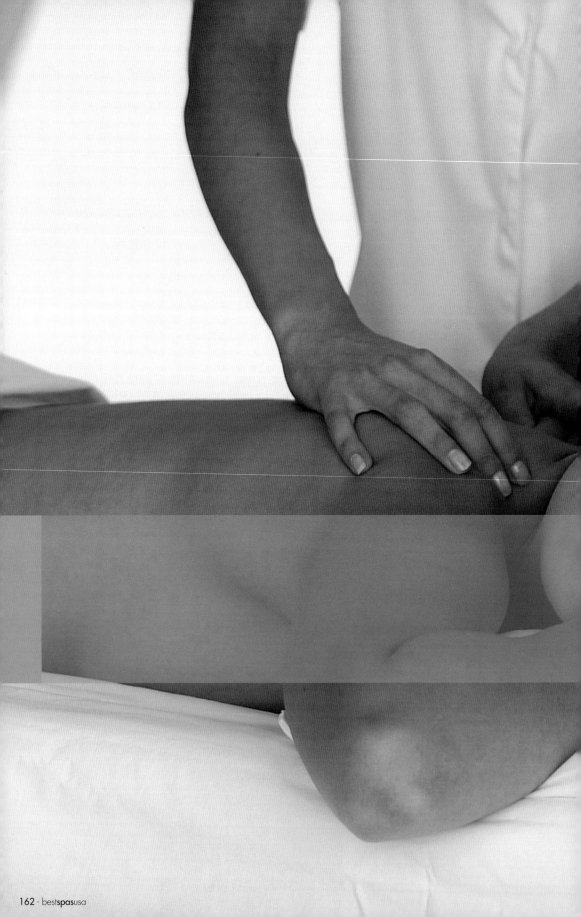

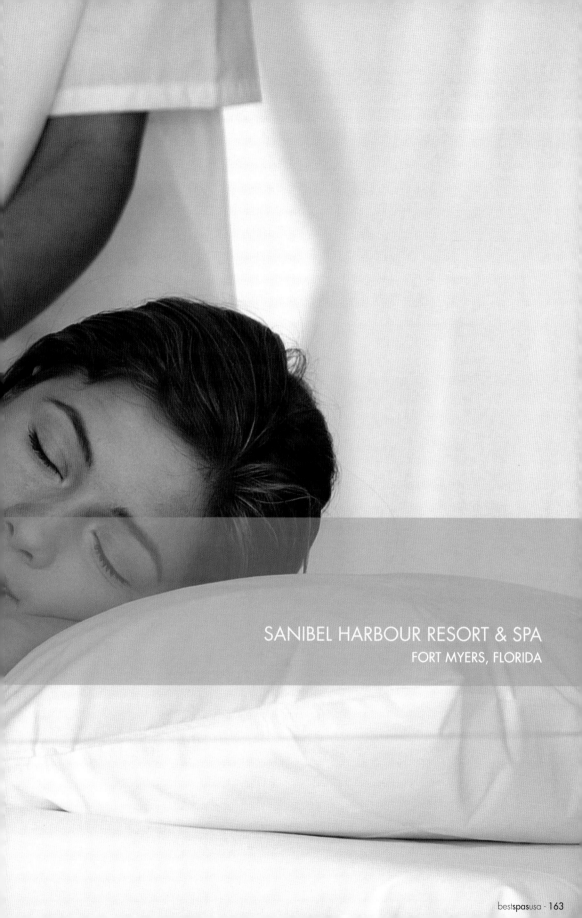

SANIBEL HARBOUR RESORT & SPA
FORT MYERS, FLORIDA

SANIBEL
HARBOUR RESORT & SPA

17260 Harbour Pointe Drive
Fort Myers, Florida 33908
Phone: 866.479.5827 / 239.466.4000
www.SANIBEL-RESORT.com

TYPE

Resort Spa

ACCOMMODATIONS

Nestled on a pristine 85-acre peninsula
on Florida's Gulf Coast, Sanibel Harbour Resort
embodies the essence of seaside grandeur.
This resort features 385 elegant accommodations,
including 69 suites, 38 two-bedroom
condominiums, and the exclusive 107-room
concierge hotel, Grande Bay at Sanibel Harbour.

SPA

The Spa at Sanibel Harbour is a 40,000-
square foot modern facility dedicated to timeless
relaxation. The award-winning spa includes
separate men's and women's areas with sauna,
steam and whirlpool; a state-of-the-art fitness
center; 28 treatment rooms; an indoor exercise
pool; aerobics room; championship tennis
facility; and full-service salon.

The essence of the sea is at the heart of
The Spa at Sanibel Harbour. Pampering
sea-based treatments, inspired by the rituals
of the Caloosa Indians who inhabited the
area centuries ago, draw upon nature and
the sea for healing. The sea-derived products
are known for their nourishing and detoxifying
properties. Named one of the Top 10 Spa
Resorts by *Conde Naste Traveler*, this tropical
getaway caters to women, men and couples
and offers a seemingly endless menu of
indulgences for mind, body and spirit.
From water therapies and salt glows, to
cutting edge fitness and expert instruction
including yoga and Pilates, The Spa at
Sanibel Harbour is a world-class facility
dedicated to timeless relaxation.

STEP INSIDE THE DOORS OF THE SPA AND ENTER A WORLD OF SERENITY. BE RESTORED BY THE GENTLE KNOWING TOUCH OF A WELL-TRAINED THERAPIST. UTILIZING NATURAL AND SEA-BASED ELEMENTS FOR HEALING, SPA TREATMENTS INCLUDE THOSE FOUNDED ON THALASSOTHERAPY THAT APPLY LAYER UPON LAYER OF BLISSFUL MOISTURE-RICH SEA-DERIVED PRODUCTS TO SOOTHE, PURIFY AND REVITALIZE.

SPA MENU

Couple's Massage

Sea Botanical Wrap

Maternity Massage

Peppermint Sea Twist

Gentlemen's Facial

Aromatherapy Massage

Day of Indulgence

Sea Spa Manicure

Refining Glycolic Facial

Therapeutic Massage

Sea Shell Body Mask

Deep Cleansing Facial

SIGNATURE TREATMENTS

The Caloosa Experience

The Betar Sensation

Sanibel Exclusive Pedicure

Four-Layer Facial

Sea Shell Scrub

Mango Salt Glo

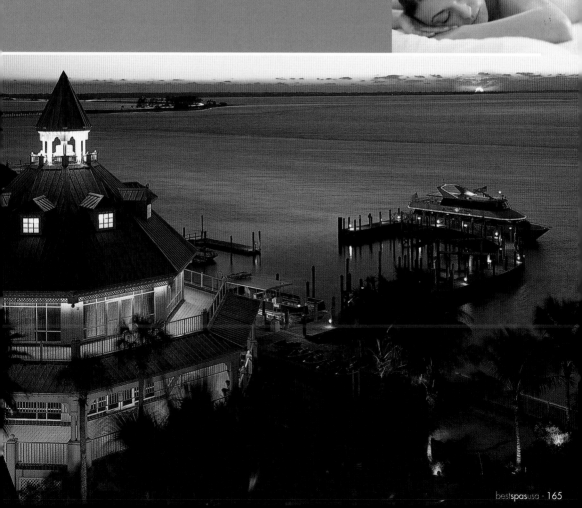

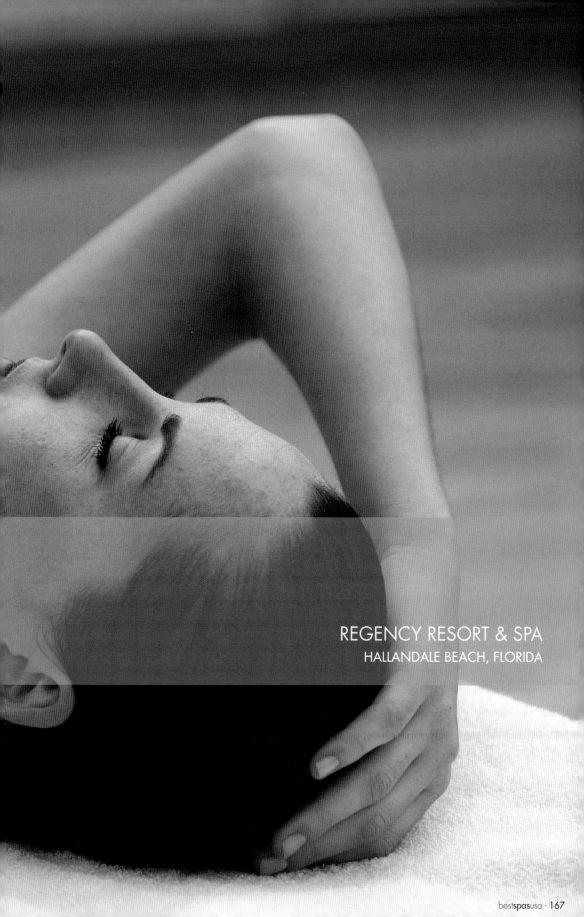

REGENCY RESORT & SPA
HALLANDALE BEACH, FLORIDA

REGENCY
RESORT & SPA

2000 South Ocean Drive
Hallandale Beach, Florida 33009
Phone: 800.454.0003 / 954.454.2220
www.REGENCYHEALTHSPA.com

TYPE
Resort & Destination Spa

ACCOMMODATIONS
Located on the Atlantic Coast in sunny southern
Florida, the hotel is surrounded by miles of
sandy white beaches. The friendly staff will
welcome and escort you to one of the ocean
view, pool view or garden view rooms.

SPA
The Regency Resort & Spa is a holistic
health center with a successful history of helping
guests lose weight. High-quality vegetarian
nutrition combined with stress management
skills, behavior modification and aerobic
exercise is at the heart of the program.
And just as important is the emphasis
placed on taking home your success.

Applying the concept of holistic living, guests
experience the benefits of weight loss, physical
fitness and the karma of a peaceful mind and
positive attitude. A private consultation with
Health Director, Dr. Frank Sabatino results in a
personalized program to enhance your lifestyle
awareness. It encompasses low-impact aerobics,
stretching, toning, power walking, upper body
weight training, t'ai chi, Pilates, yoga and
meditation. Aqua exercise classes are held in
the ocean or outdoor heated pool. The five-star
vegetarian cuisine reflects food from around the
world and includes gourmet meals and juice
fasting (optional). Daily lectures cover health and
nutrition. To maintain a healthful lifestyle once
you return home, cooking demonstrations and
"shopping smart" skills are emphasized.

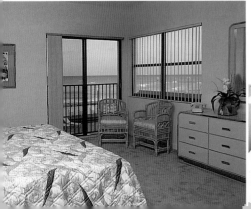

EXERCISE PROGRAMS ARE COMBINED WITH STRESS REDUCTION AND BEHAVIOR MODIFICATION TO CONTRIBUTE TO YOUR WELL-BEING. THERE ARE LUXURIOUS TREATMENTS INCLUDING:

Anti-cellulite massages, European-style lymphatic drainage, reflexology, facials, sea salt and essential oil body wraps and scrubs, hair and scalp treatments and salon services.

The Regency Signature Treatment is the "Non-Surgical Facelift Facial." The ultimate facial, this pampering therapy repairs and rebuilds the skin by combining a pumpkin complex to gently exfoliate, followed by peptide amino acids to diminish fine lines and wrinkles, smooth skin texture and improve hydration and circulation. The facial ends with an enzyme lifting treatment to firm and tighten the skin, resulting in a visible "lift" and healthy, younger looking skin.

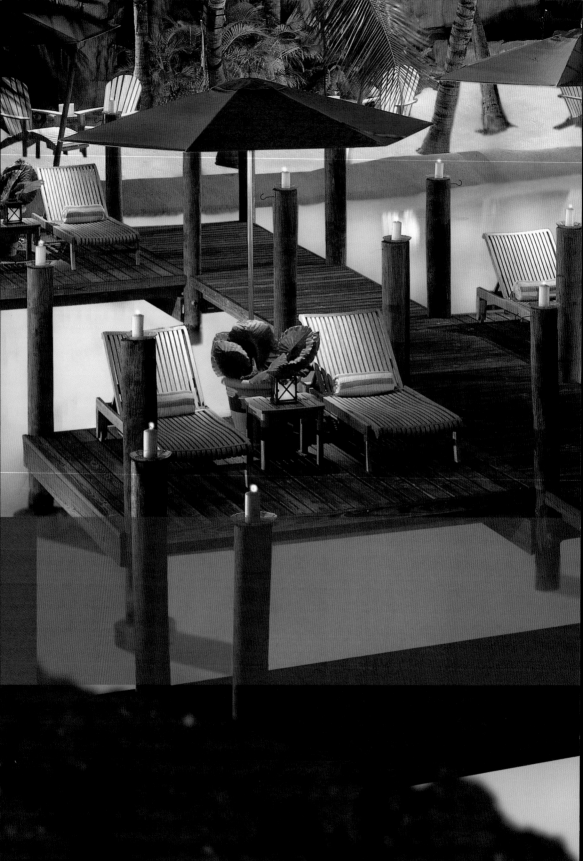

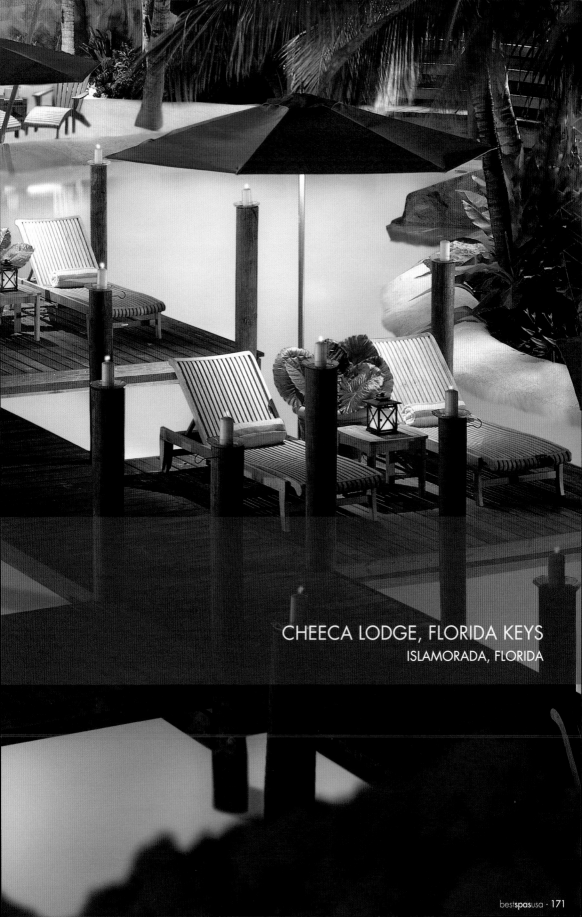

CHEECA LODGE, FLORIDA KEYS
ISLAMORADA, FLORIDA

CHEECA LODGE
FLORIDA KEYS

81801 Overseas Highway, Mile Marker 82
Islamorada, Florida 33036
Phone: 800.327.2888 / 305.664.4651
www.CHEECA.com

TYPE
Resort Spa

ACCOMMODATIONS
This impressive resort offers elegant
accommodations in the main lodge and
charming bungalows. Ocean and resort
view deluxe rooms and suites are decorated
in a West Indies motif characterized by
mahogany-accented furniture. Luxurious
appointments include tasteful marble
bathrooms with soaking tubs and showers.

SPA
Partake of gentle indulgences beneath
the swaying palms of the Florida Keys.
Pamper yourself with one of the revitalizing
and nourishing treatments that reflect the spa's
local flavor. Invigorate both body and soul
at a private poolside "cabana for two"
and enjoy a very special couple's interlude.

Flavored with the captivating spirit and aura
of the West Indies, this exquisite ocean resort
is secluded on 27 lovingly landscaped acres.
With more than 1,100 feet of palm-fringed
beach and verdant tropical landscaping,
Cheeca Lodge was designed with your
pleasure in mind. Restore yourself with an early
morning dip in the warm waters of the Atlantic,
or do laps in one of the two freshwater pools
or the saltwater lagoon. Awaken to spectacular
sunrises, fill your day with spa indulgences
and then stroll the white sandy beach at sunset.
Everything you've dreamed of – epicurean
spa treatments, romantic dining, golf, tennis
and a score of water sports await you at
this alluring getaway.

A SPA SAMPLING ...

SUNRISE TO SUNSET MASSAGE
Targets your high-stress areas.

RIVER STONES MASSAGE
Strategically places smooth stones for a deeply relaxing treatment.

FOUNTAIN OF YOUTH FACIAL
Employs fleece masks to imbue your skin with a more youthful appearance.

KEY LIME SALT SCRUB
Leaves skin soft, supple and tingly. A Vichy rain shower follows and concludes with a moisturizing coconut-lime body cream.

ENCHANTED GARDEN
Revitalizes skin with a rose exfoliating therapy and soothing Rose Gel scalp massage.

MANGO SUGAR SMOOTHIE
Combines a mango sugar scrub, warm Vichy shower and the application of specially blended Shea butter cream.

GIFTS FROM THE SEA BODY WRAP
Begins with a Dead Sea salt exfoliation and ends with hydrating lotion massaged into the skin, ahhh.

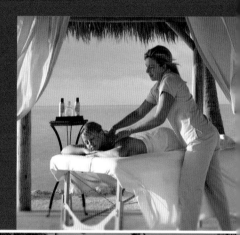

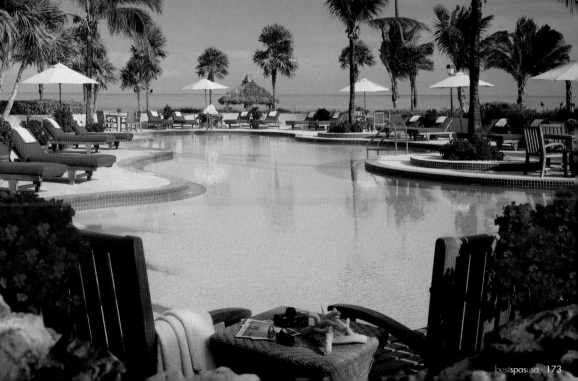

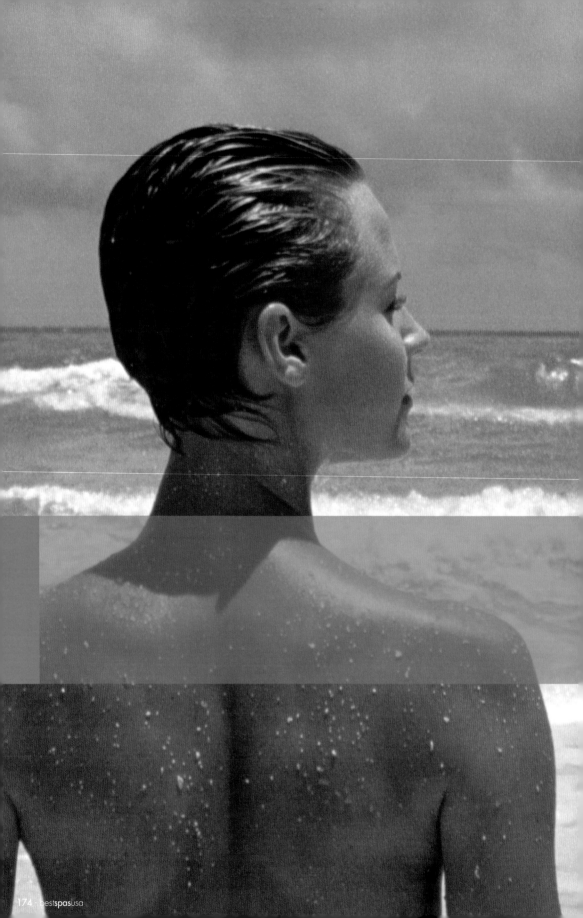

OCEAN KEY RESORT & SPA

KEY WEST, FLORIDA

OCEAN KEY RESORT & SPA

Zero Duval Street
Key West, Florida 33040
Phone: 800.328.9815 / 305.295.7017
www.OCEANKEY.com

TYPE
Resort Spa

ACCOMMODATIONS
Spacious guest rooms and suites feature ocean or Old Town views and are appointed with sumptuous marble baths, whirlpool tubs and private balconies. Interiors are bright and bold, full of Florida Keys energy. Island-style art and hand painted furniture round out the ensemble.

SPA
SpaTerre was designed to represent the classic Floridian beach house. Cross-cultural therapies and exotic Balinese rituals from Indonesia, Thailand, India and Australia are custom-designed to promote your well-being. Soak in a Japanese tub on the balcony of one of the massage rooms and capture the essence of the Key West experience.

Blessed by balmy weather and blue skies, the Ocean Key Resort & Spa is a calming refuge sited on historic Duval Street between Key West Harbor and Mallory Square. The resort embodies the spirit of Key West, one of America's architectural and botanical treasures. Your dream escape continues with SpaTerre, an oasis of wellness designed to pamper your mind and impart a feeling of intense tranquility and spiritual awareness. The healing properties of flowers and spices are used liberally to enhance each spa visit. The Hot Tin Roof, their waterfront restaurant, features original "Conch Fusion" cuisine. Nightly entertainment and the best view on the island await you at the Sunset Pier.

AT THIS SPA REFUGE, DISTINCTIVE THERAPIES ARE DESIGNED TO REPLACE THE WEIGHT OF THE WORLD WITH A FEELING OF COMPLETE RELAXATION. MANY TREATMENTS EMPLOY A BLEND OF HERBS AND MINERALS INDIGENOUS TO THE AREA.

TAKE YOUR SENSES ON AN UNFORGETTABLE SPA JOURNEY WITH THE CARIBBEAN SEAWEED BODY MASK

Improves circulation with a mineral-rich seaweed application from nearby Key West shores. A Dead Sea salt exfoliation and soothing body mask follow.

THE SPATERRE SIGNATURE FACIAL

Restores your natural glow with the natural ingredients and essential oils of their trademark treatment.

JAVANESE LULUR ROYAL SPA TREATMENT

A lavish Balinese massage ritual that encompasses an herbal exfoliation, cool yogurt splash and aromatic shower. It ends with a rose petal soak infused with tropical fragrances.

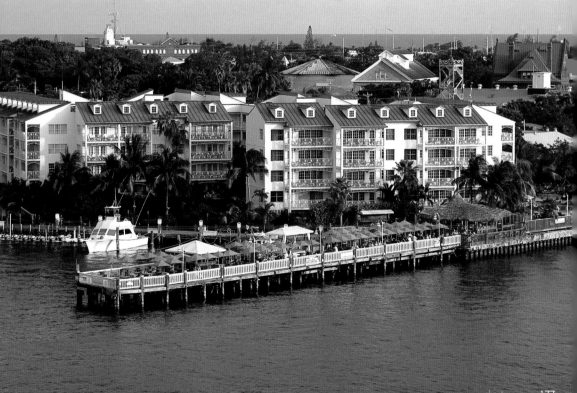

LONGBOAT KEY CLUB AND RESORT
LONGBOAT KEY, FLORIDA

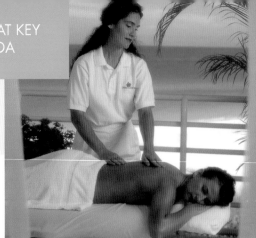

LONGBOAT KEY CLUB AND RESORT

301 Gulf of Mexico Drive
Longboat Key, Florida 34228
Phone: 888.541.2099 / 941.383.8821
www.LONGBOATKEYCLUB.com

TYPE
Resort Spa

ACCOMMODATIONS
Longboat Key Club and Resort is set like
a jewel on a barrier island just off the coast
of Sarasota. It boasts 215 luxurious rooms
and suites with private balconies, 45 holes
of championship golf, four restaurants
and the Island House Spa.

SPA
Relax, renew and refresh yourself in tropical
tranquility at the Island House Spa. This
9,000-square foot world-class spa features
twelve treatment rooms, a full menu of facials,
massages, body treatments, aromatherapies,
manicures and pedicures, as well as signature
spa and beauty products at the spa boutique.

A relaxation destination, the Island House Spa
is an oasis of pleasure. Known for its charm,
romance, friendly staff and quaint intimacy, the
spa is a place where individuals, couples of all
ages, and honeymooners alike can relax at an
island pace. The spa's philosophy is pampering
on a personal level. Indulge in an array of
refreshing treatments and therapies, including
the Body Pina Colada, the Double Chocolate
Sundae, the Tropical Facial or the Island
Couple's Escape, each a singular experience
designed to offer a soothing respite from the
outside world. And as a true Florida resort spa,
the spa exclusively uses products from Osea,
the industry leader in high-tech, all-natural,
marine-based skin care.

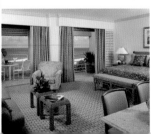

OFFERING A TOTAL BODY
ESCAPE, THE ISLAND HOUSE
SPA INVITES YOU TO
EXPERIENCE TIME DEDICATED
SOLELY TO YOU, YOUR
WELL-BEING, YOUR SPIRIT.
FROM FACIALS AND BODY
WRAPS TO MANICURES
AND PEDICURES, YOU CAN
CHOOSE FROM A FULL
RANGE OF TREATMENTS
AND SERVICES AND ENJOY
THEM IN ISLAND TIME.

FACE
Tropical Facial
Deep Sea Detox Facial
Anti-aging Facial
Sun-repair Facial
Lip, Eyebrow or Chin Waxing

BODY
Body Pina Colada
Bikini Island Body Prep
Seaweed Healing Cocoon
Aromatherapy Massage
Island Herbal Ritual
Pre-natal Massage

HANDS
His Manicure
Sun-repair Manicure
Island Classic Manicure
French Polish

FEET
His Pedicure
Ocean Deluxe Pedicure
Island Classic Pedicure
French Polish

COUPLES
Island Couple's Escape
Double Chocolate
 Body Sundae
Private Beach Rub and Scrub
Duo Detox Experience

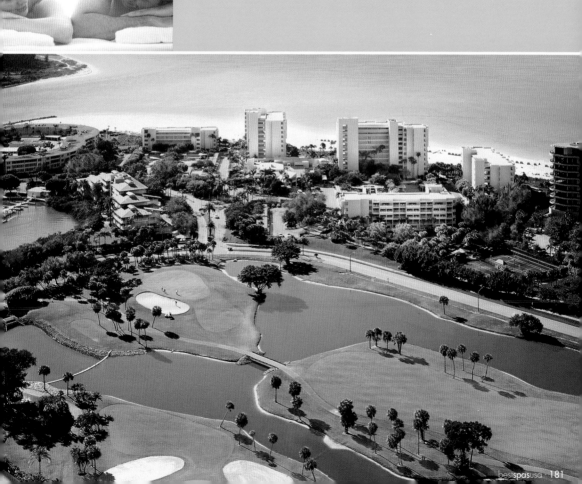

PONTE VEDRA INN & CLUB
PONTE VEDRA BEACH, FLORIDA

PONTE VEDRA INN & CLUB

200 Ponte Vedra Boulevard
Ponte Vedra Beach, Florida 32082
Phone: 800.234.7842 / 904.285.1111
www.PVRESORTS.com

TYPE
Resort Spa

ACCOMMODATIONS
The Atlantic coastline serves as dramatic
backdrop for 250 luxurious rooms and suites.
The award-winning interiors combine exquisite
furnishings, rich fabrics and classic details to
create an atmosphere of sheer indulgence.
Private patios and balconies frame
panoramic views of the sea and sky.

SPA
Ponte Vedra's spa, the largest in northeast
Florida with more than 28,000-square feet,
features 22 treatment rooms including 2
couple's suites, a magnificently-sized relaxation
room and dining area, salon, men's barber
shop, locker rooms, outdoor specialty pool
with therapy grottos and retail boutique.

A northeast Florida landmark since its
celebrated opening in 1928, the AAA
Five-Diamond rated Ponte Vedra Inn & Club
has graciously welcomed three generations
of resort guests with award-winning hospitality.
Recreational pleasures include the beach,
Atlantic surf, golf, tennis, pools, an oceanfront
gym and luxury spa. Additionally, biking,
fishing, sailing and horseback riding combine
to create a sporting paradise. For the socially
minded, three restaurants feature a variety of
imaginative themes while shopping enthusiasts
will delight in ten boutiques. Time honored
and steeped in tradition, the Ponte Vedra
Inn & Club successfully combines stylish
lodging, amenities and activities in a
warm, inviting atmosphere.

HONORED BY THE PRESTIGIOUS MOBIL TRAVEL GUIDE AS ONE OF "AMERICA'S BEST HOTEL & RESORT SPAS," PONTE VEDRA DELIGHTS GUESTS WITH AN IMPRESSIVE SELECTION OF MORE THAN ONE HUNDRED BEAUTY AND NURTURING SERVICES. THE PALETTE OF PERSONAL INDULGENCES AND SENSORY DELIGHTS ARE CERTAIN TO SOOTHE BOTH MIND AND BODY WHILE LAYERS OF TENSION AND STRESS MELT AWAY.

HERE'S A SAMPLING OF SERVICES FROM THE FAMILIAR AND THE EXOTIC.

MASSAGE

Lomi Lomi

Dual Decadence

Maternity

BODY TREATMENTS

Fiji Tropical Isle Coconut Scrub

Milk and Honey
 Rehydrating Treatment

Rose Hydrating Cocoon

AESTHETIC SERVICES

Baby Boomer Facial

DiamondTome Skin
Resurfacing Facial

Beyond Botox Facial

ENHANCEMENTS

Pumpkin Enzyme Peel

Alpha Beta Peel

NAIL TREATMENTS

Sweet Feet Pedicure

Paraffin Manicure

Pressure Point Therapy

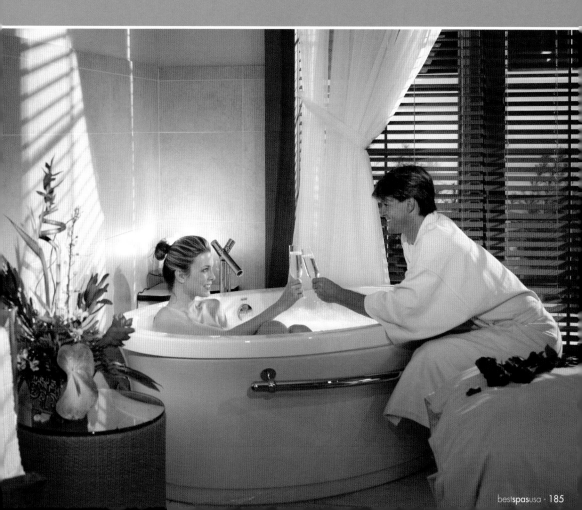

THE SPA AT THE WESTIN MAUI
LAHAINA, HAWAII

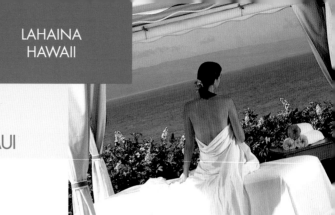

THE SPA AT THE WESTIN MAUI

2365 Kaanapali Parkway
Lahaina, Hawaii 96793
Phone: 808.661.2588
www.WESTINMAUI.com

TYPE
Resort Spa

ACCOMMODATIONS
Nestled oceanfront on Kaanapali Beach,
The Westin Maui Resort & Spa features 758
modern guest rooms and suites, all featuring
the Westin trademark Heavenly Beds and
Baths. The tropical resort boasts five swimming
pools, swim through waterfalls, a luxury spa
and award-winning dining.

SPA
A luxurious 15,000-square foot facility featuring
a relaxing oceanview lounge, 16 treatment
rooms (including two couple's massage rooms),
full-service salon (manicures, pedicures, make-
up and hair services), state-of-the-art Westin
Workout facility and opulent men and women's
changing rooms with saunas, steam rooms
and whirlpools.

Heaven and Aloha meet at the spa, a newly
appointed 13,000-square foot luxury facility
boasting sixteen treatment rooms offering the
ultimate in personalized massage, skincare and
body therapies. Perceiving the healing powers of
its indigenous resources, the spa has integrated
volcanic rock, Maui-grown lavender and island
essences into their protocols, custom tailoring
the spa's menu to provide an assemblage of
exotic indulgences. Your authentic Hawaiian
experience will begin in the oceanfront lounge
with its stunning views of neighboring islands
and continue with all the little touches meant to
put you in the mood for pampering like the subtle
scent of lavender eucalyptus in the steam room
or their Ginger Lavender Lemonade. Select a
"Heavenly Spa" signature treatment or just unwind
in the effervescent waters of a hydrotherapy
tub. Whatever your whim, you'll find the perfect
treatment for you.

FROM THE SIGNATURE "HEAVENLY SPA" TREATMENTS AND SERVICES TO THE EFFERVESCENT WATERS OF THE HYDROTHERAPY TUB AND WHIRLPOOLS, ALL THE SENSES ARE STIMULATED WITHIN THE EXTRAORDINARY SURROUNDINGS.

SIGNATURE TREATMENTS AT THE SPA

Heavenly Massage

Hawaiian Lomi Lomi Massage

Heavenly Body

Island Lavender Body Butter Treatment

Helani Tropical Indulgence

Volcanic Men's Pedicure

Caviar & Pearl Facial

Ola Body Latte with Vichy

"Pohaku" Hot Stone Massage

Heavenly Golfer's Massage

Gentlemen's Revitalizer Facial

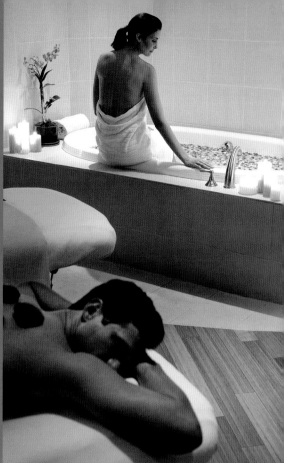

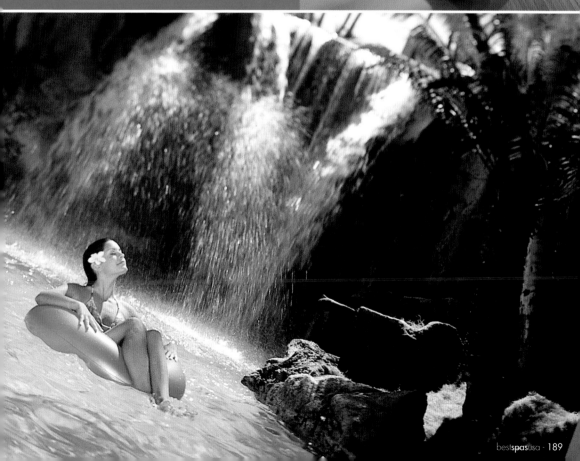

ANARA SPA GRAND HYATT KAUAI
POIPU, HAWAII

ANARA SPA
GRAND HYATT KAUAI

1571 Poipu Road
Poipu, Hawaii 96756
Phone: 808.742.1234 / 808.240.6440
www.ANARASPA.com

TYPE
Resort Spa

ACCOMMODATIONS
This award-winning luxury resort spans
50 acres of meticulously manicured grounds,
and features 602 spacious rooms and suites,
each with its own lanai. There is a unique
150-foot water slide and a saltwater lagoon.
An 18-hole golf course is adjacent to
the property.

SPA
The ANARA Spa offers a 25-yard lap pool,
separate men's and women's treatment rooms,
Jacuzzis, wet rooms for body treatments,
open-air lava rock showers, hydrotherapy tubs,
Turkish steam rooms, Finnish saunas, fitness center,
exercise area and five private, open-air treatment
hales (thatched roof Hawaiian huts), ideal for
all-day treatment experiences.

The pristine, 25-yard lap pool in the main
courtyard sets the stage for ANARA Spa.
The open-air milieu is representative of the
spa's thoughtful design and structure and
takes full advantage of nature's talent for
healing and relaxing. Every massage room
has its own private garden with open-air lava
rock showers intended to bring you even closer
to the outdoors. Innovative treatments combine
Hawaiian culture, nature's healing powers
and a therapist's nurturing touch. In a casual
but gracious setting, the ANARA Salon and
Boutique offers popular salon services as
well as body and hair care products.
The friendly, knowledgeable staff makes
you feel comfortable and at ease.

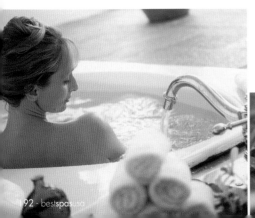

SET AGAINST A SERENE
BACKDROP OF WATER
FEATURES AND TROPICAL
FLORA AND FAUNA,
HAWAIIAN CULTURE
IS INTEGRATED WITH
THE INSCRUTABLE AND
SOOTHING POWERS
OF NATURE.

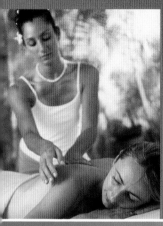

SPA MENU

Serenity Head to Toe
Aromatherapy
Sports Massage
Epicuren Enzyme Facial
Stone Facial
Essential Oil Therapies
Energy Balancing
Gentlemen's Facial
4-Handed Pohaku
 (stone) Massage
Vitamin C Facial
Honey Ginger
 Body Masque
Herbal Wrap
Eminence Deep
 Cleansing Facial

Blackberry Balm
 Hand Massage
Shiatsu Massage
Personal Training
Fitness Assessment

HAWAIIAN EXPERIENCES

Royal Hawaiian Facial
Polynesian Noni Wrap
Seaweed Body Masque
Hawaiian Salt Glo
Lomi Lomi Massage
Plush Papaya
 Polish & Massage
Hawaiian Pedicure

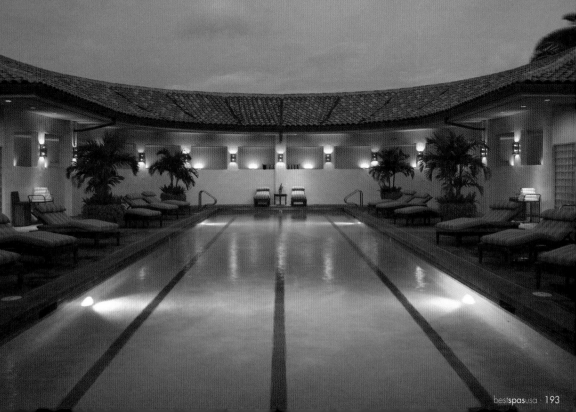

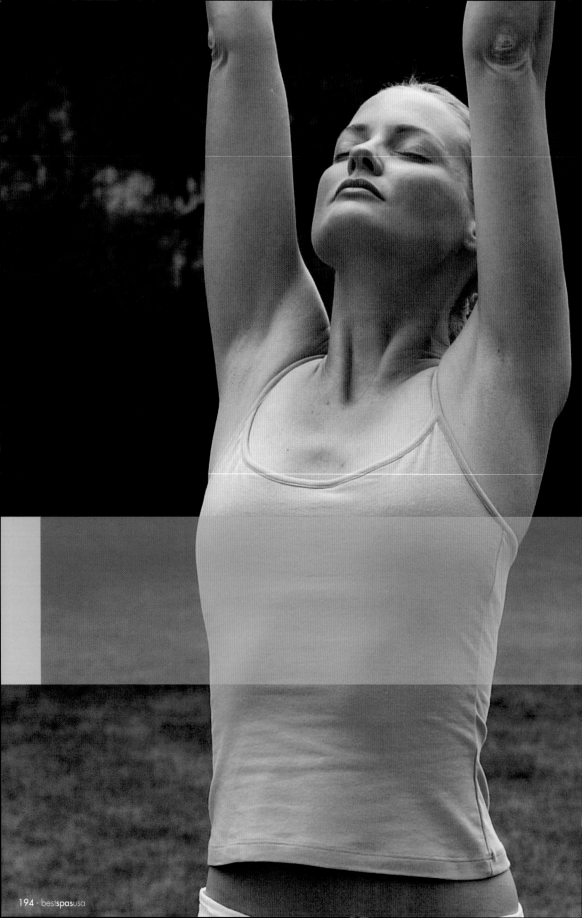

CRANWELL RESORT, SPA AND GOLF CLUB
LENOX, MASSACHUSETTS

CRANWELL RESORT, SPA AND GOLF CLUB

55 Lee Road, Route 20
Lenox, Massachusetts 01240
Phone: 800.272.6935 / 413.637.1364
www.CRANWELL.com

TYPE
Resort Spa

ACCOMMODATIONS
A combination of traditional elegance and modern comfort is the hallmark of Cranwell Resort. The 107 distinctive guest rooms, suites, cottages and townhouses are the perfect complement to Cranwell's rich history and dramatic hilltop setting in the Berkshires.

SPA
The 35,000-square foot Spa at Cranwell is a state-of-the-art facility featuring a wealth of world-class amenities and over fifty spa treatments. There are lounges with fireplaces, saunas, steam rooms and whirlpools, a comprehensive Fitness Center and a 60-foot heated indoor pool with views of the encompassing mountains.

Cranwell Resort, Spa and Golf Club is an all-season resort in the heart of the scenic and culturally rich Berkshires in Western Massachusetts. A graceful, historic Gilded Age Mansion is the centerpiece of this AAA Four Diamond resort set on 380 hilltop acres. There is a panoramic 18-hole golf course, the Golf Digest Golf School, four restaurants and one of the largest resort spas in the Northeast. Cross-country skiing and snowshoeing are available in winter. A Zagat-rated resort and member of Historic Hotels of America, Cranwell has received many awards including *Boston Magazine's* New England Travel & Life Top Resorts in Massachusetts 2006 and the "Best Restaurants in the World for Wine Lovers" award by *Wine Spectator Magazine.*

SURROUND YOURSELF WITH TRANQUILITY AT THIS SANCTUARY OF PAMPERING AND WELL-BEING. THERE ARE SIXTEEN FIRST-CLASS TREATMENT ROOMS WHERE YOU CAN INDULGE IN SPA SERVICES INCLUDING MASSAGE THERAPIES, FACIAL TREATMENTS AND HEALING WRAPS.

Authentic Aromatherapy is a European aromatherapy massage inspired by Judith Jackson. It uses pure, natural essential oils with a specific touch technique to leave you feeling peaceful and balanced.

Le Renovateur is a facial from Paris' Carita House of Beauty. An application of roasted sunflower seeds and herbs results in radiant glowing skin and erases the signs of time.

Wildflower Gommage eliminates dry skin from your body with a creamy soft beaded exfoliation. Your skin will feel smooth, your spirits uplifted.

Seaweed Experience is a warm seaweed mud mask to detoxify your system and leave your skin firm, refined and aglow.

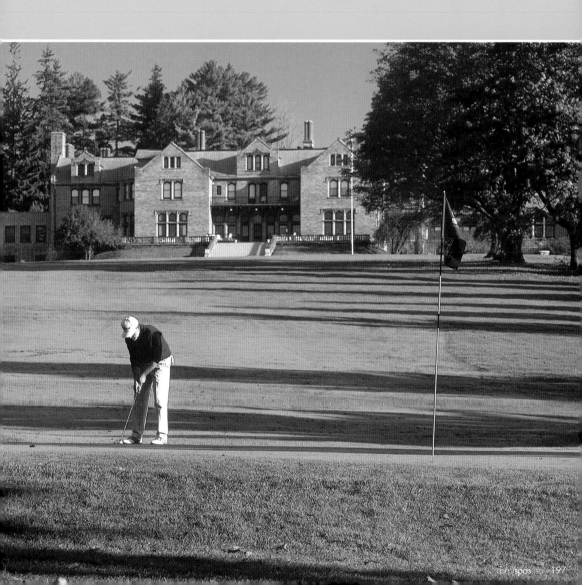

SPA CHATEAU
BRANSON, MISSOURI

SPA CHATEAU

415 North State Highway 265
Branson, Missouri 65616
Phone: 417.243.1700
www.CHATEAUONTHELAKE.com

TYPE
Resort Spa

ACCOMMODATIONS
Tucked away in the scenic Ozark Mountains, in charming Branson, Missouri, Chateau on the Lake boasts 301 beautifully appointed guest rooms. In addition to its dream-like setting, this enchanting castle features award-winning dining, indoor/outdoor pools and hot tub, a full-service marina, and the luxurious Spa Chateau.

SPA
The 14,000-square foot Spa Chateau is a place of pure indulgence. Truly an experience to savor, there are ten treatment rooms, a soothing infinity tub, outdoor Roman Bath, lake-view therapy studio for Pilates, yoga, and tai chi, and an innovative Barber Spa featuring products from Truefitt & Hill, London's "Court Hair Cutter."

Nestled in the Ozark Mountains and surrounded by the natural beauty and tranquil aura of Table Rock Lake, Chateau on the Lake is a singular resort retreat. The magnificent ten-story, sky-lit Atrium Lobby features meandering streams where colorful koi swim through cool waters, and lush foliage, exotic flowers and towering trees set the tone for an elegant and relaxing European-style getaway. The expansive Veranda extends the full length of the castle on lakeside and is the perfect place to sip a cocktail while you enjoy the breathtaking views. Unwind in the spacious Library Lounge with its great stone fireplace and cozy, comfortable seating. Known for its charm, romance, friendly staff and quaint intimacy, the Chateau is a place where individuals, couples and honeymooners alike can relax in an oasis of pleasure.

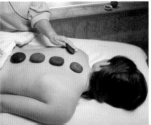

THE MOOD IS SET FROM THE MOMENT YOU WALK INTO THE SPA CHATEAU AND GLIMPSE THE DAZZLING 30' HIGH SWAROVSKI CRYSTAL WATERFALL CHANDELIER. HOLD THAT FEELING WHILE YOU CHOOSE FROM AN ARRAY OF SIGNATURE TREATMENTS THAT BLEND RICH ELEMENTS OF THE OZARKS WITH EXOTIC EUROPEAN THERAPIES.

MASSAGES
Chateau "Dogwood" Signature Massage
Grand Chateau Massage
Ozarks Couple's Crystal Massage
Mom-To-Be Massage
Fall Creek Deep Tissue or Sports Massage

BODY TREATMENTS
Chateau "Dogwood" Signature Body Treatment
White River Bathing Rituals
Rockaway Salt Scrub
Essential Slim & Tone Wrap
Muds of the World

FACIALS
Chateau "Dogwood" Signature Facial
Citrus Skin Brightening Facial
Forever Young Facial
Face & Body Transformation
In & Be-Teen Facial
Green Tea Peel

NAIL FINISHES
Chateau "Dogwood" Signature
 Manicure or Pedicure
Talking Rocks "Stone" Manicure or Pedicure
Jubilee Aroma Paraffin Treatment

SEAVIEW RESORT & SPA
GALLOWAY, NEW JERSEY

SEAVIEW RESORT & SPA

401 South New York Road
Galloway, New Jersey 08205
Phone: 800.205.6518 / 609.652.1800
www.SEAVIEWMARRIOTTRESORT.com

TYPE
Resort Spa

ACCOMMODATIONS
This world-class escape combines the classic style of a bygone era with all the amenities of today's modern world including individual room climate control, high-speed Internet connections and full cable TV programming. There are 297 guest rooms and special suites tastefully appointed with antique furnishings and fittings.

SPA
You'll get the red carpet treatment from head to toe at the Red Door Spa. The sumptuous facility has twenty treatment rooms offering every thoughtful service such as facial and body procedures, body polishes and masks, nail treatments and hair and make up services.

The Seaview Resort & Spa is the legendary jewel of the New Jersey Shore, a haven for comfort and relaxation for nearly a century. At this peaceful venue, you'll feel welcome every minute of your stay. Its world-class Elizabeth Arden Red Door Spa is an almost magical place for those who crave the ultimate indulgences. You'll sense it from the moment you step inside the welcoming environment. More than 12,000 square feet is singularly dedicated to making you look and feel your absolute best. Skilled therapists offer a complete menu of salon and spa services for both women and men. By the time you leave, you'll feel pampered and indulged, your entire body rejuvenated and relaxed, your mind and soul refreshed.

CHOOSE FROM A WIDE RANGE OF
LAVISHLY INDULGENT SERVICES INCLUDING:

Masterful hair design and make up
to complement your individual style.

Full massages and exotic body treatments.

Facial and total skincare services.

Soothing aqua and aromatherapies.

Waxes, manicures and pedicures.

Select services designed especially for men.

AND SOME VERY SPECIAL
SIGNATURE TREATMENTS SUCH AS

RED DOOR SIGNATURE FACIAL WITH PREVAGE
This is the one they're famous for. An esthetician
will study your skin and determine the best
products and techniques for your skin type.
A thorough deep cleansing and exfoliation
treatment is followed by a customized mask.
Of course, every facial ends with Prevage,
Elizabeth Arden's revolutionary antioxidant.

RED DOOR SIGNATURE MASSAGE
After a private consultation, the perfect combination
of essences, shea butter, reflexology and acupressure
will be formulated especially for you.

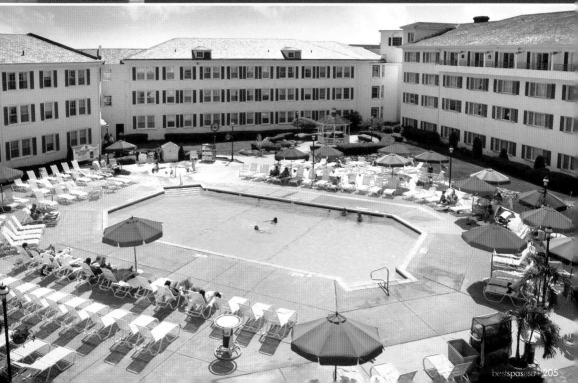

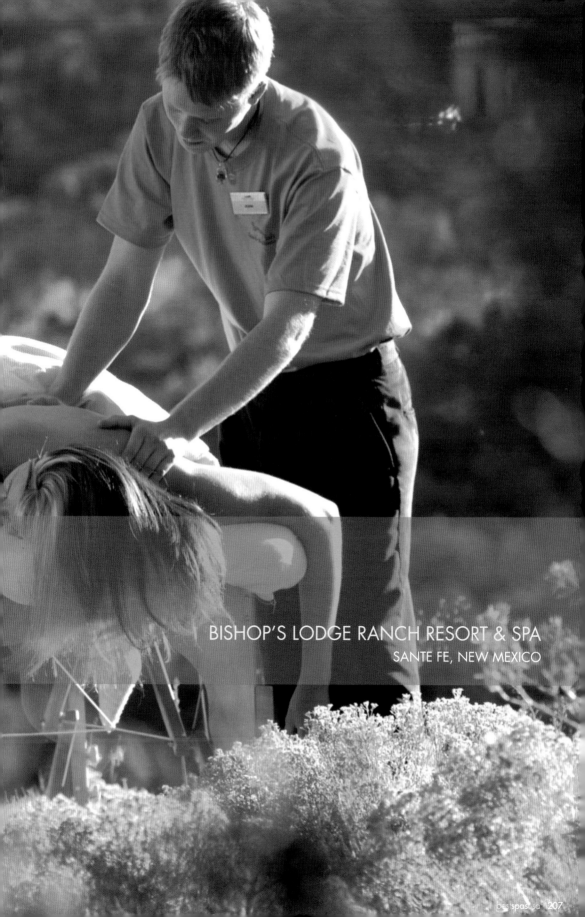

BISHOP'S LODGE RANCH RESORT & SPA
SANTE FE, NEW MEXICO

BISHOP'S LODGE
RANCH RESORT & SPA

1297 Bishop's Lodge Road
Santa Fe, New Mexico 87501
Phone: 505.983.6377 / 800.732.2240
www.BISHOPSLODGE.com

TYPE
Resort Spa

ACCOMMODATIONS
A picturesque retreat encompassing over
450 acres, the 111 room resort is just minutes
from Santa Fe. A four-season hideaway,
it offers the perfect balance of soothing luxury
and exhilarating recreation in a time-honored
setting. Outdoor enthusiasts can enjoy guided
trail rides on horseback, hiking, and skeet
and trap shooting.

SPA
Steeped in Native American traditions,
the SháNah Spa & Wellness Center provides
a sheltered mountain haven with six indoor
treatment rooms, two outdoor private treatment
areas in a succulent garden, an authentic
Native American Teepee, and Watsu pool.
Customized services include massage,
Ayurvedic and body treatments, yoga,
Pilates, aerobics, facials, nail and hair care.

Tucked in the shadows of the Sangre
de Cristos, SháNah Spa & Wellness
Center is a pristine high desert mountain
retreat where ancient pueblo healing traditions
endure. The Spa was honored with Conde Nast
Johansens' "Most Outstanding Spa" Award,
as the premier facility of its kind in North
America. In Navajo, SháNah means vitality
or energy, and at SháNah Spa, traditional
Native American customs and healing arts
blend with revitalizing modern spa treatments.
Sessions are 60 or 90 minutes and begin with
an optional blessing to set the intention and
open the heart. Each procedure is customized.
Therapists work in an environment that
enhances their healing energy, their SháNah,
and in turn nourishes and deepens the
experience for you.

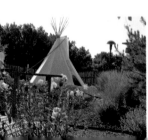

THE SPA TREATMENT MENU OFFERS A
WIDE VARIETY OF CUSTOMIZED SERVICES,
EACH CREATED TO INVOKE THE BODY'S
NATURAL HEALING RESPONSE. MASSAGES
ARE OFFERED INDOORS OR OUTDOORS,
IN A PRIVATE TENT OR PRIVATE GARDEN.
TREATMENTS ALSO INCLUDE FACIALS,
REFLEXOLOGY, CRANIAL SACRAL MASSAGE,
DEEP TISSUE MASSAGE, AND AQUASSAGE
IN A WATSU POOL. A TRADITIONAL
SWEAT LODGE IS ALSO AVAILABLE.

THE NATIVE STONE MASSAGE
Melts away tension.

THE PURIFICATION POLISH
A combination of blue corn,
mineral salts and Aloe Vera.

THE TESUQUE CLAY WRAP
Nourishes and detoxifies the skin.

THE ABIYANGA MASSAGE
Uses traditional custom-blended
aromatic oils that soothe and restore
your nervous system to harmony.

THE DESERT FUSION MASSAGE
Employs custom-blended essential oils.

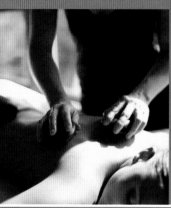

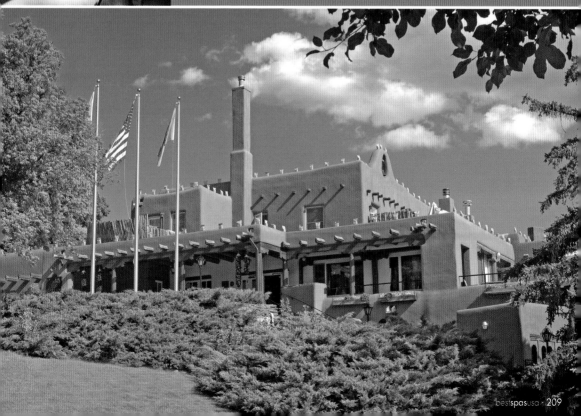

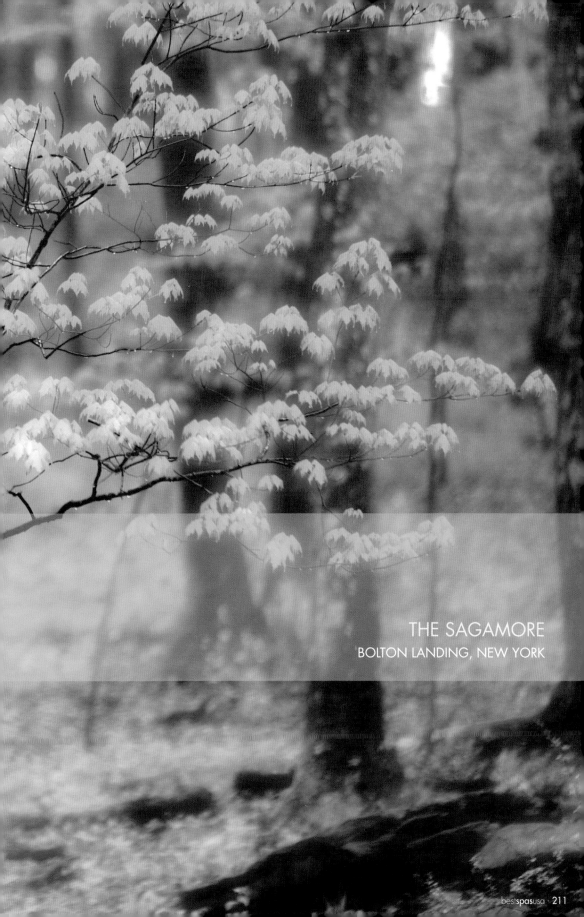

THE SAGAMORE
BOLTON LANDING, NEW YORK

THE SAGAMORE

110 Sagamore Road
Bolton Landing, New York 12814
Phone: 800.358.3585 / 518.644.9400
www.THESAGAMORE.com

TYPE
Resort Spa

ACCOMMODATIONS
Within the peacefulness of the Adirondacks,
the historic Sagamore is a private island resort
on Lake George comprised of handsome
landscaping, serene gardens and a white
sandy beach. Enjoy a choice of luxurious,
spacious accommodations in the Historic
Hotel or the Adirondack-style Lodges.

SPA
In a naturally beautiful milieu, the spa offers
treatments ranging from facials and body wraps
to Swedish Massage and Stone Therapy. The
hydrotherapy center includes steam rooms, saunas
and whirlpools. Enjoy a swim in the indoor pool
or take advantage of a complimentary exercise
class in the separate Fitness Club.

At The Sagamore, the common pressures
of everyday life give way to the welcome
pleasures of a tranquil setting amidst the
wondrous allure of Lake George. This historic
island resort combines the activities and
comforts you desire today with luxury
and service reminiscent of the past. Escape
to The Sagamore Spa and experience the
care and service of professionals attuned to
your needs, experts at nurturing your body
and revitalizing your spirit. Choose from a
slate of European-style therapies that combine
traditional rituals with natural herbs, oils
and gemstones to rejuvenate your body.
The treatments are designed to balance and
restore your inner radiance and reestablish
a sense of health and well-being.

DISTINCTIVE SIGNATURE TREATMENTS STRIVE TO ACHIEVE WELLNESS AND BALANCE BY FUSING THE HEALING TRADITIONS OF THE PAST WITH RESPECT FOR, AND IN HARMONY WITH, NATURE.

SACRED EARTH HEALING RITUAL

Based on Native American traditions of medicinal herbs, aromatic steam and massage to detoxify and purify.

ZEN HARMONY FACIAL

An ancient Japanese art form to restore beauty, health and vitality by blending traditional Japanese facial massage movements with Eastern and Western aesthetics.

DREAMTIME SIGNATURE MASSAGE

A mingling of Western, Eastern and esoteric techniques, a journey of physical, mental and spiritual awakening to unblock energy and oxygenate your spine.

ADIRONDACK HOT STONE MASSAGE

Uses heated basalt stones and essential oils to relieve tense, sore muscles and relax mind and body.

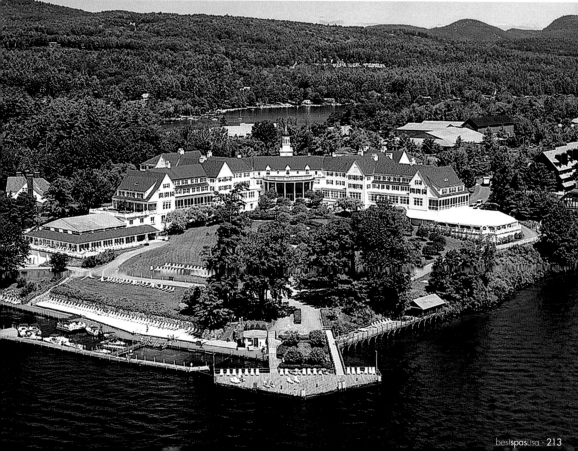

COPPERHOOD INN & SPA
SHANDAKEN, NEW YORK

COPPERHOOD INN & SPA

70-39 Route 28
Shandaken, New York 12480
Phone: 845.688.2460
www.COPPERHOOD.com

TYPE
Destination Spa

ACCOMMODATIONS
This outdoor-oriented destination spa boasts
a glorious location in the heart of thousands
of acres of Catskill State Park Wilderness
Preserve only two hours from New York City.
A small, intimate getaway, the spa has
fifteen rooms and suites, each enjoying a
balcony and magnificent views of Garfield
Mountain and the Esopus Creek.

SPA
The Copperhood Spa is comprised of seven
treatment rooms including an outdoor cabana
for riverside massages. A water therapy suite
is outfitted with a Vichy shower, hydrotherapy
tub and Scotch hose. A fitness center, sixty-foot
indoor swimming pool, sauna, Jacuzzi and
steam room round out the spa's offerings.

This subtly elegant European-style inn and spa
provides the ideal environment for rejuvenating
both body and spirit. Within this relaxing venue,
you'll rediscover the peace to be found in the
quietude of nature. Their program is inspired
by the great outdoors, and concentrates on
all aspects of your well-being. Grounded in
a philosophy that you treat yourself gently
while practicing a wholesome discipline,
you can enjoy a wide range of spa services
and sports facilities. Pamper yourself with
one of their special therapies. Unwind in
the serene yoga studio, work out in the gym,
take a dance class or do laps in the indoor
pool. Bring your hiking boots and discover
the natural beauty that is part of the experience.
Wade in a creek, relax in the sun, play tennis
or bird-watch at this comfortable mountain retreat.

COPPERHOOD SPA BELIEVES THE ESSENCE OF YOUR SPA EXPERIENCE IS BASED ON FOUR KEY ELEMENTS FOR PROPER BALANCE: EXERCISE, NUTRITION, PEACE OF MIND AND CARE OF THE BODY. THE SPA OFFERS MASSAGES, FACIALS, BODY THERAPIES, PROGRAMS AND CLASSES.

MODERN DANCE

This dance class provides a supportive environment to explore movement through a combination of different dance forms. A wide variety of music is used from the world over. The class begins with a floor warm-up and a series of movements that heighten awareness of the body. A dance phase follows, and the class closes with a meditative stretch.

LA GRAND KUR

Dead Sea salt glow with Vichy shower affusion, hydroaroma massage and botanical facial with eye contour.

EUROPEAN BODY TREATMENT

Their signature therapy blends an invigorating almond body scrub, Swedish massage and hot herbal wrap.

THE SPA AT GLENMOOR
CANTON, OHIO

THE SPA AT GLENMOOR

4191 Glenmoor Road NW
Canton, Ohio 44718
Phone: 888.456.6667 / 330.966.3524
www.GLENMOORCC.com

TYPE
Resort Spa

ACCOMMODATIONS
An historic, 1930s vintage Gothic-style building, the Glenmoor evokes the aura of an upland Scottish castle. Set on rolling green hills, this getaway features seventy-four guest rooms decorated in a variety of styles. A former seminary, the Glenmoor Country Club offers natural seclusion and tranquility.

SPA
The 20,000-square foot European spa boasts ten treatment rooms including wet rooms and couple's rooms, a full-service salon, and spa lounge where you can savor a light lunch. The fully equipped fitness center includes a cardiotheater and Cybex weight gym, racquetball, handball and squash courts and locker facilities complete with sauna, steam and whirlpool.

Set amidst a picturesque Jack Nicklaus signature golf course, The Spa at Glenmoor is a peaceful sanctuary and the perfect place to unwind, relax and escape everyday stresses. Refresh your mind and body with an array of services in an environment of luxury, privacy and comfort. Ancient and modern technologies including Reiki, Ayurveda, holistic, herbology and the latest therapies have been incorporated into body treatments to provide a complete range of European spa services. When your spa day has ended, a variety of activities await you including culinary classes and wine samplings. Come evening, opt for fine dining at The Black Heath Grill or enjoy a spectacular panoramic view of the golf course from Scot's Grill. For a casual experience, make yourself at home in the comfortable Loch Bar.

THE SPA AT GLENMOOR PROMISES
AND DELIVERS AN INDULGENT FULL-BODY
EXPERIENCE. THERAPEUTIC AND TOTALLY
RELAXING, YOUR BODY WILL BE SOOTHED,
YOUR SPIRIT RENEWED.

SIGNATURE TREATMENT

Iris Serenity begins with an Iris Body Wrap
and a shiatsu pressure point scalp massage
during resting time. It concludes with a deluxe
Iris Pedicure with Glenmoor's Signature Iris Lotion.

MASSAGE

Classic Swedish

Zen Aromatherapy

Reflexology

Hot Stone

Rose Petal Couple's Massage

Maternity Massage

Raindrop Oil Therapy

Siddha & Shirodhara

BODY TREATMENTS

Bodyology

Stimu-Lite Hip Wrap

Ultimate Detox Wrap with Green Tea

Shimmering Bodyglo & Bronze

Mud Masque Treatment

FACIALS

Guinot Hydradermie

Microdermabrasion

Golden Honey Holistic Facial

Teen Zeno Facial

Grecian Olive Oil Facial

GQ Facial

bestspasusa · 221

DEERFIELD SPA
EAST STROUDSBURG, PENNSYLVANIA

DEERFIELD SPA

650 Resica Falls Road
East Stroudsburg, Pennsylvania 18302
Phone: 800.852.4494 / 570.223.0160
www.DEERFIELDSPA.com

TYPE
Destination Spa

ACCOMMODATIONS
Cozy Victorian country home complete
with porch and patio, luxuriously accommodates
33 guests in single and double rooms with
A/C and cable TV, most with private bath.
Heated outdoor pool, gazebo–enclosed
outdoor hot tub, sport court.

SPA
Fully equipped Cybex® gym, spacious sun-filled
aerobic gym, sauna, massage and treatment
rooms, tennis, volleyball and basketball on
outdoor sport court. Pilates, yoga, aquatics,
cardio and strength training, various level hikes,
lush carpeted lounges with eclectic book
and video collections. Gourmet spa cuisine.

Deerfield has it all. Relaxed attitude and
atmosphere loosen you and yet, Deerfield is
an energized state-of-the-art destination spa
offering the vanguard in exercise philosophy
and equipment. Deerfield's renowned gourmet
cuisine is rich in flavor, texture and health
benefits, beautifully presented and satisfying.
Complete your spa vacation by treating yourself
to an incredible assortment of pampering
treatments that soothe body, mind and soul;
massages such as Nuat Thai and Lomi-Lomi will
deliver you to a whole new realm of relaxation.
Beautifying treatments such as glycolic and
microdermabrasion treatments and LumiLift®
and pulse light therapy facials leave you
positively glowing. Body, mind and soul are
tended to at this congenial spa nestled on
11 acres in the scenic Pocono Mountains.

CALORIE FREE, THIS SAMPLING OF
PAMPERING SPA TREATMENTS IS THE
PERFECT ACCOMPANIMENT TO A DAY
OF HEALTHY LIVING: CRISP COUNTRY AIR,
EXERCISE, GOOD NUTRITION AND THE
COMPANY OF FRIENDS:

SPA MENU

Anti-Aging Multi-Vitamin Anti-Oxidants Facial

LumiLift® and LumiFacial®

Intensive Glycolic Peel Facial

Detoxifying Seaweed Body Masque

Body Contouring
 with P.R. Cell / Anti-Cellulite Treatment

Micro-Dermabrasion Body Treatment

Aromatic Body Polish

Reflexology

Craniosacral Therapy

Sports Massage

Neuromuscular Massage

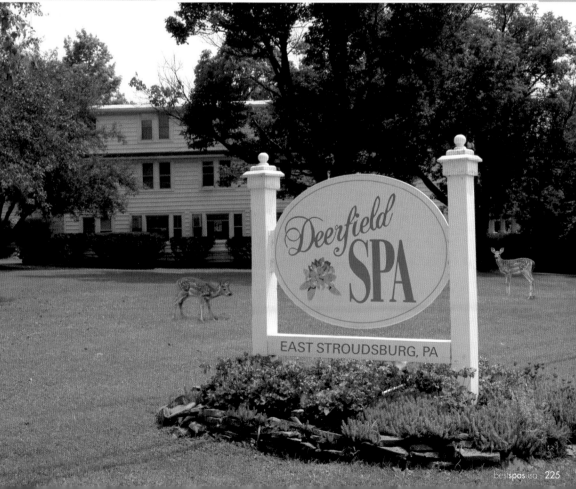

HOTEL VIKING
NEWPORT, RHODE ISLAND

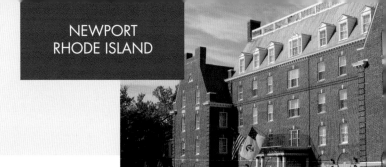

HOTEL VIKING

One Bellevue Avenue
Newport, Rhode Island 02840
Phone: 800.556.7126 / 401.847.3300
www.HOTELVIKING.com

TYPE
Hotel Spa

ACCOMMODATIONS
Experience the luxury and refinement of old New England at the Hotel Viking, an elegant lodging landmark in Newport's Historic Hill neighborhood. Built in 1926, the hotel is recognized among the prestigious Historic Hotels of America. Classic Georgian and Queen Anne furnishings create a graceful ambience throughout the hotel.

SPA
A Newport refuge, SpaTerre offers global cross cultural experiences and rituals from Indonesia, Thailand, India and Fiji. A blend of ancient spa traditions once reserved for royalty creates a feeling of utter relaxation. The healing properties of flowers and spices are used liberally to enhance each spa experience.

The Hotel Viking combines timeless beauty, classic tradition and the excitement of a traditional New England seacoast town. A distinguished red brick building, the Hotel Viking sits atop Newport's Historic Hill on fashionable Bellevue Avenue, a place where New England hospitality meets the grace and refinement of a European country manor. Imbued with character and the attentive service of a boutique hotel, there are 209 guest rooms and suites featuring classic Queen Anne and Chippendale-style furnishings. Partake of fine dining at One Bellevue or plan a vigorous workout in their fitness center. Of course, there's always the lure of SpaTerre, your personal refuge for relaxation and renewal.

EAST MEETS WEST IN THE LUXURIOUS SPATERRE, AN OASIS OF TRANQUILITY AND SPIRITUAL AWARENESS.

Indulge in a Thai treatment. Consider the Kelapa Ritual, a tropical experience of aromatic coconut, rice and vetiver skin scrub applied to the body. This therapy includes a foot massage, a soak in a Japanese tub with fresh flower blossoms and lemongrass essences and concludes with a traditional Thai massage. Or consider the Gentlemen's Indulgence, a European facial specifically designed to soothe skin irritated by daily shaving and environmental factors.

Enjoy private time with your partner in the couple's massage room, a perfect setting for two. Choose from a selection of massage rituals and experiences or select a Newport-inspired modality like the Atlantic Seaweed

Body Wrap, a blend from the sea used for beautification and therapeutic purposes. Relax and luxuriate while your skin detoxifies, re-mineralizes and hydrates from a rich array of vitamins and ointments.

THE WATERLEAF SPA AT SKAMANIA LODGE
STEVENSON, WASHINGTON

THE WATERLEAF SPA AT SKAMANIA LODGE

1131 SW Skamania Lodge Way
Stevenson, Washington 98648
Phone: 800.221.7117 / 509.427.2529
www.SKAMANIA.com

TYPE
Resort Spa

ACCOMMODATIONS
Skamania Lodge is a tranquil all-season destination resort encompassed by 175 wooded acres in the spectacular Columbia River Gorge National Scenic Area. The 254 tastefully appointed guest rooms are complemented by original artwork and each boasts a forest or river view.

SPA
Enhanced by its picturesque setting, The Waterleaf Spa is a perfect getaway. It features nine treatment rooms and offers a complete selection of indulgences from traditional to exotic. An indoor swimming pool, outdoor and indoor whirlpools, dry saunas and a state-of-the-art fitness center complete the assemblage.

A renowned Northwest destination only forty-five minutes from Portland, Oregon, this Cascadian-style lodge is characterized by high-pitched roofs, interesting use of timbers, wood paneling and native stone. Black wrought iron was used for artistic highlights and the custom-designed Mission-style furnishings evoke the great lodges of the early 1900s. Continuing the architectural spirit of that period, Montana slate was used for the lobby floor and complements the rock of the beautiful 85-foot tall fireplace. Original local artwork, ceramics and petroglyph rubbings depicting local Native American history handsomely adorn the lodge. The resort also features award-winning dining and an 18-hole golf course. A haven for naturalists, the lodge's Columbia River Gorge locale is laced with dozens of pine-scented hiking trails and waterfalls including the famous Multnomah Falls, the fifth highest in the United States.

AFTER A VIGOROUS DAY OF HIKING OR A
CHALLENGING GAME OF GOLF, THERE'S NO
BETTER PLACE TO EXPERIENCE A PAMPERING
TREATMENT THAN THE WATERLEAF SPA.

REJUVENATING MUD WRAP

Using exquisite clay, indigenous to Australia,
this wrap combines a powerful blend of mud
with essential oils and rich fatty acids. You'll be
covered in velvety warm aromatic clay and gently
cocooned in natural cloth followed by a tangerine
and rose massage.

BODY ROCK MASSAGE

This relaxing massage employs heated
rocks throughout the procedure to warm
and loosen tense muscles. The smooth hot
stones are incorporated with a Swedish
massage to melt tension, ease stress
and soothe body soreness.

PARAFFIN HAND TREATMENT

A simply luxurious moisturizing and uplifting
hand therapy, the treatment promotes a
satin-like skin texture.

SUN MOUNTAIN LODGE
WINTHROP, WASHINGTON

SUN MOUNTAIN LODGE

604 Patterson Lake Road
Winthrop, Washington 98862
Phone: 800.572.0493 / 509.996.2211
www.SUNMOUNTAINLODGE.com

TYPE

Resort Spa

ACCOMMODATIONS

Set on 3,000 acres, Sun Mountain Lodge
features an inviting combination of privacy,
tranquility and serenity. There are 96
mountaintop guest rooms and 16 lakeside
cabins, each possessing wondrous views.
Furnishings reflect the rustic quality of the
location and include handmade maple
and cherry furniture and original artwork.

SPA

The spa mirrors the very essence of its
surroundings and is imbued with the same
relaxed, casual atmosphere as the lodge. Set
your own pace and shape the day to suit your
personal preferences. Choose from a collection
of tempting choices including a couple's package
bound to make you feel special and pampered.

Sun Mountain Lodge, an AAA Four Diamond-
award winning resort is the ultimate four-season
destination vacation. Inspired by its magnificent
natural milieu and colorful history and culture,
the beautiful setting imparts a sense of harmony.
The main lodge and its guest accommodations
seem to have been hewn from the mountain
itself with huge beams, wood ceilings and walls,
a split-log bar, carved mantels and massive
stone fireplaces. Peak experiences, open skies
and 3,000 private acres of pristine wilderness
encompass the lodge and heighten the drama of
your stay. In addition to its welcoming spa, this
all-season mountain resort offers endless activities
including mountain biking, cross country and
helicopter skiing, fishing, boating, nearby golf
and more. Whether you long to quietly remove
yourself from the stresses of every day life or
you're seeking an abundance of outdoor pursuits,
you'll find it all at this rustic getaway.

THE WARM AND HEALING SPA IS THE PERFECT PLACE TO UNWIND. THE FULL-SERVICE SPA AND SALON FEATURES A VARIETY OF WELLNESS PROTOCOLS INCLUDING MASSAGES, SKIN TREATMENTS AND HAIR AND NAIL SERVICES.

If you're into mountaintops and vistas, consider the High Country Hydroptimale Facial. The eight-step procedure treats your face with creams, serums, oils and a seaweed soft clay mask.

If you've spent the morning hiking, try the Hot River Rock Massage and experience the gentle pressure applied with soothing hot rocks that penetrate to relieve tense muscles and sore joints.

Or start your day with a clean slate and try the Sea Salt Deep Cleansing Body Polish. After a brisk exfoliation, an invigorating body scrub is applied using sea salts and essential oils. It's finished with a mountain mist and moisturizing body milk.

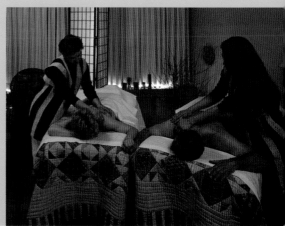

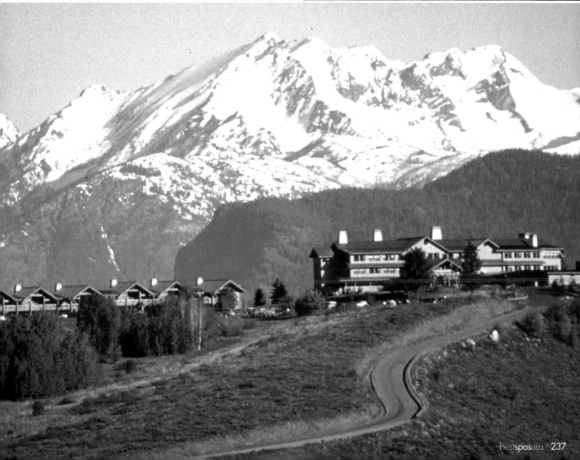

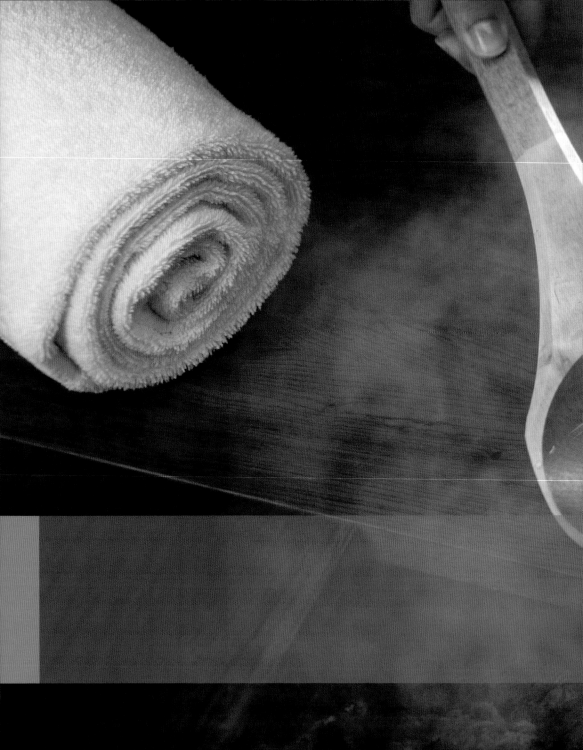

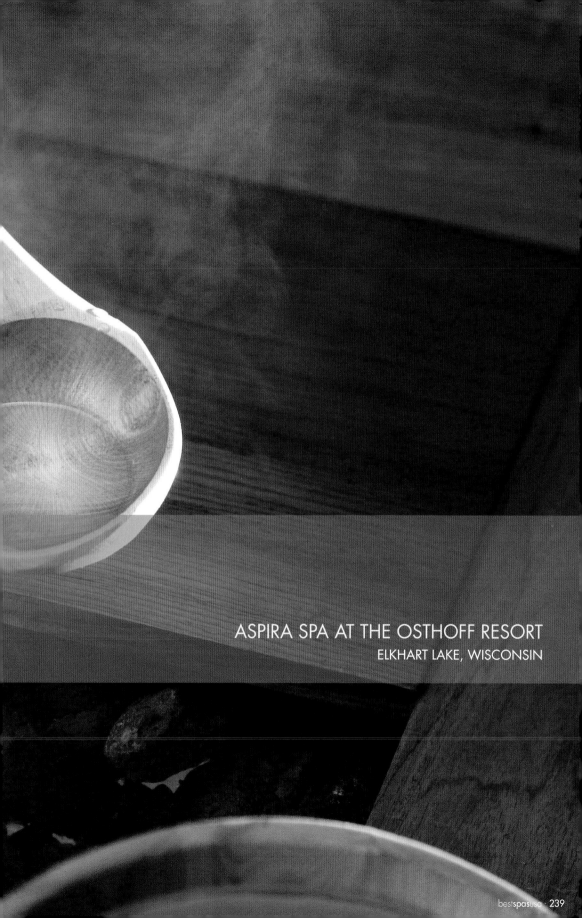

ASPIRA SPA AT THE OSTHOFF RESORT
ELKHART LAKE, WISCONSIN

ASPIRA SPA AT
THE OSTHOFF RESORT

101 Osthoff Avenue
Elkhart Lake, Wisconsin 53020
Phone: 877.772.2070 / 920.876.5843
www.ASPIRASPA.com

TYPE
Resort Spa

ACCOMMODATIONS
Aspira Spa at The Osthoff Resort is located
along the shores of pristine Elkhart Lake.
The resort offers 245 spacious suites and guest
rooms, two lakeside restaurants, Aspira Spa,
salon, indoor and outdoor pools, saunas,
whirlpools, fitness center and tennis court.

SPA
The 20,000-square foot spa features 22
treatment rooms, meditation sanctuary, yoga
room, whirlpool lounge, Finnish sauna, learning
center, spa café, outdoor whirlpool, full-service
salon and spa boutique. Appointed with master
shower, whirlpool bath, stone fireplace and
accommodating up to three massage beds,
SpaSuites™ provide a place of retreat where
couples can experience Aspira together.

Surrounded by the natural beauty and energy
of pristine Elkhart Lake, once considered
sacred by the Native Americans who lived on
its shores, Aspira Spa™ emerged as one of
the Midwest's premier resort spas. It was here
that Aspira, meaning "infused with spirit,"
was borne as a place to take one's journey
– a place to move forward in nature and
peace. Aspira's holistic approach to the spa
experience embodies the teachings of feng shui
and the relationship between the five elements
of wood, fire, earth, metal and water. Through
these elements, their treatment philosophy
brings balance, peace and harmony.

ASPIRA SPA OFFERS SPECIALIZED
TREATMENTS EMBRACING THE ANCIENT
HEALING WISDOM OF INDIGENOUS
PEOPLES FROM THE WORLD OVER.

SPA MENU
Sacred Waters Massage
Crystal Chakra Balancing Massage
Aspira Chroma Facial
Violet Clay Envelopment

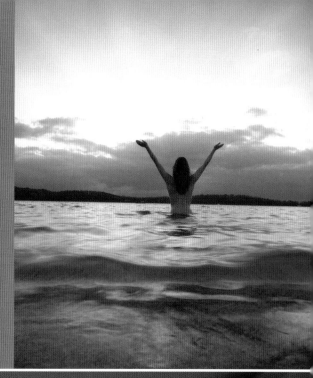

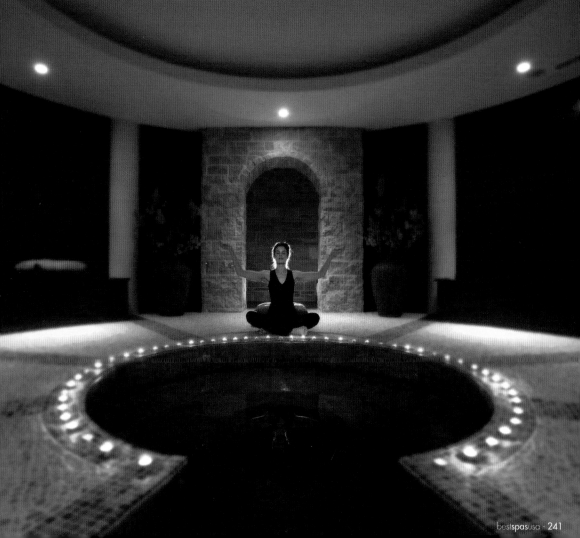

TETON MOUNTAIN LODGE
TETON VILLAGE, WYOMING

TETON MOUNTAIN LODGE

3385 West Village Drive
Teton Village, Wyoming 83025
Phone: 800.801.6615
www.TETONLODGE.com

TYPE
Hotel Spa

ACCOMMODATIONS
Every detail of this intimate mountain retreat has been designed to create a gracious "home-away-from-home" experience. Choose from 129 lodge rooms and suites with inviting rustic styling blended with a host of luxury services and amenities. Expect stone fireplaces, tasteful lighting, hardwood floors, classic millwork and sumptuous baths.

SPA
Escape to luxury and relaxation amidst the peaceful Teton Mountains. The Mountain Lodge Spa is a "green" spa embracing the philosophy that harmony begins within. The spa nurtures the inner self while providing the highest quality treatments. Examples of their "green" efforts are exemplified by the natural focus of their interior design as well as the use of organic and local skincare products.

A true Wyoming welcome awaits you at Teton Mountain Lodge, a full-service hotel and spa located slope-side at the Jackson Hole Mountain Resort, less than a mile from the breathtaking wilderness of Grand Teton National Park. This milieu combines blissful outdoor venues with fine accommodations and an alluring, earth-friendly spa environment where you can indulge yourself in a wonderful array of treatments and fitness classes. The lodge's spectacular setting is perfect for naturalists and offers the entire spectrum of winter and summer activities including ski-in convenience just steps from the gondola. Take advantage of the lodge's locale and enjoy open-air pursuits such as hiking, wildlife watching, river rafting, fly-fishing, cycling, climbing, horseback riding or just long walks in a picturesque backdrop.

BEGINNING IN THE SUMMER OF 2007, THE 16,000-SQUARE FOOT SPA WILL FEATURE TEN TREATMENT ROOMS INCLUDING A VICHY SHOWER, TWO COUPLE'S ROOMS EACH WITH A FIREPLACE, WHIRLPOOL AND DECK, INDOOR AND OUTDOOR POOLS, MEN'S AND WOMEN'S STEAM ROOMS, ROOF-TOP HOT TUBS WITH VIEWS OF THE TETON RANGE AND A MOTION STUDIO FOR YOGA, PILATES AND FITNESS CLASSES.

PAMPERING THERAPIES INCLUDE:

THE FACIAL REJUVENATION ACUPUNCTURE
Restores the skin of the face, improves circulation, muscle tone and stimulates collagen formation.

TRAVELER'S RECOVERY TREATMENT
This uses Jurlique's Travel Blend essential oil especially designed to alleviate unnatural stress on the body and psyche due to prolonged traveling. The Aromatic Hydrating Concentrate relaxes, hydrates and prepares the skin for deep cleansing. A Tee Tree Body Exfoliating Mask cleanses with anti-oxidants, gathers damage causing free radicals and feeds the skin with vital nutrients.

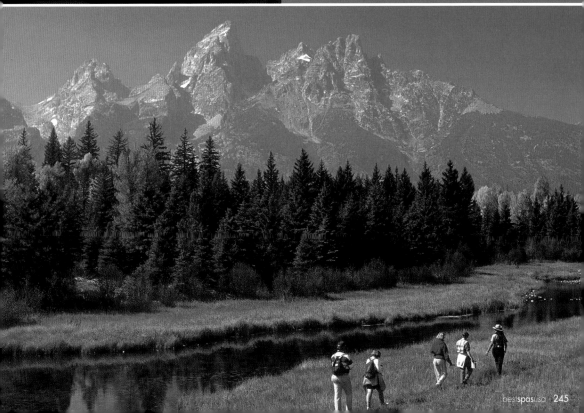

SPA GLOSSARY

ACCUPRESSURE
Finger massage designed to release muscle tension and promote healing by applying pressure to "energy points" or "meridians" in the body. The pressure applied to these vital points (the same points used in acupuncture) was identified by medical practitioners in China centuries ago and is believed to improve the flow of energy (chi) throughout the body. Similar in many ways to Shiatsu.

ACUPUNCTURE
An ancient oriental healing technique discovered and developed more than three thousand years ago, acupuncture is based on Taoist philosophy. The aim is to balance the energy meridians to permit the body to "heal itself. A relatively painless technique, it is administered by inserting fine needles at key points of the body that relate to different organs in order to relieve muscular, neurological and arthritic problems, cure disease and relieve pain (as in surgery). Alternative related techniques include the use of low voltage electric current (electro acupuncture), or pinpoint massage (acupressure) to those key body points.

AEROBICS
Series of rhythmic exercises, set to music, used to stimulate the aerobic capacity of heart and lungs, burn fat, and improve endurance. These movements are fully supported by oxygen delivered to the working muscles by the blood circulation. Examples of aerobic activity include walking, ballroom dancing, and steady, slow jogging. In contrast to aerobic activity, anaerobic exercise involves muscular work that is not fully supported by the oxygen available from the circulating blood. Activities like weight lifting, bodybuilding, and sprinting (100-yard dash) have a large anaerobic component. (See also Low-impact aerobics)

AFFIRMATION
Similar to visualization, this technique is used to overcome physical ailments (e.g. backaches) and emotional problems (e.g., family or professional problems) through repetition of a positive statement. For example, a person who is afraid of flying would repeat, "I like to fly" and envision a pleasant flying experience.

ALEXANDER TECHNIQUE
Most people stand and move in imbalanced ways that result in a multitude of physical problems, such as backaches. The Alexander Technique is a massage system created in the 1890s by the Australian actor F. M. Alexander to correct those physical habits that cause stress. This technique teaches how to move with greater ease and coordination by focusing on correct posture, the right way to lift objects, the proper position of feet when standing, the angle of one's shoulders and so forth.

ALGOTHERAPY
Seaweed bath. See Thalassotherapy

ALTERNATIVE THERAPIES
Treatments based on speculative or abstract reasoning. Such treatments include: Acupuncture, Aromatherapy, Ayurveda Treatment, Cathiodermie, Colonic, Cranio-sacral Therapy, Electro Therapy, Energy Balancing, Fango, Flotation, Gerovital, Gommages, Homeopathy, Light Treatment, Lymph Drainage, Mud Therapies, Music Therapy, Panchakarma, Phytotherapy, Primordial Sound, Reiki, Spinal Release Therapy and Ultrasound.

ANAEROBIC
Involves exercise and muscular work that is not fully supported by blood circulation and delivery of oxygen to the working muscles. Weight lifting and bodybuilding are examples of anaerobic exercise. The opposite of aerobic exercise.

APPLIED KINESIOLOGY
The study of muscles, especially the mechanics of human motion.

AQUA AEROBICS (AQUAEROBICS)
Aerobics workouts performed in a swimming pool. Water resistance is utilized to stretch, strengthen and increase stamina. This activity is also commonly known as aquacize.

AQUACISE (AQUACIZE)
Aerobics workouts performed in a swimming pool. Water resistance is utilized to stretch, strengthen and increase stamina. This activity is also commonly known as aqua aerobics.

AROMATHERAPY
An ancient healing art dating back to 4500 B. C., Aromatherapy usually refers to treatments such as massage, facials, body wraps or hydro baths with the application of essential oils from plants, leaves, bark, roots, seeds, resins and flowers. These oils are used to treat emotional disorders, organ dysfunction, and skin problems through a variety of internal and external application techniques. Plants and flowers from which these oils are extracted include rosemary, lavender, roses, chamomile, eucalyptus and pine.

ASANAS
Yoga postures

ASLAN THERAPY (ASLAVITAL)
The use of either Gerovital H3 or Aslavital drugs, both developed by Dr. Ana Aslan of Romania. Both are used for their regenerative effect in fighting the aging process.

ATHLETIC MASSAGE
A very deep penetrating massage that concentrates on all muscle groups, but is particularly focused on muscles primarily used in a person's chosen sports activities. See Sports Massage.

ATTITUDINAL HEALING
A concept based on the belief that it is possible to choose peace rather than conflict, love rather than fear.

ATTUNEMENT
To bring the whole person into harmony.

AYURVEDIC
An ancient system of traditional folk medicine from India that employs a large variety of techniques to restore the organism to perfect balance. These techniques incorporate nutrition, herbal medicine, aromatherapy, massage and meditation.

BACH FLOWER CURES
The use of flowers as a means of healing.

BALNEOTHERAPY
A generic term for mineral water treatments, balneotherapy is the traditional practice of treatments by waters, using hot springs, mineral, or sea waters to restore and revitalize the body. Since antiquity, balneotherapy has been used to improve circulation, fortify the immune system, as an analgesic (pain reliever) and as an anti-stress treatment.

BATHS (FOOT, ARM, SITZ, FULL, HALF, PARTIAL)
The act of soaking or cleansing the body, as in water or steam. The water used for cleansing the body. A building equipped for bathing. A resort providing therapeutic baths; a spa.

BEHAVIOR MODIFICATION
Change in personal habits (e.g., bad eating patterns, smoking and other substance abuse) brought about through counseling and psychological conditioning that includes careful repetition of the desired behaviors. Most spas incorporate behavior modification into their weight loss program. Rather than prescribing a special diet, the behavior modification approach teaches people how to change lifelong eating habits so they can still enjoy all types of food, within reason.

BEHAVIORAL MEDICINE
The application of behavior therapy techniques, such as biofeedback, relaxation training, and hypnosis, to the prevention and treatment of medical and psychosomatic disorders and to the treatment of undesirable behaviors, such as overeating and substance abuse.

BINDI
Bodywork combining exfoliation, herbal treatment, and light massage.

BIOFEEDBACK
A technique by which one can learn conscious control of biological processes by means of monitoring one's physical responses. This is usually accomplished by placing an electronic sensing device on the skin to measure changes in skin surface temperature and chemistry that, in turn, reflect internal physical changes. Through this method one can learn to control physical functions formerly thought to be involuntary, such as blood pressure, pulse rate, digestion and deep muscle tension. Many people who suffer from headaches, chronic pains and migraines can use this feedback technique to reduce their dependency on drugs.

BODY & BEAUTY TREATMENTS
Various treatments provided by day and destination spas to enhance beauty and overall well-being. Beauty and cosmetic treatments include: beauty salon, facials, image consultation, makeovers, manicure/pedicure, and waxing. Body treatments include massage, cellulite treatments, herbal wrap, salt glow and seaweed wrap and various forms of hydrotherapy, including steam and saunas.

BODY ALIGNMENT
Developed from the system of Rolfing and includes an in-depth structural analysis and strengthening and flexibility exercise program.

BODY COMPOSITION (TEST)
Method of measuring the ratio of body fat against lean muscle mass. Using standard weight charts; a computerized system compares personal data with standard percentages to determine whether an individual is overweight. This test (usually part of an overall fitness analysis) determines the percentage of body fat by using a skin-fold caliper (measuring instrument) that gently pinches the skin below the underarm. Used to develop a realistic weight loss goal and create a nutrition and exercise program suited to individual requirements.

BODY CONTOUR
Body contour exercises work on specific parts of the body, such as the abdomen, buttocks, hips and thighs to promote toning, increased flexibility and mobility.

BODY IMAGE
An individual's perception of his or her own body in such terms as size, shape, thinness, fatness, and degree of attractiveness.

BODY MASS INDEX (BMI)
A measure of body weight adjusted for height.

SPA GLOSSARY

BODY SCRUB (also see Exfoliation)
Body Scrubs/Skin Care, which include Brush & Tone,
Dulse scrub, loofah scrub, paraffin treatment, repaichage
and Vichy shower.

BODY SUGARING
Hair-removal process said to date from the time of Cleopatra.

BODY TUNING
Stretching and muscle firming exercises.

BODY WORK - DOMAIN IV
This refers to all forms of therapeutic touch
such as massage that retrain the body's
posture and movements for optimal functioning.

BODY WRAP
Strips of cloth soaked in herbal teas and cocooned
around the body. Also called herbal wrap.

BREEMA BODYWORK
Originated in the mountains of Kurdistan. Practitioners of this
method view the body as an energy system, although its
meridians are not the same as those identified in the healing
arts of China. Breema practitioners regard the body as a
self-healing organism. Breema work is designed to create or
recreate the natural balance and harmony that governs our
mental, emotional and physical energies. The larger aim of
Breema is to teach through experience the possibility of living
with the full participation of body, mind and feelings.

BRINE (SALT WATER) BATHS
Water saturated with or containing large amounts of a salt,
especially of sodium chloride. The water of a sea or an ocean.

BROSSAGE
A fine body polish done with a series of brushes and salicylic
salt. Used to create a fine texture of the skin's surface.

BRUSH AND TONE
Dry brushing of the skin, intended to remove dead layers
and impurities while stimulating circulation. This is one of
many exfoliation techniques used as a pre-treatment for
mud and seaweed body masks. The body is brushed in
invigorating, circular motions to remove dead skin,
followed by the application of moisturizing lotion that
leaves the skin silky smooth, alive, and glowing.

CALIPER (TEST)
A device to measure skin fold,
determining the percent of fat in the body.

CARDIOVASCULAR ENDURANCE TESTING
Cardiovascular endurance is the ability of the heart (muscles)
and blood vessels to meet the demands of physical exertion.
Fitness is relative; one must always ask "Fit for what?' Someone
who is fit to play tennis may not be fit for cross-country skiing or
mountain climbing. Thus, different levels of fitness are achieved
by different kinds of physical training. Cardiovascular fitness
can be determined with considerable precision in the laboratory
by the use of one or more tests of "maximal aerobic power."
Maximal aerobic power (Vo2max) is the highest oxygen uptake
a given individual can achieve while performing a standardized
exercise, like running on a motorized treadmill. The degree of
testing and training varies widely from spa to spa. The maximum
stress test with electrocardiogram evaluation is performed on
a treadmill to detect the possible presence of heart disease,
determine the heart's capacity to pump and help provide
guidelines for an exercise program. Sometimes body composition
and vital capacity also are tested. Training and testing equipment
includes Lifecycles, rowing ergometers, Versa Climbers, Stair
Masters, stationary bikes, Nordic trainer and Quinton treadmills.

CATHIODERMIE
A rejuvenating treatment for the skin using electric stimulation in a
low voltage dose. An electric machine is employed, using both
galvanic and high-frequency currents that are claimed to deep-
cleanse and revitalize your skin and oxygenate its outer tissue layer.

CELLULAR THERAPY
Injections with concentrated live tissue, derived from fetal lamb.
Used to reverse the aging process. This treatment is not approved
by the FDA and is not available in the US. Also known as live
cell therapy or fresh cell therapy, treatment includes injection by
an intromuscular route of fresh embryonic animal cells, typically
from sheep or cows, suspended in a physiological serum, or
frozen, freeze-dried (lyophilized) cells from ampoules. Used for
total body revitalization, to maintain or return the body to its state
of healthy equilibrium and prevent premature aging. Developed
in the early 1930s by Paul Niehan MD, a Swiss physician, it
became popular with wealthy individuals and celebrities as a
means of reversing the aging process. Wolfram Kuhnau MD,
a colleague of Neihans, introduced the treatment in Tijuana,
Mexico in the late 1970s as a cancer treatment. It is claimed
to help build the immune system. In 1985 the FDA banned
importation into the USA of all cellular powders and extracts
intended for injection. In 1987 the Health Office of Germany
suspended the product licenses of live-cell preparations.

CELLULITE
A nonscientific term used to describe peddly or uneven surface
of the skin of the hips, thighs, or buttocks of women. Caused by
the sagging or breaking down of the quilt-like strands of collagen
which attach the skin to underlying structures and is associated
with increased deposits of fat in those areas.

MEMBER

CEREMONY
A formal act or set of acts as prescribed by ritual, custom
or etiquette. Comes from the Latin word meaning sacredness.

CHAKRA
Refers to the seven energy centers on your body.
Taken from the Sanskrit word meaning, "wheel."

CHRONOBIOLOGY
The study of biological rhythms.

CIRCUIT (WEIGHT WORK) TRAINING
The blending of aerobics and high-energy workout with weight-
resistance equipment such as that produced by Nautilus, Klesser,
or Universal. On a circuit, you put yourself through a series of
training stations, stopping only briefly before each exercise to keep
your heart rate within an acceptable range throughout the circuit.

COGNITIVE TRAINING
In weight control programs, the replacing of negative
or defeatist thinking with positive attitudes to help
those trying to lose weight to stick to their program.

COLD PLUNGE
Deep pool for the rapid contraction of the capillaries,
intended to stimulate circulation after sauna.

COLLAGEN
The main organic constituent in animal connective tissue,
produced in gelatin form by boiling. An important ingredient
in many natural cosmetics.

COLONIC IRRIGATION
An intense water irrigation (enema) of the entire
colon, intended to cleanse out trapped impurities,
preventing the recycling of toxins into the blood stream.

COLOR ANALYSIS
Think you look good in blue? A color analysis may prove
otherwise. Each season of the year represents a group of colors
that are flattering to certain skin tones. To determine whether you're
a spring, summer, fall or winter color type, swatches of fabric from
each season are held next to your face. The analysis, based on
the colors that are most becoming to you, then gives you guidelines
for choosing wardrobe and makeup colors.

COLOR HEALING
Based on the law of attraction wherein the vibration
of the color attracts a similar vibration in the human body.
Dates back to ancient Egypt and other pre-modern societies.

CONTOUR
Physical training for deep toning of specific muscle groups.

COOL-DOWN EXERCISES
Movements at the conclusion of your exercise session to
give your body a chance to ease out of the routine while
your pulse rate returns to normal.

CRANIO-SACRAL THERAPY
Gentle massage centering on the head.

CREATIVE MOVEMENT
This includes dance, aerobic and stretch exercises
designed to improve your coordination and mobility.

CREATIVE VISUALIZATION
An effective process of creating what we want in our lives.
The art of using mental energy to transform and greatly
improve health, beauty, prosperity, loving relationships,
and the fulfillment of all one's desires. This relaxation technique
is similar to hypnosis except you remain conscious. It is usually
done with a group of people lying in a quiet, dark room. In a
soft, even-toned voice, an instructor asks the group to imagine
themselves in a serene, relaxing environment, such as a beautiful
sand beach or peaceful meadow. By describing things like
the color of the sky or the smell or wildflowers, the instructor
creates a soothing fantasy environment. About half of the group
falls asleep; the other half goes into a state of deep relaxation.
Visualization is also used to treat phobias by having people
imagine successfully doing whatever it is they fear.

CRENOTHERAPY (CROUNOTHERAPY)
All types of treatment carried out with mineral water,
mud and vapor.

CROSS TRAINING
Alternating high-stress and low-stress exercise or
sports to enhance physical and mental conditioning.

CRYOTHERAPY (TREATMENT)
A therapy using a "wand" of frozen products which produce
a vasoconstricting effect on skin tissue and muscle mass
thereby creating a "lifting" of the areas to be treated.

CRYSTAL HEALING
Healing energy believed to be generated by quartz and other
minerals. Crystals are known to have electromagnetic energy,
as does the human body. When a natural quartz crystal
is brought into contact with a person's etheric body, the
electromagnetic attraction is capable of drawing imbalanced
energy out of the human body.

CYBEX
Patented equipment for isokinetic strength evaluating and testing.

SPA GLOSSARY

DANCE THERAPY
Combining self-knowledge and personal analysis with
studies in psychotherapy, dance has been rediscovered
as a healing art.

DANCERCISE (DANCERCIZE)
Aerobic workout using steps and patterns
of movement derived from modern dance.

DAVID SYSTEM
Pneumatic weight training units in which air is pumped.
See Circuit training.

DEAD SEA MUD TREATMENT
Applications of mineral-rich mud from the Dead Sea
in Israel. Used to detoxify skin and body; also used
to ease painful symptoms of rheumatism and arthritis.

DEEP (TISSUE) MUSCLE MASSAGE
This massage technique separates muscle groups and loosens
fascia (a thin layer of connective tissue covering and supporting or
connecting the muscles or inner organs of the body) so as to bring
about the realignment of the body and freedom of movement.
Sometimes called deep tissue massage, this massage is a deep,
sometimes painful kneading of the muscles. The best-known types
of deep muscle massage include Rolfing, Reichian, Heller and
Benjamin. It's not for everyone as some people find deep muscle
massage very uncomfortable and not the least bit relaxing. Its
proponents, however, claim that the massage has ample benefits
(e.g. improved posture and relief of chronic tensions).

DEEP-CLEANSING FACIAL
Use of sophisticated machines or manual techniques
to open pores, extract blackheads by hand, purify skin,
close pores, and revitalize skin.

DEPILATORY WAXING
See waxing.

DERMATOLOGY (SKIN CARE)
A branch of science dealing with the skin,
its structure, functions, and diseases.

DESTINATION SPA
A destination spa is a facility with the primary purpose
of guiding individual spa-goers to develop healthy habits.
Historically a seven-day stay, this lifestyle transformation can
be accomplished by providing a comprehensive program
that includes spa services, physical fitness activities, wellness
education, healthful cuisine and special interest programming.

DETOXIFICATION
Cleansing the body of accumulated poisons
often from over-taxation due to addictive habits.

DIETARY FIBER
A number of chemically different components of plant cell walls
and cell contents that are not broken down by the digestive
enzymes in the human gastrointestinal tract. Some types of fiber
help move food more rapidly through the body, aid in bowel
regularity, and promote a healthy digestive tract. Certain types
of fiber can also effect a modest lowering of blood cholesterol
levels. Fibers are found in a wide range of foods, including
fruits, vegetables, grains, cereals, nuts, seeds and legumes (dried
beans and peas). Only foods from plant sources contain fiber.

DIETETICS
The study of the kinds and types of food needed for health.

DIETITIAN
A person qualified in or expert at practicing dietetics.

DIURETIC
A medicine that promotes the loss of salt, water, and other
constituents from the body via the urine. Diuretics are used in
the treatment of high blood pressure and certain types of edema.

DULSE SCRUB
A vigorous scrubbing of the entire body with a mixture of
powdered dulse seaweed and oil or water to remove dead
skin and provide a mineral and vitamin treatment to the skin.
This is a gentle treatment for sensitive skin, which leaves
the skin incredibly smooth.

EASTERN MEDICINE
A holistic perspective on health and illness, which
sees the relationship of a symptom to the person
as a whole, physiologically and psychologically.

EDEMA
Swelling of a part or parts of the body (for example, the feet or
ankles) due to abnormal retention of water in certain body tissues.

ELECTRO-ACUPUNCTURE
Use of an electrical pencil-like instrument that is placed on
the same body points used in acupuncture, generating current
through the tip of the wand without penetration of the skin. It is
highly sensitive to body heat and thus can immediately pick up
trouble spots.

ELECTROTHERAPY / DIATHERMY (ELECTRO-IMPULSE)
Treatments using the stimulating properties of a low voltage electric
current. Used to reaffirm muscle, eliminate cellulite and help in
weight loss treatments. Electrotherapy is the generic term for the
treatment of disease by means of electricity (e.g. nemectron,
galvanionization, ultrashort waves, infrared rays, ultraviolet rays,
illumination - partial and total baths, diadynamic currents,
and ultrasound). Diathermy refers to the generation of heat in
tissue by electric currents for medical or surgical purposes.

EMOTIONAL CLEANSING
Healing and health of the emotional body.

ENERGY BALANCING
A general term for techniques, which channel and stimulate energy in the body.

ERGOMETER (TRAINING)
Exercise machine designed for muscular contraction. Includes a built-in digital timer and workload indicator to enable you to measure your performance in a given time. These instruments can help you avoid overexertion at the start, and measure your improvements on a continuing basis.

ESALEN MASSAGE
Developed and refined over the last 20 years by the Esalen Institute in California, this massage combines Swedish and sensory relaxation massage techniques. This soothing and comforting massage utilizes long, full handed strokes, maintaining a sense of presence with another being throughout the massage, allowing full contact through hand touch. It is both energetic and relaxing because it releases muscle tensions and opens and harmonizes the whole body.

ESSENTIAL OILS
Aromatic liquid substances which are extracted from certain species of flowers, grasses, fruits, leaves, roots and trees which are used in the medicinal, food and cosmetic industries. The positive effect of essential oils on blood circulation is due to bringing oxygen and nutrients to the tissues while assisting in the disposal of carbon dioxide and other waste products produced by cell metabolism.

EXERCISE WEIGHTS
Small weights gripped in your hand, strapped or Velcroed to your wrist, or worn across your chest while working out to add to the impact of exercise routines, build upper body muscles, and intensify workouts.

EXFOLIATION
Skin treatment where the upper layer of dead skin cells is sloughed off. A variety of techniques can be used and the treatment is called accordingly: loofah rub, salt scrub, body glow, brush and tone, etc.

FACIAL
There are many types of facials. A standard facial usually includes massaging the face, cleansing, toning, steaming, exfoliating and moisturizing. Other types of facials, mask and skin treatments are available at most spas. They include a European facial (similar to a standard facial except the products are European); a peeling mask designed to lift dead skin and encourage new skin growth; a paraffin mask, which helps increase circulation and rehydrate the skin; and a deep cleansing facial which purifies and revitalizes the skin.

FANGO TREATMENT (THERAPY) (FANGO BATH)
The Italian word for mud. Used in treatments, a highly mineralized mud may be mixed with oil or water and applied over the body as a heat pack to detoxify, stimulate the circulation and relieve muscular and arthritic pain. Sometimes only an area such as a shoulder is covered. Otherwise the whole body is dipped or covered. "Parafango" is similar, using mud mixed with paraffin. This treatment relaxes the body, alleviates sore muscles, and softens the skin. Radioactivity is present in the mud at several spas. Pregnant women and women in their reproductive years should not risk possible genetic mutation by avoidable exposure to radioactivity. Fango creates an all-encompassing, gooey warmth and works like a poultice, softening the skin. Natural ingredients, such as peat moss and sea kelp, often are mixed into the mud to help contain the warmth and increase mineral content.

FAST (FASTING)
To abstain from certain, or all, food and certain drink, except water, for a period of time for the purpose of physical detoxification and rejuvenation. A supplemented fast, or very low-calorie diet, consists of small amounts of regular foods and extra vitamins and minerals, or of a liquid "formula" diet which is nutritionally adequate except for its content of calories. A protein-sparing modified fast (PSMF), another term for a very-low-calorie diet, is usually limited to lean meats, poultry, and fish (supplemented with vitamins and minerals), which in aggregate provides 600 to 800 calories a day.

FELDENKRAIS (METHOD)
System of bodywork developed by Moshe Feldenkrais that attempts to reprogram the nervous system through movement augmented by physical pressure and manipulation.

FINNISH SAUNA
A simple form of traditional bathing aimed at cleansing the body through perspiration. A pile of stones covering a stove is heated by wood, preferably birch, spruce or pine until it turns red hot. Water is then thrown over the heated stones to generate steam; leafy birch twigs are used to stimulate the circulation by beating the body.

FITNESS & CONDITIONING (EVALUATION)
A test for aerobic capacity, flexibility, and strength administered under the direction of an exercise specialist. Results enable a spa to design an individualized program, based on personal goals, abilities and lifestyle.

FLEXERCISE
Sometime called stretch and tone or stretch and flex, these gentle stretching exercises increase flexibility. A popular early morning activity, flexercise helps you wake up and prepare yourself for more rigorous exercise later on.

SPA GLOSSARY

FLOTATION (ISOLATION) TANK
A little larger than a twin-size bed, filled with 10 to 12 inches of water, this enclosed tank, containing warm water and Epsom salts, allows you to float comfortably in a totally dark, silent environment. This can be a serene, deeply relaxing experience for some, but claustrophobic for others. It creates a sensation that has been likened to returning to the womb.

FREE WEIGHTS
Hand-held dumbbells or barbells whose use allows isolation and toning of selected muscle groups.

HAKOMI THERAPY (HAKOMI INTEGRATIVE SOMATICS)
A unique approach to personal growth wherein the body is used as a source of information about the unconscious mind, serving as a vehicle to contact those key memories and basic emotional attitudes which determine the overall quality of our daily experience.

HAND AND FOOT TREATMENT
This often includes a standard manicure and pedicure, followed by a seaweed or paraffin mask to soften and smooth the skin.

HAYSACK WRAP
Kneipp treatment with steamed hay intended to detoxify the body.

HELLERWORK
Named after its founder, Joseph Heller, Hellerwork is a series of eleven 90-minute sessions of deep tissue bodywork and movement designed to realign the body and release chronic tension and stress. Verbal dialogue is used to assist the client in becoming aware of emotional stress that may be related to physical tension. It is regarded as preventive rather than curative and reflects a holistic approach to health. Hellerwork is designed to produce permanent change.

HERBAL WRAP (hot and cold)
The body is wrapped in warm linen or cotton sheets, which have been steeped like tea bags in a variety of aromatic herbs, then covered with blankets or towels, preventing the moist heat from escaping. Additionally, a cool compress is applied to the forehead. Herbal wraps help relax the muscles, soothe soreness and soften skin. However, some people find the heat oppressive and the cocoon effect of the wet sheets and blankets smothering. To avoid feeling claustrophobic, the arms may remain outside of the wrap. See also aroma bath and herbal bath.

HERBOLOGY (HERBALISM)
The study and use of herbs for healing purposes and diet. Herbs are prepared for internal and external use in a variety of ways including teas, tinctures, extracts, oils, ointments, compresses, and poultices.

HOLISTIC HEALTH
Also known as wholistic (from whole), this is a non-medical approach to the healing and health of the whole person that looks to combine physical and mental well being. This philosophy of health views the environmental, physical, mental, emotional and spiritual aspects of life as intricately interwoven, and seeks to create balance by attending to all. When one aspect is out of sync, the others are affected. For instance, even regular exercise and nutritionally balanced meals don't make up for a mentally troubled state. To induce relaxation, holistic-oriented spas often teach ancient Eastern systems such as T'ai Chi and yoga, as well as Western systems such as biofeedback.

HOLISTIC MEDICINE
General term for various forms of alternative or complementary medicine including homeopathy, chelation therapy, clinical ecology, acupuncture, stress reduction, nutritional therapy and other alternative medicine methods.

HOLISTIC NUTRITION
A nutritional philosophy based on the concept that food is a natural medicine and that the body only needs whole foods to remain healthy.

HOLISTIC SPA
Spas focusing on alternative healing methods and nutrition, mainly vegetarian or macrobiotic. Holistic healing seeks a "high level of wellness", integrating body and mind in a higher consciousness.

HOMEOPATHY
A form of medicine based on the principle that "like cures like". Patients are treated with natural substances in minute quantities, which cause symptoms much like those manifested, by the disease. In this way, the body's own vital force is stimulated to cure itself.

HOT PLUNGE
Deep pool for the rapid expansion of the capillaries.

HOT SPRING
A place in the earth's surface, often volcanic, where hot mineral waters rise to the surface.

HOT TUB
A soaking pool made of wood or other materials.

HYDROPATHY
The internal and external use of water to treat disease.

HYDROSTATIC WEIGHING
Underwater weight test.

HYDROTHERAPY

Long a staple in European spas, this is the generic term for water therapies using jets, underwater massage and mineral baths (e.g. Balneotherapy, Iodine-Grine Therapy, Kneipp Treatments, Scotch Hose, Swiss Shower, Thalassotherapy, and others. It also can mean a whirlpool bath, hot Roman pool, hot tub, Jacuzzi, cold plunge and mineral bath. These treatments use physical water properties, such as temperature and pressure, for therapeutic purposes, to stimulate blood circulation, dispel toxins and treat certain diseases.

HYDROTUB

Underwater massage in a deep tub equipped with high-pressure jets and hand-manipulated hose. See also hydromassage.

IDEAL WEIGHT

Strictly speaking, this confusing expression refers to the tables of "ideal weights" published by the Metropolitan Life Insurance Company in 1942-43. In 1959, Metropolitan Life replaced the ideal-weight tables with new "desirable- weight" tables. In 1983, the desirable weight tables were, in turn, replaced by "The 1983 Metropolitan Life Tables" based on more recent mortality statistics. Although "ideal weight" is an outdated term, it continues to be used (improperly) to refer to the desirable weights for height determined by Metropolitan Life in 1959 or associated with the greatest longevity in the 1983 tables.

IMMUNOTHERAPY

A biological therapy for revitalization and improvement of the immune system, this therapy consists of cell therapy, enzymes, placenta and/or vitamins. Some trade names are Omnigen and Transvital.

INFRARED TREATMENT

A heat treatment to aid in muscular relaxation and increase blood circulation.

INHALATION THERAPY (ROOM)

A wood-paneled room filled with hot vapors and/or steam from sea water, mineral water, or thermal water, sometimes augmented with pine eucalyptus and other oils for relieving respiratory congestion and enjoying the pleasures of aromatherapy. Hot vapors, or steam combined with eucalyptus oil, for treatment of respiratory, pulmonary and sinus problems are breathed through inhalation equipment or in a specific steam room. In Europe, this sometimes refers to breathing vapors piped from below ground for varying treatments.

INTERVAL TRAINING

A series of high-energy exercises succeeded by a period of low-intensity activity. A combination of high-energy exercise followed by a period of low-intensity activity.

IODINE-BRINE BATH THERAPY

Mineral baths, naturally rich in salt and iodine, used mostly in Europe for recuperation and convalescence.

ISOKINETIC EXERCISE

Resistance balances effort applied against a device.

ISOMETRICS (EXERCISE)

Pushing against a stable object to tone muscles. Movements in which opposing muscles are so contracted that there is little shortening of the muscles but a great increase in the tension of the muscles involved. For example, attempting to lift a weight that is too heavy to move will result in increasing the tension of certain muscles without muscle shortening. See also isotonic exercise.

ISOTONIC EXERCISE

Movements that involve muscle contraction with shortening. Exercises like tennis, running, and golf are isotonic. See also isometric exercise.

IYENGAR YOGA

Exercise system developed in India by B.K.S. Iyengar.

JACUZZI

A patented design of a whirlpool bath or a mechanism, which swirls water in a bath with underwater jets.

JAPANESE ENZYME BATH

A three-part treatment lasting about an hour. First you are served hot enzyme tea, and then you submerge in a large wooden tub filled with fragrant blends of cedar fibers and plant enzymes imported from Japan. The enzyme bath stimulates circulation and metabolism.

JIN SHIN DO®

A form of energy-balancing massage.

JINN SHIN JYUTSU®

A form of energy-balancing massage.

JUNGIAN THERAPY

Therapy based on the work of Carl G. Jung. Focuses on the realization of personality and our search for meaning through the use of dreams, symbols, journals, and Jung's particular theory of basic human archetypes to explore the unconscious.

KEISER CAM II

A patented system of pneumatic weight training units. Keiser Cam III is the new version.

KETOSIS

The accumulation in the body of ketone bodies, generally associated with a low carbohydrate intake and commonly observed in cases of starvation, prolonged ingestion of low-calorie, low-carbohydrate diets, and poorly controlled insulin-dependent (Type I) diabetes.

SPA GLOSSARY

KINESIOLOGY
Diagnosis and treatment of a disease through muscle testing. Virtually any diseased area of the body will have a structural manifestation, a specific "body language," represented by specific muscle weakness patterns. This system restores the structural, mental and chemical balance of the body through the strengthening of weak muscles, stimulation of meridian points and diet.

KINESITHERAPY
Physically active or passive movement of various areas of the body. Known more generally as physiotherapy.

KIRLIAN PHOTOGRAPHY
A special photographic technique that shows the energy field around the body, typically the hands.

KNEIPP BATHS (THERAPY/TREATMENTS)
Treatments combining hydrotherapy, herbology, and a diet of natural foods, developed in Germany in the mid-1800s by Pastor Sebastian Kneipp. Includes the use of herbal bath oils, eucalyptus, lavender, rosemary, meadow blossom, spruce, pine, juniper, chamomile, and hops to comfort body and mind as a component of treatment. See Kneipp Kur System.

KNEIPP KUR SYSTEM
Treatments combining hydrotherapy, herbology, and a diet of natural foods, developed in Germany in the mid-1800s by Pastor Sebastian Kneipp. Includes the use of herbal bath oils, eucalyptus, lavender, rosemary, meadow blossom, spruce, pine, juniper, chamomile, and hops to comfort body and mind as a component of treatment. These highly regarded European therapies are particularly popular in Austria, Switzerland and Germany. Kneipp combined the practice of physical exercise with health diet and hydrotherapy to achieve physical and emotional well being.

LAYING-ON-THE-HANDS
Among the most direct approaches to healing. A "body therapy" for removing energy blockages, balancing, and improving one's healing journey through life.

LIFECYCLE
A computer-programmed exercise bicycle made by Bally.

LIFEROWER
A computer-programmed exercise machine that simulates rowing, made by Bally.

LIPIDS
A general term for fats and fat-like substances. Lipids include fats, cholesterol, lecithins, phosopholipids, and similar substances, which are generally insoluble in water.

LIPOSUCTION
A cosmetic surgical procedure that sucks excess fatty tissue out of various areas of the body.

LIQUID BALANCING
Floating in body temperature saltwater alone or balanced by a physical therapist.

LIQUID SOUND®
Light and music under and above the water for relaxation and vitalization.

LOMI-LOMI
Hawaiian rhythmical, rocking massage.

LOOFAH
A natural plant, like a dried sponge, used to slough off dead skin, especially after a sauna or steam bath. Once dried, this natural plant looks like a mutant piece of shredded wheat, but it doesn't feel scratchy.

LOOFAH BODY SCRUB
Full body massage with loofah sponge and a mixture of sea salt, warm almond or avocado oil for exfoliation of skin and renewed circulation. Includes a deep but soft massage of skin and subcutaneous tissues of specific body sites located around lymph nodes.

LOW-IMPACT AEROBICS
A dance-like exercise where side-to-side marching or gliding movements replace the jumping, hopping, jogging movements of conventional aerobic exercise without subjecting your body to excessive stress. One foot is almost always kept on the floor, and the body is kept closer to the floor than in conventional aerobics, using the body's pressure against the floor to create resistance and condition muscles. Most spas offer low-impact aerobics, as they are easier and safer to do than high-impact aerobics, which involves a lot of jumping, skipping, hopping and jogging. Some spas offer high-impact aerobics, but usually only to advanced students.

LYMPHATIC DRAINAGE MASSAGE
A therapeutic massage using a gentle pumping technique to drain away pockets of water retention and trapped toxins. Considered by many European cure doctors as a premier anti-aging treatment. Lymph drainage can be achieved through manual massage, hydro massage, or with aromatherapy massage. Sometimes called lymphatic drainage massage, it requires serious knowledge of the location of the lymph nodes. Be sure the masseuse or masseur knows what she/he is doing. Sometimes done on the face and neck, other times the entire body, lymph massage helps stimulate lymphatic circulation, which boosts the body's ability to eliminate wastes and absorb nutrients. It can also reduce swollen or puffy tissue and tone underlying tissue. Normally, lymph is drained by

LYMPHATIC DRAINAGE MASSAGE (Continued)

changes in the body's position and by the pumping action of nearby muscles. In otherwise healthy people who are physically very inactive and whose muscle tone is greatly diminished, excess fluid may accumulate in the lowest parts of the body such as the feet, ankles, or the small of the back. Large accumulations of fat under the skin can also cause mechanical interference with lymphatic drainage, resulting in edema. Increasing physical activity, muscle strengthening exercises, and when appropriate, calorie restriction to reduce the size of the fat deposit, best treat impaired lymphatic drainage in sedentary but otherwise healthy persons. Massage of the involved areas may provide temporary relief.

MACROBIOTIC SHIATSU

The theory or practice of promoting well-being and longevity, principally by means of a diet consisting chiefly of whole grains and beans.

MACROBIOTICS

An extremely restricted vegetarian diet, low in fat and high in antioxidant vitamins. This Eastern philosophy is perhaps best known in the West through its dietary principles. The macrobiotic diet offers a way to achieve a fuller sense of balance both within ourselves and with the world around us by synchronizing our eating habits with the cycles of nature.

MAGNETOTHERAPY (IMPULSE MAGNETIC FIELD)

Following an acupuncture treatment, a small magnet is taped over the treatment point and left for a period of approximately one week. This provides for a continuous treatment and is thus more effective.

MANDALA

Sanskrit word literally meaning, "circle" or "center." A mandala consists of a series of concentric forms, suggestive of a passage between different dimensions. Through the mandala, man and woman may be projected into the universe and the universe into man and woman.

MANICURE

A cosmetic treatment of the fingernails, including shaping and polishing.

MARIEL

A form of energy-balancing massage.

MARTIAL ARTS (KARATE, TAI CHI)

Any of several arts of combat and self-defense (as karate and judo) that are widely practiced as sport.

MASSAGE (THERAPY)

Manipulation of skin, muscle and joints (usually by hand) to relax muscle spasm, relieve tension, improve circulation and hasten elimination of wastes. It also stretches connective tissue and improves circulation. A wonderful antidote to stress and muscle tension, massage does not rub away weight, but will rub away fatigue, inducing relaxation. Various forms of massage include: Acupressure, Athletic Massage, Polarity Massage, Reflexology, Rolfing, Shiatsu, Sports Massage, Swedish Massage, Traeger Massage, Watsu.

MASSERCISE

A thermal mask applied to the lower body combined with massage to break up cellulite.

MEDICAL SPA

A facility that operates under the full-time, on-site supervision of a licensed health care professional whose primary purpose is to provide comprehensive medical and wellness care in an environment that integrates spa services, as well as traditional, complimentary and/or alternative therapies and treatments. The facility operates within the scope of practice of its staff, which can include both Aesthetic/Cosmetic and Prevention/Wellness procedures and services.

MEDICINAL WATER

Mineral water, which has curative effects confirmed by medical observation and experiments. Medicinal waters can be cold or hot, but their curative effect and composition is essential. Most medicinal waters are thermal waters.

MEDITATION

A state of focused attention through which one emerges into an ever-increasing clear awareness of reality. Many forms of meditation are practiced. The deep relaxation of meditation heals the body, quiets the mind, and stimulates creativity and efficiency, thereby providing a sense of inner balance and peace. Often used as part of a stress reduction program, meditation is usually done in a peaceful setting outdoors or in a quiet room, away from distracting sounds and sights. As meditators assume a comfortable sitting position, an instructor tells them to concentrate on breathing in a slow, rhythmic motion, imaging the release of tension as theyexhale. Often a simple word (or mantra) is repeated with each breath. The general purpose is to relax the body and quiet the ongoing chatter of the conscious mind. Practice is required to meditate effectively, but the physical benefits are well worth it. Meditation decreases the heart rate, oxygen consumption, blood pressure, blood lactate levels, muscle tension and metabolic rate. It increases alpha brain waves, alertness, awareness, creativity and psychological well being.

SPA GLOSSARY

METABOLISM

All the biochemical activities occurring in living organisms, which, in aggregate, sustain life and support function. The chemical and physical processes continuously going on in living organism and cells, comprising those by which assimilated food is built up (anabolism) into protoplasm and those by which protoplasm is used and broken down (catabolism) into simpler substances or waste matter, resulting in the release of energy for all vital processes.

MIND / BODY (CONNECTION)

Category of activities based on speculative or abstract reasoning. These include: Reflection: Breathing exercises, gardening, meditation, nature walks, relaxation classes, stretching techniques, Tai Chi and yoga. Creative Activities: Arts and crafts, music, painting, poetry and writing. Workshops: Astrology, emotional health, lifestyle interview, relationships and couples, smoking addiction and stress-management.

MINERAL SPRINGS SPA

A spa offering an on-site source of natural mineral, thermal or seawater used in hydrotherapy treatments.

MINERAL WATER BATH

Soaking in hot or cool water from thermal springs, which contains mineral salts, natural elements, and gases.

MINERAL WATERS

Water from springs and wells, which contain a minimum of 1,000 mgr./l solid components of rare, biologically active elements or compounds. Mineral waters can be cold or hot, but their mineral composition is essential.

MOOR / PEAT BATHS

A natural, peat preparation (often imported from Austria), rich in organic matter, proteins, vitamins and trace minerals, applied to ease aches and pains. Can also be applied on a cloth as a pack.

MUSCULOSKELETAL HEALTH ASSESSMENT

This often involves examining the range of motion, muscle strength, posture, gaits, flexibility and skeletal alignment in order to focus on problem areas that might require special exercises.

NAPRAPATHY

A system of treatment by manipulation of connective tissue and adjoining structures (as ligaments, joints, and muscles) and by dietary measures which are held to facilitate the recuperative and regenerative processes of the body.

NATURAL HEALTH (FOOD)

The term is generally used to describe foods that have not been processed or refined and do not contain additives or other artificial ingredients. Often "organic" means that the food has been grown without the use of any imbalanced fertilizers or harmful sprays. "Natural" foods are not necessarily more nutritious or safer to eat than processed foods available in the supermarkets.

NATUROPATHY

Natural medicine based on the healing power of nature. The term was coined in 1895 by Dr. John Scheel of New York to describe his methods of health care. Naturopaths believe that virtually all diseases are within the scope of their practice. Current methods include: fasting, "natural food" diets, vitamins, herbs, homeopathy, tissue minerals, cell salts, manipulation, massage, exercise, colonic enemas, acupuncture, "Chinese Medicine", natural childbirth, minor surgery, and applications of water, heat, cold, air, sunlight and electricity. Radiation may be used for diagnosis but not for treatments.

NAUTILUS

Patented strength-training equipment intended to isolate one muscle group for each exercise motion, which shortens and lengthens against gravity.

NORDIC TRACK

A patented cross-country ski machine design.

NUAT THAI®

A form of energy-balancing massage.

NUTRITION COUNSELING

The review of an individual's eating habits and dietary needs by a qualified practitioner.

ONSEN

Japanese natural mineral hot springs.

ORTHION (MACHINE)

A 3-dimensional mechanical massage table used to align spine and neck. The entire body, even the head, is strapped to the table that then gently pulls, stretches, lifts and massages strategic points to help loosen and relax muscles. An attendant controls the duration and degree of movement from a control panel.

OZONIZED BATHS

A tub of thermal water or seawater with a system of jets that provide streams of ozonized bubbles, used for relaxation and stimulation of circulation and as an aid for the relief of minor aches and pains.

PANCHAKARMA

Succession of cleansing and purifying treatments from Ayurveda, using nutrition, herbs, massage and meditative techniques aimed to restore the body's own ability to create health.

PANTHERMAL

Lying in a fat metal tube, which resembles an iron lung, hot dry air circulates around your body (with the head outside the tube) and you work up quite a sweat. Gentle jets of warm soapy water then hit you from all directions. Panthermal is designed to break down cellulite. It is not recommended for people who get claustrophobic.

PARAFANGO

Combination of mud and paraffin wax.
See "Fango" and "Paraffin Treatment".

PARAFFIN TREATMENT (BATH)

Warm paraffin wax is brushed over the body. The liquid wax coats the skin and, as it solidifies, forms a vacuum that causes any dirt in the pores to be drawn out, removes dead skin, and induces a loss of body fluid in the form of perspiration. The deep heat created by this treatment helps to relieve stress and promote relaxation. Treatments leave the skin silky-smooth.

PARCOURSE / PARCOURS

A path or trail with exercise stations along the way provided with instructions and equipment for sit-ups, pull-ups, chin-ups, and a variety of other "obstacles" that are fun and challenging and designed to increase balance, agility, flexibility and body awareness. Also called vita course and exercourse and written as two words, par cours(e).

PHYSIOCHINEITHERAPY

Therapy that uses heat, light, electricity, mechanical means and movement.

PHYTOTHERAPY

Literally, healing treatment through plants, phytotherapy involves the use of herbs, aromatic essential oils, seaweed and herbal and floral extracts. Applied through massage, packs or wraps, water and steam therapies, inhalation treatments, homeotherapy and also includes the drinking of herbal teas.

PILATES (METHOD)

Strength training movements involving coordinated breathing techniques developed in Germany by Dr. Joseph Pilates during the 1920s.

PLYOMETRICS

Jumping and pushing steps to build up leg muscles.
See also step aerobics.

POLARITY MASSAGE (THERAPY)

Concept created by the Austrian born Dr. Randolph Stone in the early 1900s that is based on principles of energy and a philosophy derived from East Indian Ayurvedic teachings. Polarity therapy is designed to balance the body's subtle or electromagnetic energy through touch, stretching exercises, diet and mental-emotional balanced attitude. A four-part program is involved that restores the body's proper energy balance: clear thinking (positive mental attitude), bodywork (to alleviate energy blockages), body movement (stretching postures combining movement, breathing and sound), and diet (fresh vegetables, fruits and natural foods). As in other forms of bodywork, the practitioner of polarity therapy is viewed as a non-judgmental channel that the client can use to discover his or her own self-healing powers.

POWER YOGA

Form of yoga with an accelerated succession of yoga body postures.

PRIMORDIAL SOUND

Meditative technique from Ayurveda, using sound to restore balance and harmony.

PRITIKIN THERAPY

Strict program with a "military like" attitude toward health, especially the health of the heart. The Pritikin Program insists that one must cut all fat from the diet except for small amounts found in whole grains and vegetables. Use of any kind of animal or dairy products is limited. Use of carbohydrates such as sugar, syrup, molasses, and honey is forbidden, as are alcohol, salt, soda pop, coffee and black tea. According to the Pritikin Program you can eat unrefined, complex carbohydrate foods, whole grains, potatoes, vegetables and fruit. Avocados and soybeans are not allowed in the diet. This program does not allow for any vitamins or nutritional supplements and limits the daily fat intake to 10% fat.

PROCAINE (H3) THERAPY

A therapy based on the revitalization substance H7, a further development of H3 (Aslan therapy). This therapy normalizes and regulates metabolic processes and improves the oxygen supply to cells and tissue.

PSYCHOSOMATIC

Involving both mind and body (e.g., the psychosomatic nature of man). Also refers to bodily symptoms caused by mental or emotional disturbance (e.g., psychosomatic illness).

RACE WALKING

This brisk, exaggerated, aerobic form of walking looks like exercise on a cartoon, but helps develop stomach, thigh and buttock muscle tone.

RADU

Rigorous, low-impact aerobics for advanced students that utilizes hand weights sticks and low benches.

SPA GLOSSARY

REFLEXOLOGY

Ancient Chinese technique using pressure point massage
(usually on the feet, but also hands and ears) to restore the flow
of energy throughout the body. Also known as zone therapy,
a turn-of-the-century practice fostered by three American
physicians (Bowers, White and Fitzgerald). In their view, energy
travels from critical zones of the body and ends its journey in the
feet. Charts are available showing which zones correspond to
which internal organs. The theory is that when excessive granular
texture is felt in the feet as pressure is applied, it indicates the
presence of uric acid crystallization. By rubbing the crystals on
the nerve endings in the soles, a reflex reaction is supposedly set
up between the zone and its associated body part. Reflexology
is one of the massage techniques a person can learn to self-
administer. Reflexology is recommended for chronic conditions
such as asthma, headaches and migraines. Applied as hand,
foot or ear massage using pressure points similar to acupressure.

REIKI

Meaning "universal life-force energy," a scientific method
of activating and balancing the life-force energy present in
all living things. Techniques are applied to the entire body,
channeling energy to organs and glands, and aligning the
chakras (energy centers). Intended to relieve acute emotional
and physical conditions. See also Radiance Technique.

REPAICHAGE (REPECHAGE) MASSAGE/FACIAL:

Treatment applied to face or full body, using a combination
of herbal, seaweed, and clay or mud masks to create deep
cleansing and moisturizing.

RESORT AMENITY

A variety of services offered by resort hotels. Some resorts have
gone beyond the perfunctory salon services and hot tubs and
today are offering elaborate, imaginative and highly professional
spa services to their guests.

RESORT/HOTEL SPA

A spa within a resort or hotel providing professionally
administered spa services, fitness and wellness
components and spa cuisine menu choices.

RIGHT/LEFT BRAIN INTEGRATION

The integration or balancing of the right, or "feminine," side
of the brain with the left, or "masculine," side of the brain.

ROLFING

A technique developed by Ida Rolf of deep muscular
manipulation and massage for the relief of rigid muscles,
bones and joints. It is designed to improve energy flow
and relieve stress most often related to emotional trauma.
A complete Rolfing treatment consists of a series of ten sessions
which progress from superficial to deeper layers of tissue and
from localized areas of constriction to an overall reorganization
of larger body segments. This method of intensive manipulation
may sometimes be experienced as painful. See also Deep
Tissue Massage.

ROMAN (POOL) BATH

The Romans cherished bathing above all other luxuries. Roman baths
consisted of hot, warm and cold pools. Today the term usually refers to
a hot whirlpool/Jacuzzi, with benches to sit on for one or more persons.

RUBBER-BAND WORKOUTS

Giant rubber bands used for resistance techniques in calisthenics.
Also called elastics.

RUBENFELD SYNERGY METHOD

A practice developed by Ilana Rubenfeld of merging body
and mind through verbal expression and gentle touch.

RUSSIAN (STEAM) BATH

A steam bath.

SALT GLOW (RUB)

The body is rubbed with a vigorous, abrasive scrub, consisting of
coarse salt usually mixed with essential oils and water. Cleanses
pores and removes dead skin. It is usually followed by a gentle
shower and body moisturizer.

SAUNA

A dry heat treatment (at less than 10% humidity) in a wood-lined
room with temperatures of 160-210° Fahrenheit, designed to
bring about sweating to cleanse the body of impurities. After
a sauna, a cool to cold shower closes the pores and brings
down body temperature. In the Finnish bath tradition, where this
practice originated, even higher temperatures are sought as heat
is generated by a stove containing a heap of stones (kiuas) over
which water is thrown to produce vapor (loyly).

SCOTCH HOSE / SWISS SHOWER (DOUCHE MASSAGE)

Standing body massage delivered by therapist with high-pressure
hoses. This invigorating shower tones circulation by contracting
then dilating capillaries as water from sixteen needle-spray
shower heads and two high-pressure hoses (operated by an
attendant), ranging in temperature from 45° F to 105° F, is
turned quickly from hot to cold to hot for several seconds at a
time. This massage aids circulation and helps relieve the pain
of arthritis and rheumatism.

This spa glossary is courtesy of the International SPA Association (ISPA)

SEAWEED (BODY) WRAP
Similar to herbal wraps combined with heat packs, using sea water and seaweed with a balance of the ocean's nutrients; minerals, rare trace elements, vitamins and proteins, which are soaked into the blood stream, to revitalize skin and body.

SHIATSU (MASSAGE)
Means "finger" (shi) "pressure" (atsu), a cross between acupuncture and massage developed in Japan by Tokujiro Namikoshi in the 1940s. Like acupressure, Shiatsu works with vital points and energy meridians and uses finger-thumb-palm pressure. Unlike acupressure, Shiatsu also manipulates other parts of the body in the course of treatment. Intended to stimulate the body's inner powers of balance and healing.

SILICEOUS THERMAL (HOT SAND) BATH
Containing, resembling, relating to, or consisting of silica.

SITZ BATH
A bathtub shaped like a chair in which the hips and lower body are immersed in herbal hot water, followed by cold water, while soaking feet in water alternating from cold to hot to stimulate the immune system. Also a Kneipp treatment for constipation, hemorrhoids, prostate problems, menstrual problems, and digestive upsets.

SKIN GLOW RUB
Skin is softened with a sauna, then mineral water and sometimes salt are massaged into the skin, leaving it soft and glowing.

SKIN MASQUE
A preparation usually applied to the face and neck to stimulate local circulation, tone, cleanse and tighten pores and remove dry skin. Ingredients are varied to accommodate specific needs of one's skin type and condition.

SLENISUIM BODY WRAP
Body is covered in oils, wrapped and left to relax. Eliminates both toxins and fluids.

SPA CUISINE
Fresh, natural foods low in saturated fats and cholesterol, with an emphasis on whole grains, low-fat dairy products lean proteins, fresh fruit, fish, and vegetables and an avoidance of added salt and products containing sodium and artificial colorings, flavorings, and preservatives.

SPINNING®
An aerobic form of exercise class using special stationary bicycles.

SPORTS MASSAGE
Deep-tissue massage directed specifically at muscles used in athletic activities. This massage can be either preventive or corrective in approach. Because it is given to those whose body tone and condition is tied to performance, it can be as specific as working over of leg muscles (in a runner, for example), or kneading muscles to assure optimal flexibility appropriate to the sport the person is engaged in.

SPORTS STRETCH
Stretching exercises to limber up and better prepare the body for rigorous athletics.

SPORTS/ADVENTURE SPAS
Hotel or resort providing therapeutic baths and body treatments and that offer special sports and outdoor adventure programs that include anything from golf to skiing, fly-fishing to marathon conditioning.

STEAM ROOM
A ceramic-tiled room with wet heat generated by temperatures of 110-130° Fahrenheit designed to soften the skin, cleanse the pores, calm the nervous system and relieve tension.

STEP CLASS (STEP AEROBICS)
Aerobic workout that incorporates rhythmic stepping on and off a small platform.

STRUCTURED SPA
Spas with a strict set of rules whose entire facility is geared towards the achievement of a particular goal such as weight loss, or fitness.

SWEAT LODGE
An ancient Native American body purification ceremony involving the use of intense heat similar to that of a sauna and other methods to provoke visions and insights.

SWEDISH MASSAGE
The most commonly offered and best known type of massage. Devised at the University of Stockholm in 1812 by Henri Peter Ling, this technique employs five different movements (long strokes; kneading of individual muscles; percussive, tapping movement; rolling of the fingers; and vibration) and oils beneficial to the skin. Used to improve the circulation, ease muscle aches and tension, improve flexibility and create relaxation. Swedish massage is done with the person covered by a sheet, where each part of the body to be worked on is exposed in turn and then re-covered. The massage practitioners use kneading, stroking, friction, tapping and even shaking motions. Oil is used to reduce or eliminate friction and to facilitate making long, smooth, kneading stokes over the tissue and muscles of the body.

SWISS SHOWER

Standing body massage delivered by therapist with high-pressure hoses. This invigorating shower tones circulation by contracting, then dilating capillaries as water from sixteen needle-spray shower heads and two high-pressure hoses (operated by an attendant), ranging in temperature from 45° F to 105° F is turned quickly from hot to cold to hot for several seconds at a time. This massage aids circulation and helps relieve the pain of arthritis and rheumatism.

TAI CHI (CHUAN)

A Chinese Taoist martial art form of "meditation in movement" which combines mental concentration coordinated breathing, and a series of slow, graceful body movements. While this ancient system looks like a slow-motion dance of graceful movements and deep, relaxed breathing, it is a mobile meditation, used for health, relaxation, self-defense and to induce energy. It's widely practiced in the Orient by people of all ages.

TANTRIC SHIATSU

Any of a comparatively recent class of Hindu or Buddhist religious literature written in Sanskrit and concerned with mysticism and magic.

THALASSOTHERAPY

An ancient Greek therapy (thalasso is Greek for sea) these treatments use the therapeutic benefits of the sea, and sea water products for their vitamins, minerals and trace elements, which can heal and reinvigorate skin and hair. Various treatments include: Individual baths of fresh seawater equipped with powerful underwater jets for deep massage; or a therapist applies manual massage to body with hoses. Body wrap, similar to herbal wrap, but using seaweed or sea algae paste, to eliminate toxins, restore minerals and skin elasticity. As with most wraps, it usually involves seaweed paste rubbed on the body, which is then covered with sheets and sometimes blankets for 10 to 20 minutes. Use of seawater and sea air to treat a disease; living near the sea, bathing in the water and breathing sea air.

THERAPEUTIC TOUCH

A form of laying on of the hands, which creates a balance by transmitting energy and releasing energy blockages. It is a method of drawing and channeling the healing forces within and around us.

THERMAL (HERBAL) WRAP

A procedure claimed to eliminate "toxins" from your body through perspiration and promote muscle relaxation in which your body is wrapped in hot, wet linen sheets infused with herbal essences, and then covered with a blanket or plastic sheet to retain the heat. A cool compress is applied to your forehead. If you are claustrophobic and do not want to be completely swaddled, you can ask that your arms and hands be left outside your Egyptian mummy-like wrapping.

THERMAL (TONALASTIL) WRAP

Body wrap using oils and a thermal covering to eliminate toxins and excess fluids; tones and firms.

THERMAL WATER

Water whose temperature is steadily higher than 35°C (95°F).

THERMOTHERAPY

Heat treatment involving the use of various forms of heat for therapeutic purposes.

TRAEGER (BODY WORK) MASSAGE

A technique developed by Hawaiian physician Dr. Milton Traeger that employs a gentle, rhythmic shaking of the body to release tension from the joints. The client lies on a padded table while the practitioner works on the body using gentle, rhythmic movements that do not involve any force, pressure or oils. Sessions are from one to one-and-a-half hours long. Structural and functional improvements occur spontaneously as a result of sensory repatterning in the mind, as the body is rhythmically moved by the practitioner, producing deep relaxation and release of mental and physical stresses. There is minimal verbal communication between client and practitioner. Critical to the accomplishment of the work, this state of mind permits the practitioner to connect deeply and sensitively with the client without experiencing fatigue. A series of sessions are recommended because the benefits appear to be cumulative.

VEGETARIAN DIET

A dietary regime of raw or cooked vegetables and fruit, grains, sprouts, and seeds; natural foods with no additives. A "vegetarian" does not eat any "meat," that is, any animal product that results from the killing of that animal. They may eat by-products such as dairy, eggs and honey that are excluded from a "vegan" diet.

VICHY SHOWER (THERAPY)

Invigorating shower treatment from several water jets of varying temperatures and pressures applied while lying on a waterproof cushioned mat. This treatment is often followed by exfoliating treatments such as Dulse scrub, loofah or salt-glow.

YOGA

An ancient Hindu system of stretching and toning the body through movements or postures (asanas), composed of deep breathing, relaxation methods, and diet. Yoga is frequently part of stress-reduction programs. It helps improve muscle tone, flexibility and mobility; reduces stress and anxiety; and induces a sense of well-being. The word "yoga" denotes a concept of discipline leading to union. The body and the mind form a continuum of consciousness and life that, when achieving a state of focus and clarity, may unite with Universal Spirit.

ZEN (SHIATSU)

A Japanese acupressure art intended to ease tension and balance the body.

INDEX OF RESORT, HOTEL AND DESTINATION SPAS

For rates, special spa packages and promotions, log on to WWW.BESTSPASUSA.COM

RESORT SPAS

INDEX OF RESORT, HOTEL AND DESTINATION SPAS

For rates, special spa packages and promotions, log on to WWW.BESTSPASUSA.COM

HOTEL SPAS

DESTINATION SPAS

* Resort and destination spa facilities